Eiffel
by
EIFFEL

EDITOR'S NOTE

Text in italics is taken from Eiffel's own four-volume *Biographie industrielle et scientifique*, which he completed in 1923.

Translations of letters to and from Eiffel can be found on pages 168–169.

Official English edition
© 2014 Edition Olms AG, Zürich
EDITION OLMS AG
Willikonerstr. 10
CH-8618 Oetwil am See / Zürich
Switzerland
Email: info@edition-olms.com
Website: www.edition-olms.com
ISBN 978-3-283-01239-7
Translation: Joseph Laredo
Production: Weiß-Freiburg GmbH – Graphik & Buchgestaltung

© Éditions Michel Lafon, 2013
www.michel-lafon.com
Editorial Director: Édouard Boulon-Cluzel
Artistic Director: Mathieu Thauvin

Bibliographic information published by the Deutsche Nationalbibliothek
The Deutsche Nationalbibliothek lists this publication
in the Deutsche Nationalbibliografie;
detailed bibliographic data are available in the Internet at
http://dnb.dnb.de

Printed in Slovenia

PHILIPPE COUPÉRIE-EIFFEL

by EIFFEL

With
Dominique Bouvard

Translated by
Joseph Laredo

EDITION OLMS ZÜRICH

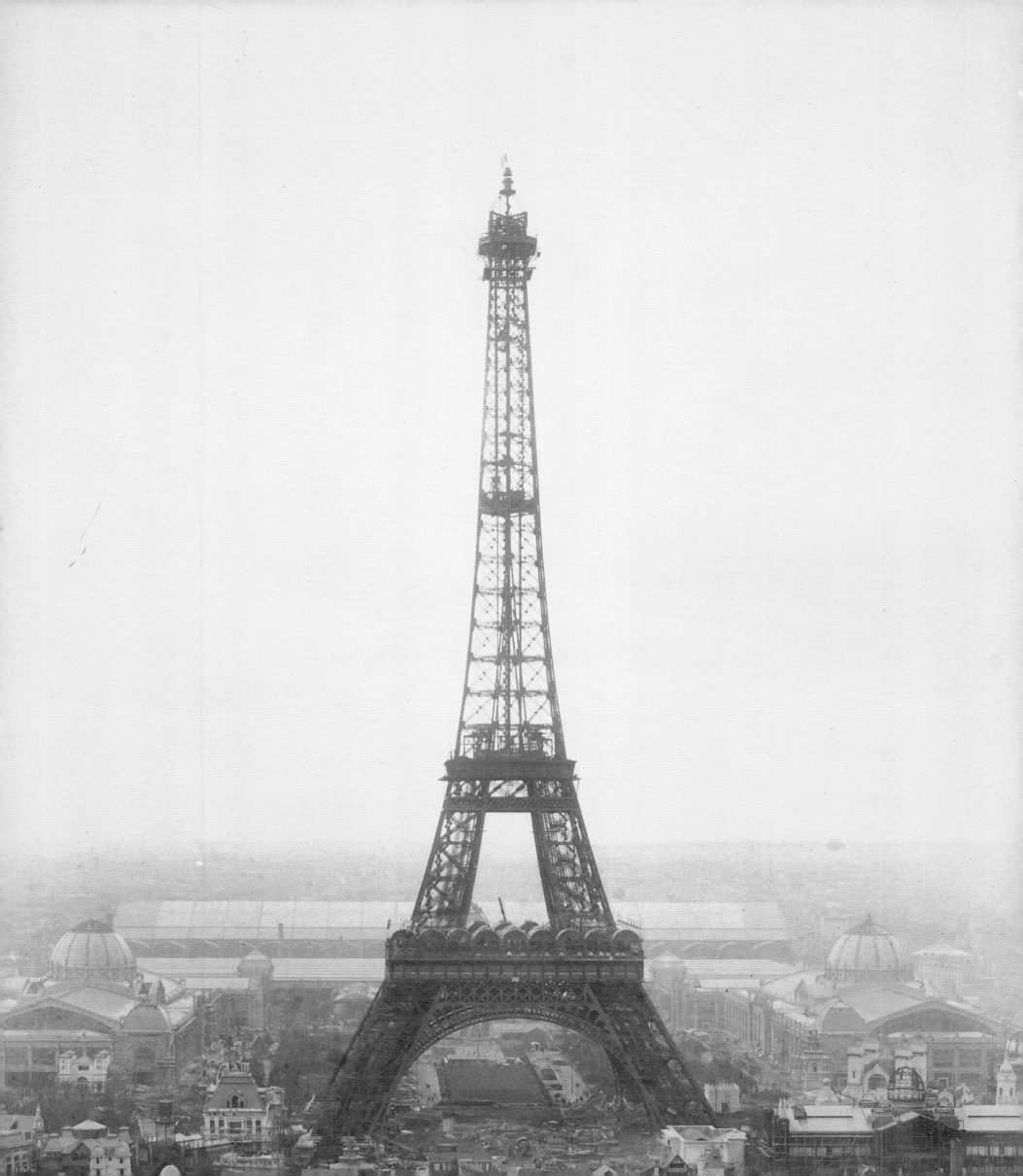

CONTENTS

*To my mother Florence and my aunt Rosine, the twin pillars of the family,
and in memory of Valentine, with whom I shared so many unforgettable times.
P. C.-E., 13th June 2013.*

P. 7
PREFACE

P. 9
FOREWORD

P. 13
CHAPTER I
GENESIS OF A GENIUS

P. 37
CHAPTER II
EIFFEL & CO.

P. 75
CHAPTER III
A 300-METRE TOWER

P. 107
CHAPTER IV
PANAMA AND AFTER...

P. 141
CHAPTER V
THE PATRIARCH

P. 167
ANNEXES

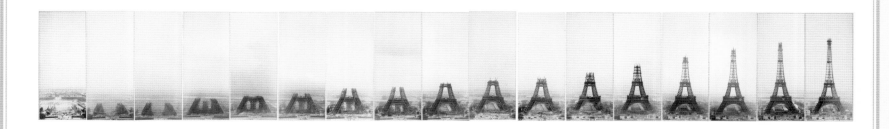

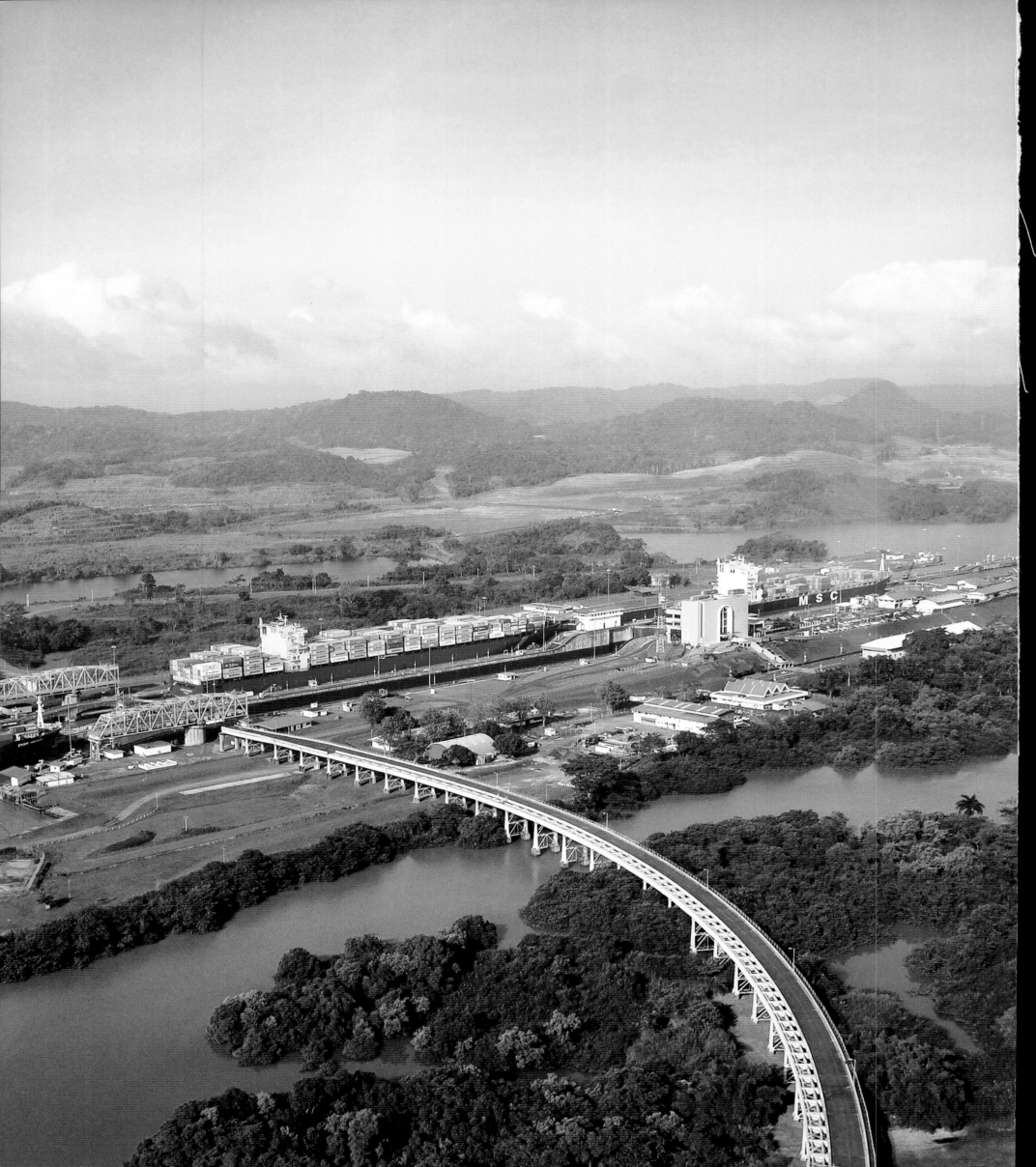

Preface

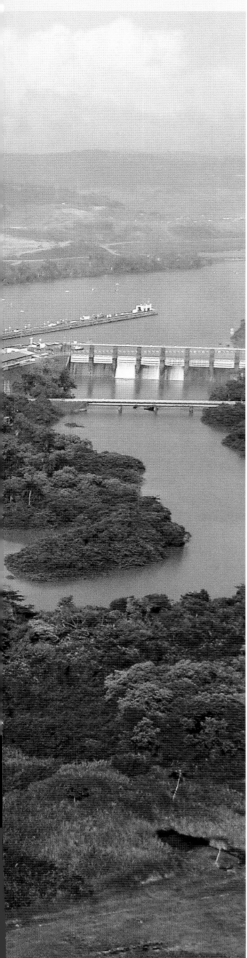

The Miraflores Locks on the Panama Canal, which open onto the Pacific Ocean, as they are today.

I first met Philippe Coupérie-Eiffel in June 2012 when he came to the Panamanian Embassy in Paris to show me his illustrious ancestor's work relating to the Panama Canal. This consisted essentially of the sketches Gustave Eiffel had made for the locks.

Apart from impressing me with their precision and beauty, these sketches made me realize that the very idea of constructing a canal with locks had come from France and not from the United States, as the majority of Panamanians still believe. It was a revelation. Philippe went on to explain to me that Gustave Eiffel was one of the few delegates at the International Congress of the Geographical Society in Paris in 1879, at which the design of the canal was finalized, to have voted against the option of a single-level canal. In other words, Eiffel knew from the outset that such a design, which had been adopted in Suez, would not work in Panama, where locks were the only solution. From that moment, Philippe Coupérie-Eiffel had my undivided attention.

The question that immediately came to my mind was: Why, then, is the name Gustave Eiffel not popularly associated with the French involvement in the construction of the Panama Canal? Philippe replied that it was not until 1887, seven years after construction had begun, when the project had run into difficulties, that Eiffel's idea of a canal with locks was accepted. He then showed me the contract with the Compagnie universelle du canal interocéanique de Panamá, in other words with Ferdinand de Lesseps, signed by Eiffel on 10th December 1887. He reminded me, however, that Eiffel's involvement in the project, crucial as it was for the future of the Canal, which would eventually be built by the Americans, lasted barely a year, since the Compagnie universelle went into liquidation on 15th December 1888. It also had most unfortunate consequences for Eiffel, whose name and reputation were tarnished by the political and financial scandal caused by the company's bankruptcy. As Philippe explained to me, the Panama Canal therefore marked a turning point in Eiffel's career. To protect his reputation from the destructive consequences of the scandal, he withdrew his name from the company's statutes, ceased his activities as an engineer and devoted himself to scientific study. At the same time, he took a number of decisions regarding his private life that were symptomatic of a desire to distance himself from the troubled waters of the Panama Canal project. Nevertheless, it bears repeating that the role played by this great visionary in the construction of the Canal was crucial to its successful outcome. Eiffel's genius lay in his drafting of plans so ingenious that those who relaunched the project in 1904 were obliged to return to them in order to complete what is now considered to be one of the Seven Wonders of the Modern World.

With Panama due to celebrate the centenary of the opening of the Canal on 15th August 1914, it is opportune to redraw its history in order to acknowledge the central role played in its construction by the French, and most notably by Gustave Eiffel, whose pivotal part has so unjustly been forgotten.

In my capacity as Panamanian Ambassador to France I therefore take this opportunity to salute him and hope that one day the entrance to the Canal will be marked not by an Eiffel tower, but by an Eiffel lighthouse, as a signal to the world of his great engineering achievement and service to mankind.

HENRY J. FAARUP
Panamanian Ambassador to France

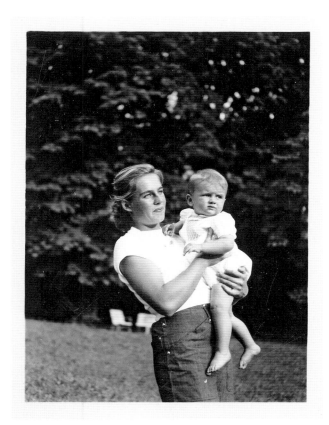

*"You must learn and understand what my father did,
and then pass on that knowledge…"*

Valentine to Philippe

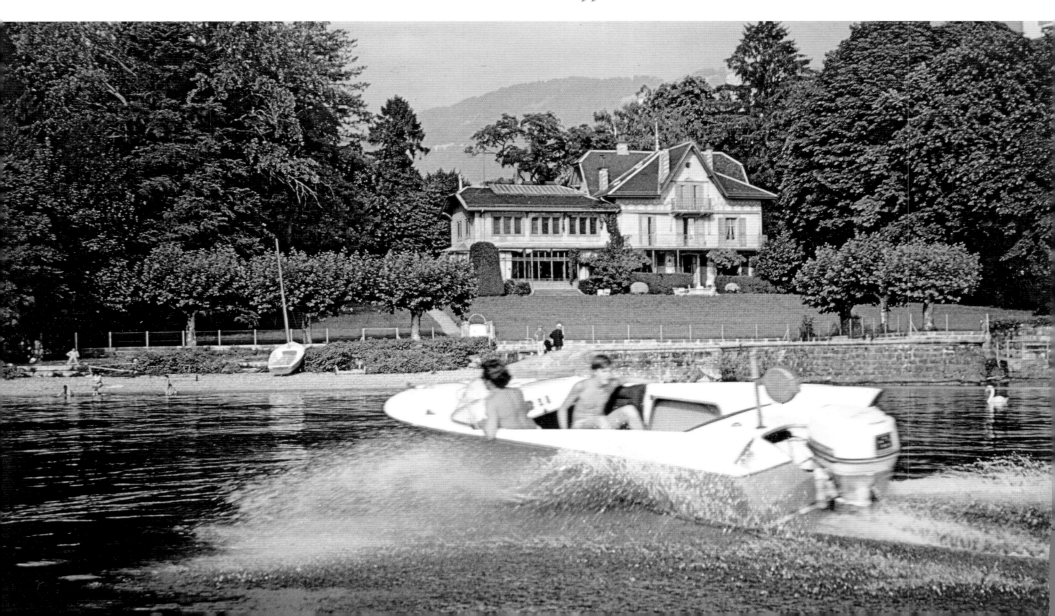

Foreword

A moral inheritance

Opposite:

Above, Philippe Coupérie-Eiffel in his mother's arms at Vevey, in 1952. Fifty-five years later, she would leave him the priceless typescript of Gustave Eiffel's autobiography "as a souvenir of his great-grandmother Valentine, with whom he spent so many holidays and who loved him dearly" (from the letter shown opposite and translated on p. 168).

Below, Philippe in 1974, aboard the boat belonging to the Villa Claire, in Vevey, which no longer exists. Eiffel bought it in 1892 and added the extension seen on the left, a ground-floor living room featuring iron-framed picture windows.

For me, it all began one fine spring day in 1989, though I had no idea at the time that it would change the course of my life in such an unexpected way. I knew, of course, that a major celebration was due to take place on the centenary of the completion of the famous tower in Paris designed by my illustrious ancestor; it had been widely announced in the media. But as no invitation had dropped into my letter box, I assumed that other members of my extensive family, more senior than I, perhaps, had been asked to attend and was not in the least offended to have been left out.

A few days before the event, however, a friend of mine, Olivier Maurey, head of the event management group Ludéric, who knew how much I had loved my great-grandmother Valentine Eiffel, asked me if I wanted to go along with him, as his company had been appointed by the Paris Town Council to do the catering. He supplied me with a special "contractor's" pass and I found myself taking the boat to the Quai de Grenelle, right at the foot of the Tower. As I waited my turn to be let in through the metal barriers, pleased to be taking part in the celebrations, if only in an unofficial capacity, a crowd quickly gathered around the building that has immortalized my family's name. Staging had been erected on the Pont de l'Alma to give the VIPs the best view of the show that had been planned for them: a concert followed by fireworks.

I scanned their faces in vain: not a single member of the family in sight. This seemed so illogical that I went over and introduced myself to the town hall's press officer, expressing my incredulity at this oversight—not angrily but almost jokingly. The woman concerned seemed most embarrassed, not to say distressed. She told me not to move; she would be back in a moment. True to her word, she reappeared a few minutes later with Claude Chirac, daughter of the then mayor of Paris, Jacques Chirac, in her wake. In a friendly tone, Mme Chirac told me straight away that no one had thought to include a descendant of the Tower's designer in the guest list. She wasted no time in making up for the oversight, immediately bestowing upon me VIP badge no. 2 before escorting me to the stage on the bridge that faced the Tower. There I was shown to a seat in the second row, right behind Jacques Chirac and the American president, Ronald Reagan, to whom I was duly introduced, as the other guests looked me up and down, no doubt wondering who this nobody was that should be accorded such an honour. But the funniest part of the story was that not a single security guard—and there were plenty of them about—thought even to check my identity, let alone to search me. I could have been a militant bristling with weapons, with a golden opportunity to gun down the world's most powerful man, or at least the most powerful man in Paris, at point-blank range. Instead, in the company of the great and the good, I was served champagne and petits fours as I enjoyed the magnificent concert and dazzling firework display from the ideal vantage point. After which the ever-attentive Claude Chirac ushered me to the marquee that had been erected beneath the Tower, where dancers from the Moulin Rouge performed a riotous can-can. All in all a delightful occasion—the more so for being entirely unexpected.

The next day, I drove back home to Bordeaux. Five hundred kilometres of motorway gives you time to think. I had to act. I could not allow my family to be dispossessed of its heritage, abstract as it may be: the glorious memory of our great ancestor. I had to preserve it—not for myself, but for my two daughters and for the grandchildren they might one day give me, for my nieces and nephews, and for all the offspring of the various branches of the family, both living and yet to be born. I wanted them to honour their great forebear Gustave Eiffel, the man who transferred

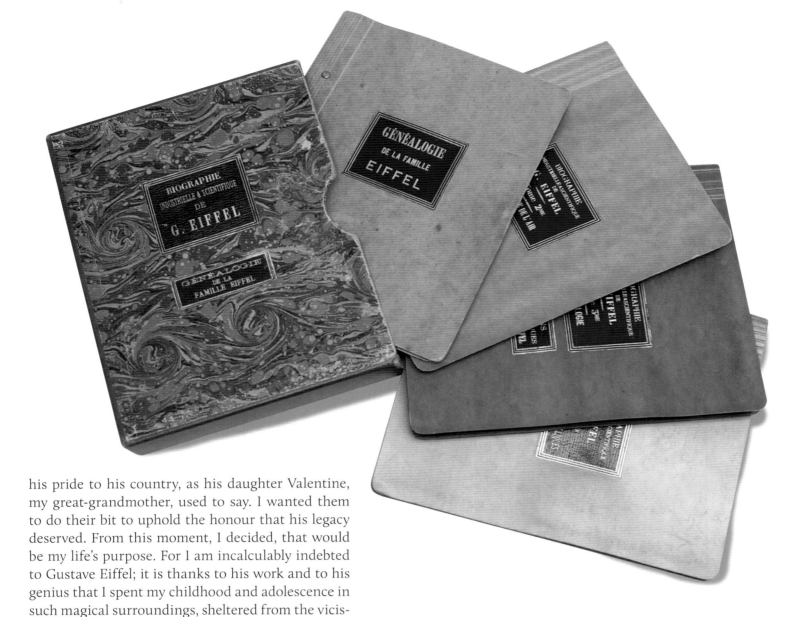

his pride to his country, as his daughter Valentine, my great-grandmother, used to say. I wanted them to do their bit to uphold the honour that his legacy deserved. From this moment, I decided, that would be my life's purpose. For I am incalculably indebted to Gustave Eiffel; it is thanks to his work and to his genius that I spent my childhood and adolescence in such magical surroundings, sheltered from the vicissitudes of life. I would also be able to pay tribute to Valentine, with whom I had been so close.

Being from Bordeaux, I began by asking a winemaker friend, who had bought part of the family estate, to produce a special vintage to mark the centenary of the Tower. We called it "Domaine Eiffel". I then drafted a request to the Council of State for permission to attach the name Eiffel to my own surname, my father's, since, like all other living members of Eiffel's family, I was descended from one of his daughters. Of his only two sons, Albert and Édouard, one died childless and the other had only one son, who also died without children. Permission was granted not only to me but also to other members of the family, with the result that we have been able to save Eiffel's name from extinction. This achievement led me to register Eiffel as a brand name, the only way to protect it against exploitation by the greedy and unscrupulous. But this was only the beginning of my crusade, which I am determined to continue until my dying day.

Why me rather than any of Eiffel's other descendants? To be honest, I have no idea. The responsibility has fallen on me because I happened to be in Paris on that fateful day in 1989. I might have assumed it sooner, or someone else might have done so, but what does it matter? I would rather think of ways in which I can restore due significance to the work of my great ancestor.

I would also like to reveal to as many people as possible aspects of Eiffel's life and work that have been overshadowed by the tower with which his name is so indelibly associated—like the tree that obscures the forest. For Eiffel created many other remarkable structures throughout the world that still deserve our attention because of the technological progress they represent and the functions they continue to serve. Eiffel never stopped inventing and innovating. It is at least partly thanks to him that modern meteorologists are able to predict weather patterns several days ahead and that Sébastien Loeb became world rally champion at the wheel of a French car. For the last decade of his life, Eiffel put his genius and his fortune at the service of his country and in doing so played his part in such recent successes. I therefore invite you to discover the many facets of Gustave Eiffel through the documents reproduced in this book, many of which come from the private collections of members of my family and have never previously been published.

Above:

Gustave Eiffel's Industrial and Scientific Biography, *completed just a few months before his death, in 1923. Eiffel himself typeset the pages and only a very few copies of this four-volume edition were printed.*

Opposite:

Eiffel dedicated his autobiography to his eldest daughter, Valentine (seen here in a photograph by Otto). It is dated 23rd September 1923, three months and two days before his death. (See translation on page 168.)

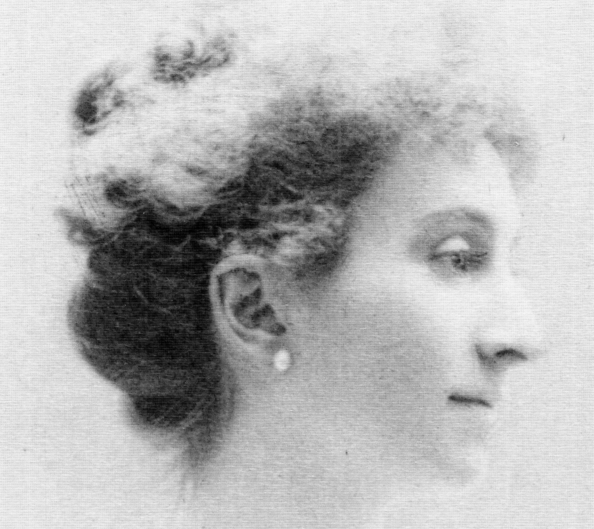

Ayant le désir que ces quelques pages rappellent à chacun de mes enfants les principaux faits que j'ai pu recueillir sur notre famille, ainsi que l'historique de ma Carrière scientifique et industrielle, j'offre cet exemplaire à ma chère fille Valentine avec l'assurance de toute mon affection.

G. Eiffel

Sèvres, le 25 Septembre 1923

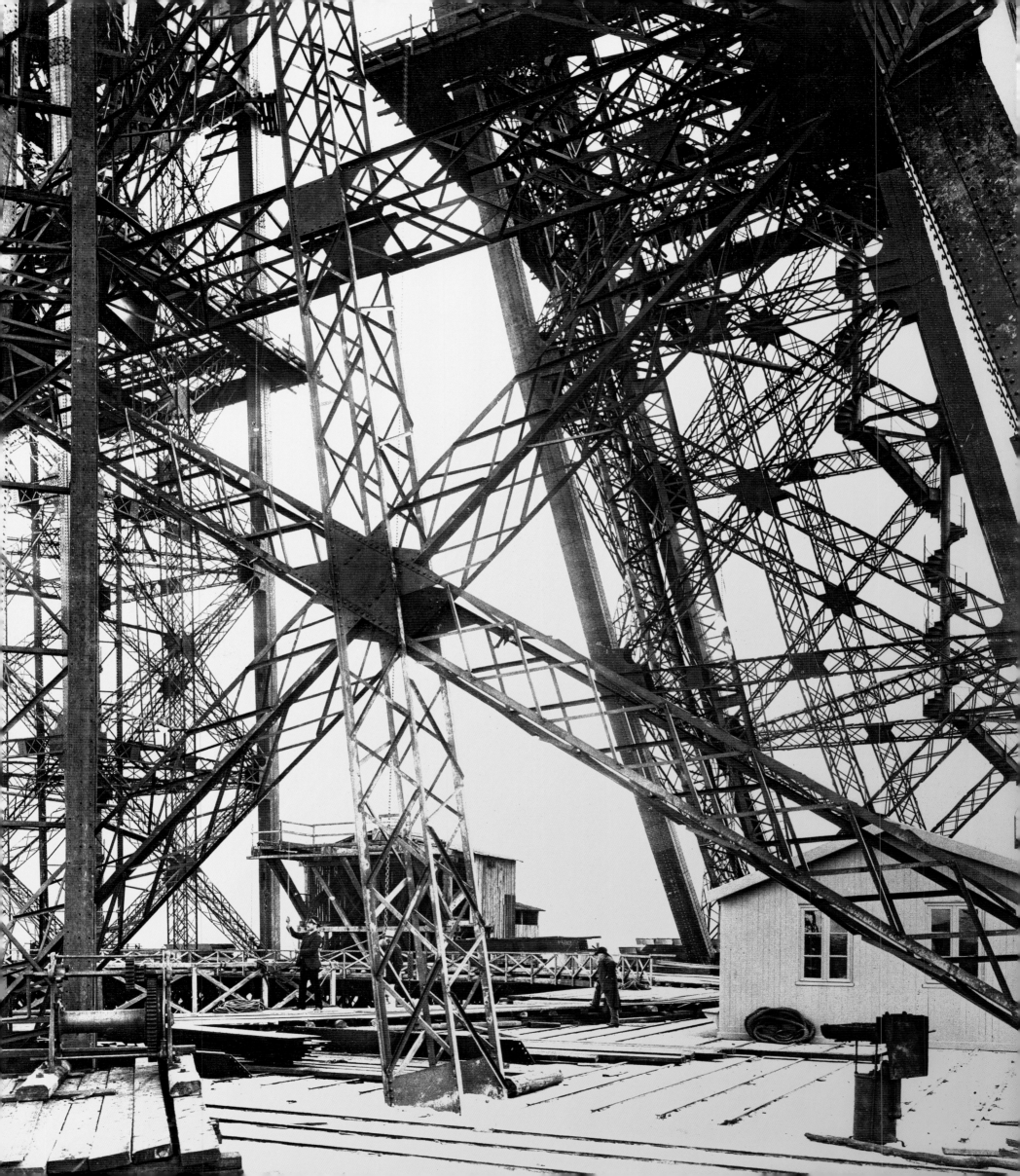

CHAPTER 1

GENESIS OF A GENIUS

*From his childhood and painful schooldays in Dijon
to his early career in and around Bordeaux
and his discovery of Paris, whose symbol he will one day create...*

cent vingt

n° 723

Bonickhausen dit Eiffel
alexandre
gustave

Suivant jugement rendu par le Tribunal de première instance de Dijon le quinze Décembre mil huit cent quatre vingt, il a été ordonné que l'acte de naissance ci contre serait rectifié en ce que le nom de Eiffel seul sera substitué à celui de Bonickhausen dit Eiffel.

La présente mention faite par le C⁵ Greffier du Tribunal soussigné

E. Bonnier

les dites déclaration et présentation faites en présence de Sieur Debosredon âgé de trente sept ans employé chef secrétaire rue [...] de l'hôpital, et de Philippe Jacotot âgé de quarante un ans chantre tous deux domiciliés à Dijon et soussignés avec le père et nous après lecture faite du présent acte de naissance.

Belot

J. Debron Jacotot

L'an mil huit cent trente deux le seize décembre à une heure du soir, par devant nous Bernard-Charles Belot adjoint au maire de la ville de Dijon, Côte d'Or, faisant par délégation spéciale les fonctions d'officier public d'état civil, est comparu François-Alexandre Bonickhausen dit Eiffel âgé de trente sept ans négociant demeurant à Dijon, faubourg d'Ouche sur le port du canal, lequel nous a présenté un enfant que nous avons reconnu être du sexe masculin, né en son domicile le quinze décembre présent mois, à huit du soir, du mariage contracté en cette ville le vingt trois novembre mil huit cent vingt quatre entre lui déclarant et Catherine Moneuse son épouse âgée d'trente trois ans, auquel se fait il déclare donner les prénoms d'Alexandre-Gustave. Les dites déclaration et présentation faites en présence de Benoît-Nicolas-Casimir-Alphonse Lefebvre âgé de quarante huit ans propriétaire et maire de Lajarre notairable et de Claude Bossu âgé de soixante cinq ans chef de Bataillon en retraite, chevalier de Saint Louis, officier de la Légion d'honneur et Colonel de la garde nationale, tous deux domiciliés à Dijon et soussignés avec nous après lecture faite du présent acte de

Eiffel Bossu Belot

Opposite:

Gustave Eiffel's birth certificate, dated 15th December 1832. In the left-hand margin has been added the statement: "In pursuance of the judgment [...] of 15th December 1880 it has been prescribed that the name Eiffel shall be substituted for that of Bönickhausen known as Eiffel." It was Gustave's grandfather who, in 1710, had added the pseudonym Eiffel to his family name, as it was easier to pronounce and reminded him of his native region, Eifel in North Rhine-Westphalia.

Below:

The only known photograph of Gustave as a boy, aged 7.

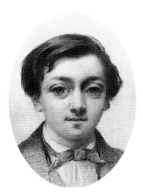

Genesis of a genius

The young Gustave

Gustave Eiffel was born on 15th December 1832 in Dijon. His parents, François Alexandre and Catherine Mélanie, were so busy with the coal distribution business she had started that they first engaged a nanny to look after him and then entrusted his care to a baker's wife. Gustave therefore spent most of his childhood either with his grandmother, who was virtually blind, or with one of his aunts. His own family was completed by the arrival of two sisters—much to his delight, as he got on famously with Marie, who was two years younger than he was.

His early school years left him with hateful memories: a hail of punishment and lessons that bored him to death. It was not until his fifth year of schooling that he discovered the joy of learning and the pleasure of reading great literature. He proved to be equally gifted in the sciences and the arts and obtained successive baccalauréats in both subject groups. The young Gustave also enjoyed landscape painting, particularly in watercolour, and sport, becoming a keen fencer. Although he had a middle-class upbringing and therefore knew neither deprivation nor hunger, he was not spoilt. As he would later remind his own children: "We weren't exactly pampered in those days." That did not mean there was any lack of love and respect, as the boy Gustave's letters to his parents testify. With precocious maturity, he signed these "Gustave Eiffel" from the age of seven. In fact, he was a well-behaved child with an inquiring mind. A major role in his intellectual development was played by his uncle, Jean-Baptiste Mollerat, and the latter's friend Michel Perret, both chemists, who involved him in regular philosophical discussions. It was they who introduced him to Saint-Simonianism—the sociopolitical theories of Claude Henri de Rouvroy, Count Saint-Simon—and the positivist philosophy of Auguste Comte, both of which were to have a lasting influence on Eiffel. The Eiffel family believed in work, progress and the Republic—values to which Gustave would adhere throughout his life. Even as a child, he had admired the effort his parents had put into developing their business, and it is probably to his mother that he owed the business acumen that would enable him to make his fortune.

In 1850, at the age of 18, Gustave went to Paris for the first time and fell in love with the city. He would never tire of exploring its streets and became a regular visitor to its theatres. On more than one occasion, he wrote to his mother asking her to send him money to enable him to indulge in the delights of Parisian life. London had a no-less-dazzling effect on him, especially the Great Exhibition of 1851, the first of its kind, which he went to see. Nor was the young Gustave unaffected by the charms of English women... Armed with his two baccalauréats, he enrolled at the Collège Sainte-Barbe and took the entrance exam for the École Polytechnique, which he failed. But his results were good enough for a place at the recently opened École Centrale. Initially, he chose to study chemistry, as it was intended that he would take over his uncle Jean-Baptiste's business, but a family dispute put an end to that plan and Gustave changed direction, opting for metallurgy and construction.

The year 1855 saw the first great exhibition in Paris, the Exposition Universelle, at which the public were able to marvel at the latest technological achievements. Gustave persuaded his mother to buy him a season ticket so that he could see and study every display. It was also the year of his graduation from the École Centrale.

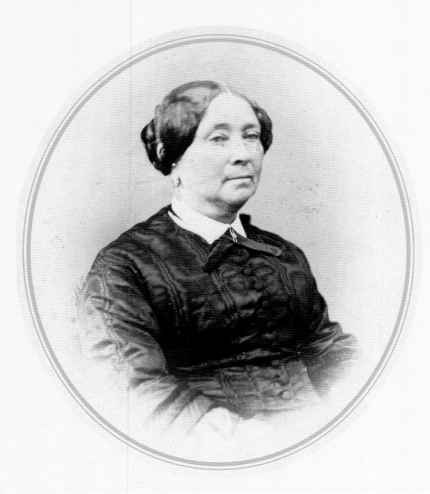

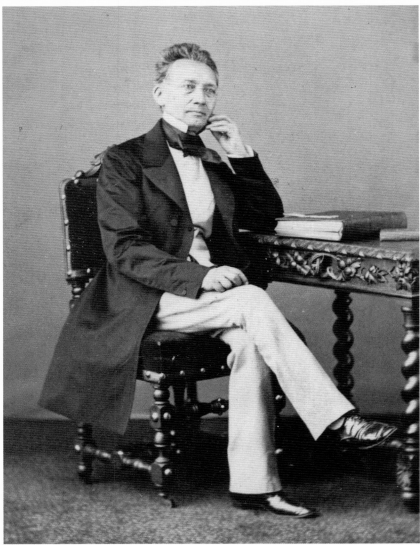

"My father, Alexandre Eiffel, had, in his capacity as adjutant at the garrison in Dijon, made the acquaintance of the Moneuse family, which supplied the garrison's heating. In 1824, he married Catherine Mélanie Moneuse, 25 years of age, daughter of Mr Jean-Baptiste Moneuse, wood tradesman, and his wife Jeanne Peuriot, who lived in the Rue Turgot. Prior to their engagement, however, my mother, who wished my father to have greater independence, asked him to resign from military service and obtain a civil position. He duly obtained the post of secretary to Mr Rabou, a steward at the Dijon garrison, which he held until 1832, the year of my birth and of Mr Rabou's retirement.

Until that year, my parents had been able to live modestly by remaining under their parents' roof, but my arrival persuaded my mother, in particular, that she would need to revise her domestic arrangements. In order to increase their combined resources, my father secured a post at the police headquarters of the Côte-d'Or region. For her part, my mother sought a position in commerce that would broaden her prospects both in terms of income and from the point of view of her remarkable business acumen.

[...] The coal business, alongside the steel industry, was beginning to expand and, in particular, the Épinac mines seemed destined to acquire considerable importance, not only in terms of their local clientele, but also in view of the growing industrial demand throughout the region. The department of Haute-Marne in particular, with its new blast furnaces, was obtaining its supplies of Épinac coal from the port of Dijon, on the Canal de Bourgogne, where great barges were loaded daily. My mother turned her attention determinedly to this opportunity and was appointed sole distributor for the mines in Dijon and the surrounding areas, including Haute-Marne. The coal was delivered regularly by road and stockpiled within the port itself. The depot was a hive of activity, such that my father was soon obliged to quit his post at the police headquarters and work alongside my mother, where his efforts were more amply rewarded."

Left:

Gustave Eiffel's parents, Catherine Mélanie, née Moneuse (1799–1878), and François Alexandre Bönickhausen known as Eiffel (1795–1879), photographed by Antoine Guipet and Alexandre Ken, respectively, in about 1870.

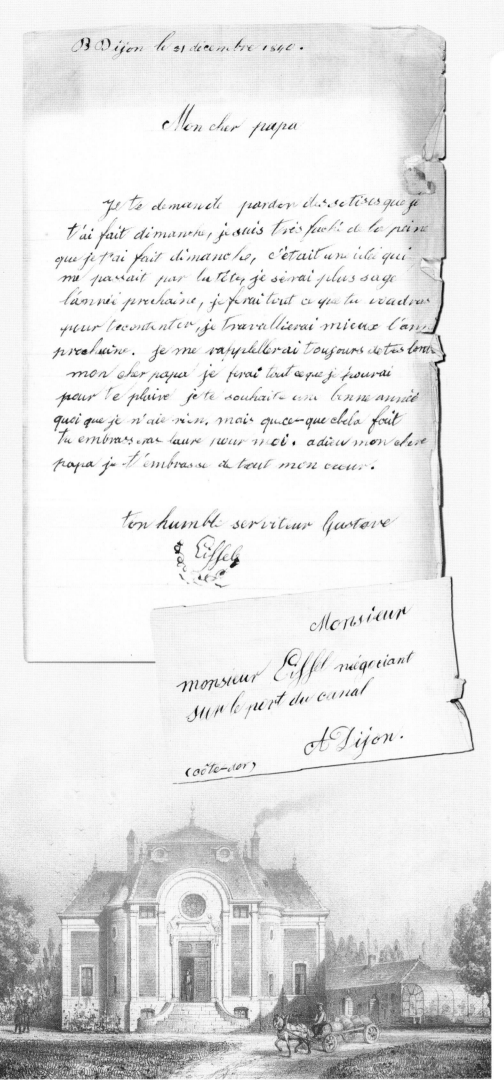

"Their professional dedication, which meant that they left their home, itself right by the canal, at dawn and did not cease work until nightfall in order to supervise the unloading of the boats and the loading of the carts in all weathers, made a great impression on my youthful imagination.

They had had several boats built for their own use, the first of which was called 'Le Beau Gustave' and the second 'La Petite Marie', which was my sister's name.

Thanks to their assiduity and organizational aptitude, their business prospered to such an extent that within 11 years, by 1843, they had amassed, by a combination of hard work and careful spending, a capital of some 300,000 francs, which at that time represented a substantial retirement fund of 15,000 francs per year, which would allow them to take their ease and enjoy the fruits of their labour.

My mother, in the event, was so pleased with this situation, which she had scarcely dared to hope for, that when a few small losses were incurred and one or two debtors went bankrupt, she took fright and decided, with my father, that it would be prudent, before fortune should turn against them, to cease trading and to sell the business, for which they had already received a number of attractive offers.

Finding themselves with no outlet for their energies, they turned to one of their principal customers, Mr Édouard Régneau, owner of the Castel brewery, and offered to invest in his business by offering him a loan for its development. At the same time, they asked him if they might rent part of the property known as 'Le Castel', which was at the time unoccupied. Mr Régneau had three adult children: Paul; Fanny, wife of Mr Gaudelet, whose daughter I later married; and Célestine, wife of Mr Robin and mother of Albert Robin.

This proposal was accepted and my father assumed responsibility for the firm's sales and accounting, while Mr Régneau was able to concentrate on his principal activity: brewing. Mr Régneau moved into the buildings that housed the brewery, which were part of the vast estate appertaining to the beautiful 13th-century château Le Castel."

Left:
One of the earliest surviving letters Gustave sent to his father, dated 31st December 1840, in which he wishes him a happy new year... and apologizes for various misdemeanours (see page 168).

An engraving of the rear of the Castel de Dijon, where Gustave spent much of his adolescence.

> "I was shocked by Mr Gustave's reaction!
> His mean, selfish, arrogant manner has lately grown out of all proportion."
>
> Mr Dubois, principal of the Pension Dubois

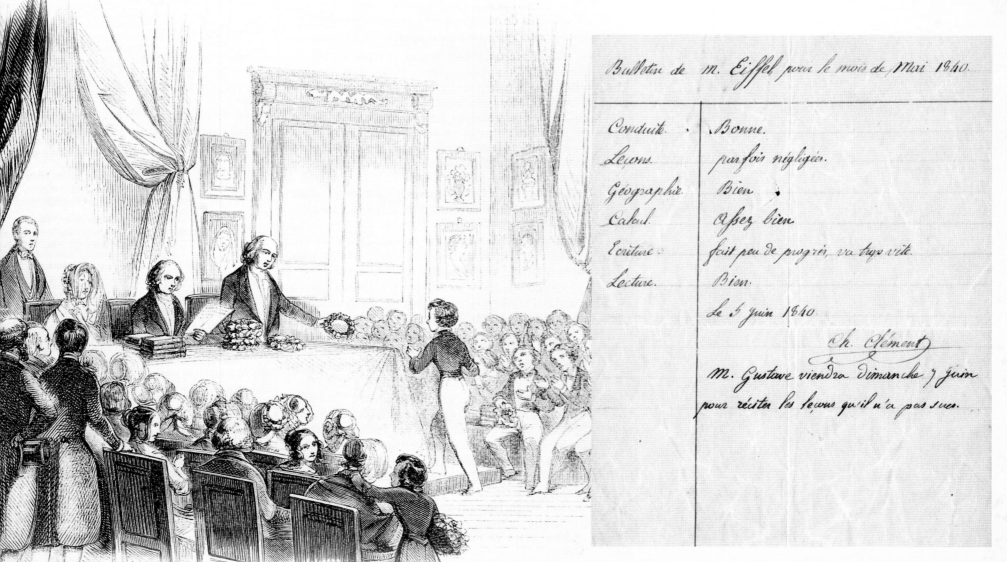

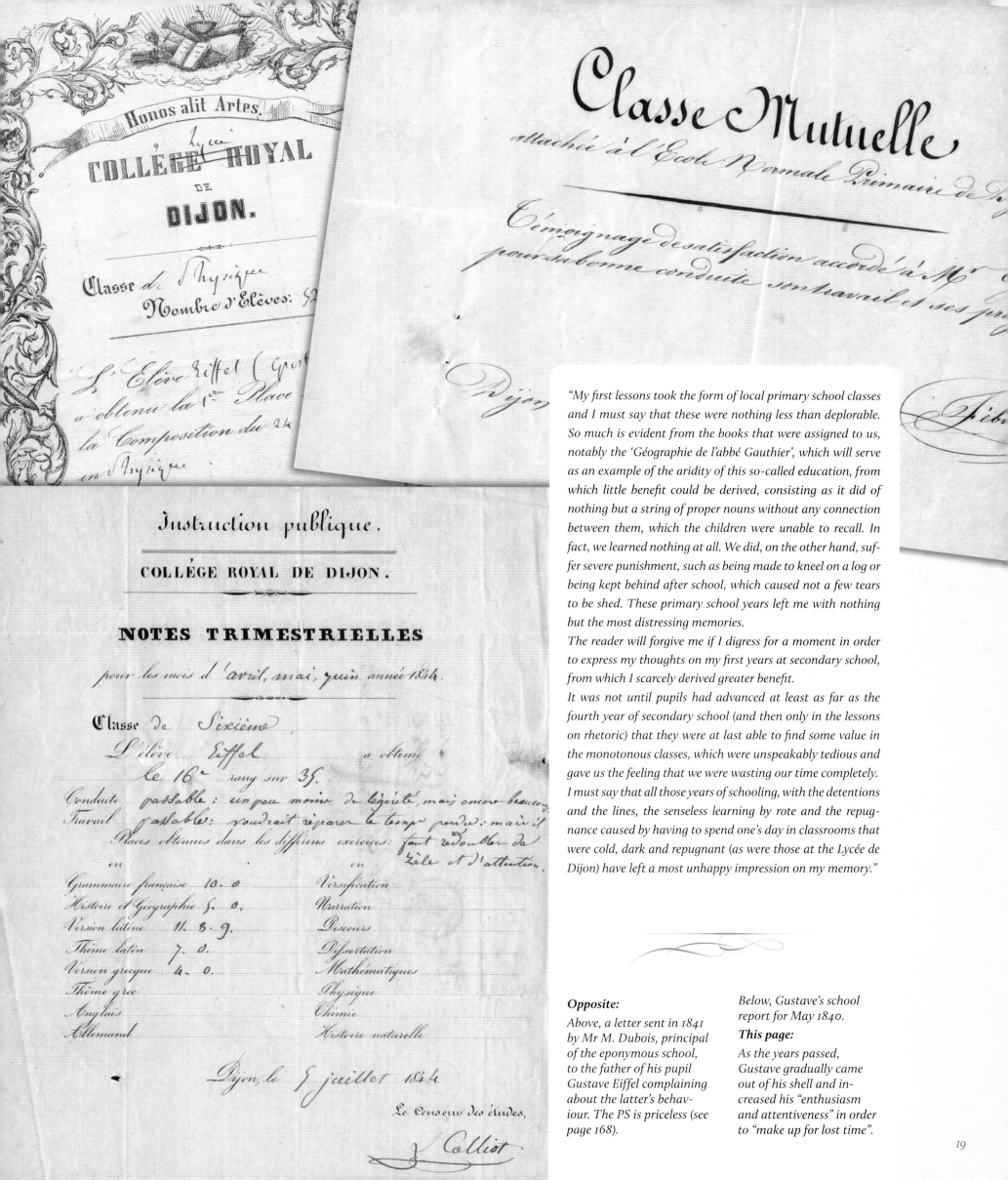

"My first lessons took the form of local primary school classes and I must say that these were nothing less than deplorable. So much is evident from the books that were assigned to us, notably the 'Géographie de l'abbé Gauthier', which will serve as an example of the aridity of this so-called education, from which little benefit could be derived, consisting as it did of nothing but a string of proper nouns without any connection between them, which the children were unable to recall. In fact, we learned nothing at all. We did, on the other hand, suffer severe punishment, such as being made to kneel on a log or being kept behind after school, which caused not a few tears to be shed. These primary school years left me with nothing but the most distressing memories.

The reader will forgive me if I digress for a moment in order to express my thoughts on my first years at secondary school, from which I scarcely derived greater benefit.

It was not until pupils had advanced at least as far as the fourth year of secondary school (and then only in the lessons on rhetoric) that they were at last able to find some value in the monotonous classes, which were unspeakably tedious and gave us the feeling that we were wasting our time completely. I must say that all those years of schooling, with the detentions and the lines, the senseless learning by rote and the repugnance caused by having to spend one's day in classrooms that were cold, dark and repugnant (as were those at the Lycée de Dijon) have left a most unhappy impression on my memory."

Opposite:
Above, a letter sent in 1841 by Mr M. Dubois, principal of the eponymous school, to the father of his pupil Gustave Eiffel complaining about the latter's behaviour. The PS is priceless (see page 168).

Below, Gustave's school report for May 1840.

This page:
As the years passed, Gustave gradually came out of his shell and increased his "enthusiasm and attentiveness" in order to "make up for lost time".

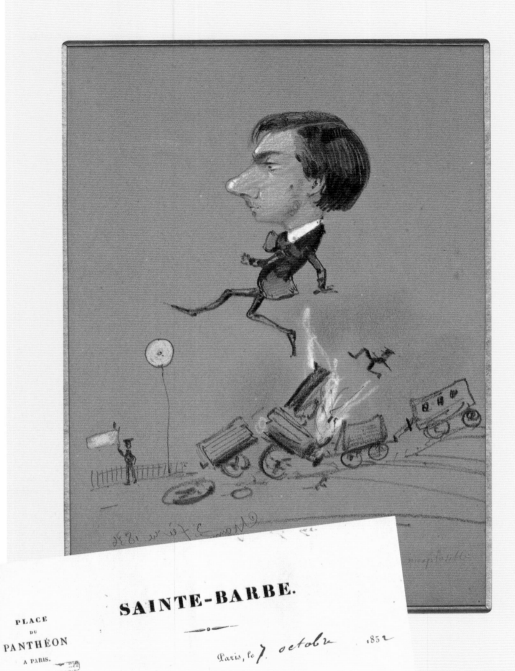
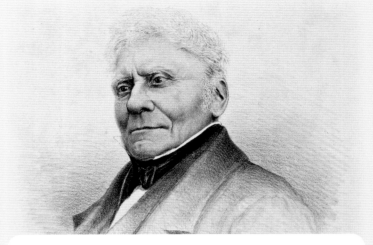

"My uncle Jean-Baptiste Mollerat, who was born in 1770 and died at the age of 85 in 1855, was married to my mother's sister, Catherine Moneuse. He was an eminent chemist, who numbered among his colleagues and friends many of the leading scientists of his time.

I have a most lifelike lithograph of him, made after his death by his friend François Hippolyte Walferdin, who was a noted physician but is known principally today as a collector of the paintings of Jean-Honoré Fragonard. The lithograph carries the inscription 'VIR', Latin for 'man', with the entirely appropriate connotation of 'virile'; the portrait does indeed present a most realistic image of his powerful, leonine features. I clearly remember his tall figure, generally dressed in a black 'master's' frock coat. His face was always meticulously shaven and he wore large, silver-rimmed spectacles, through which shone dark, darting eyes. His head was crowned with a shock of white hair, forever slightly unkempt. He spoke in a loud, commanding voice. He was respected and somewhat feared, and never permitted any familiarity.

My uncle played an important part in my childhood and youth. I admired him immensely and greatly feared the severe reprimands he would mete out whenever I committed some minor childhood misdemeanour such as not sitting properly at table. On one occasion, having been invited by my aunt to dine with them, I spilt my food on the tablecloth and was instantly sent from the room to finish my meal with the servants in the kitchen."

Above:

Jean-Baptiste Mollerat (1772–1855), Gustave's uncle, was a chemist and a considerable influence on his nephew… who nevertheless failed the entrance exam for the École Polytechnique, as the letter from the Lycée Sainte-Barbe (left) informed his mother (see translation on page 168). Lithograph by François Hippolyte Walferdin.

Above left:

A caricature of Gustave, probably by a friend of his at the École Centrale by the name of Chamoit. The caption reads: "The famous engineer E. tests his design for an indestructible locomotive."

Opposite:

Gustave's report from the École Centrale, 1852–1853.

École Centrale des Arts et Manufactures

Année scolaire 1852–1853

1re année d'études.

Bulletin des numéros de mérite obtenus par M. **Eiffel, Alexandre** dans les diverses branches de l'enseignement depuis le commencement de l'année scolaire.

Cours.	Examens particuliers.						Observations.	Moyennes	Examens généraux
Géométrie descriptive	16	"	"	"	"	"			
Analyse géométrique	16	16	"	"	"	"			
Mécanique générale	"	"	"	"	"	"			
Physique générale	15	17	"	"	"	"			
Chimie générale	16	"	"	"	"	"			
Histoire naturelle	"	"	"	"	"	"			
Transmission de mouvement	"	"	"	"	"	"			
Manipulations de { Chimie	"	"	"	"	"	"			
Physique	"	"	"	"	"	"			
levé de bâtiment	"	"	"	"	"	"			
levé de machines	"	"	"	"	"	"			

1°

	1.	2.	3.	4.	5.	6.	7.	8.	9.	10.	11.	12.	13.	14.	15.	16.	17.	18.	19.	20.
Dessin architectural	9	11	9	8	11	10	"	"	"	"	"	"	"	"	"	"	"	"	"	"
et croquis	9	10	"	"	"	"	"	"	"	"	"	"	"	"	"	"	"	"	"	"
Épures de { Géométrie descripve	12	11	12	14	13	12	14	15	13	"	"	"	"	"	"	"	"	"	"	"
et croquis	11	13	12	"	"	"	"	"	"	"	"	"	"	"	"	"	"	"	"	"
Physique																				
Mécanique																				

2° Absences depuis le commencement de l'année 2

3° Autorisations de sortie — idem — 1

Conduite et travail.

4° A été 1 fois au conseil d'ordre

5° Conduite laisse à désirer

Travail soutenu

N.a. Le mérite de tout travail est apprécié par un chiffre qui varie entre 0 et 20; les chiffres 0, 5, 10, 15, 20, répondent aux mots nul, mal, assez-bien, bien, très-bien, les autres chiffres expriment des degrés intermédiaires.

Paris le 11 Février 1853

Le Directeur des Études.

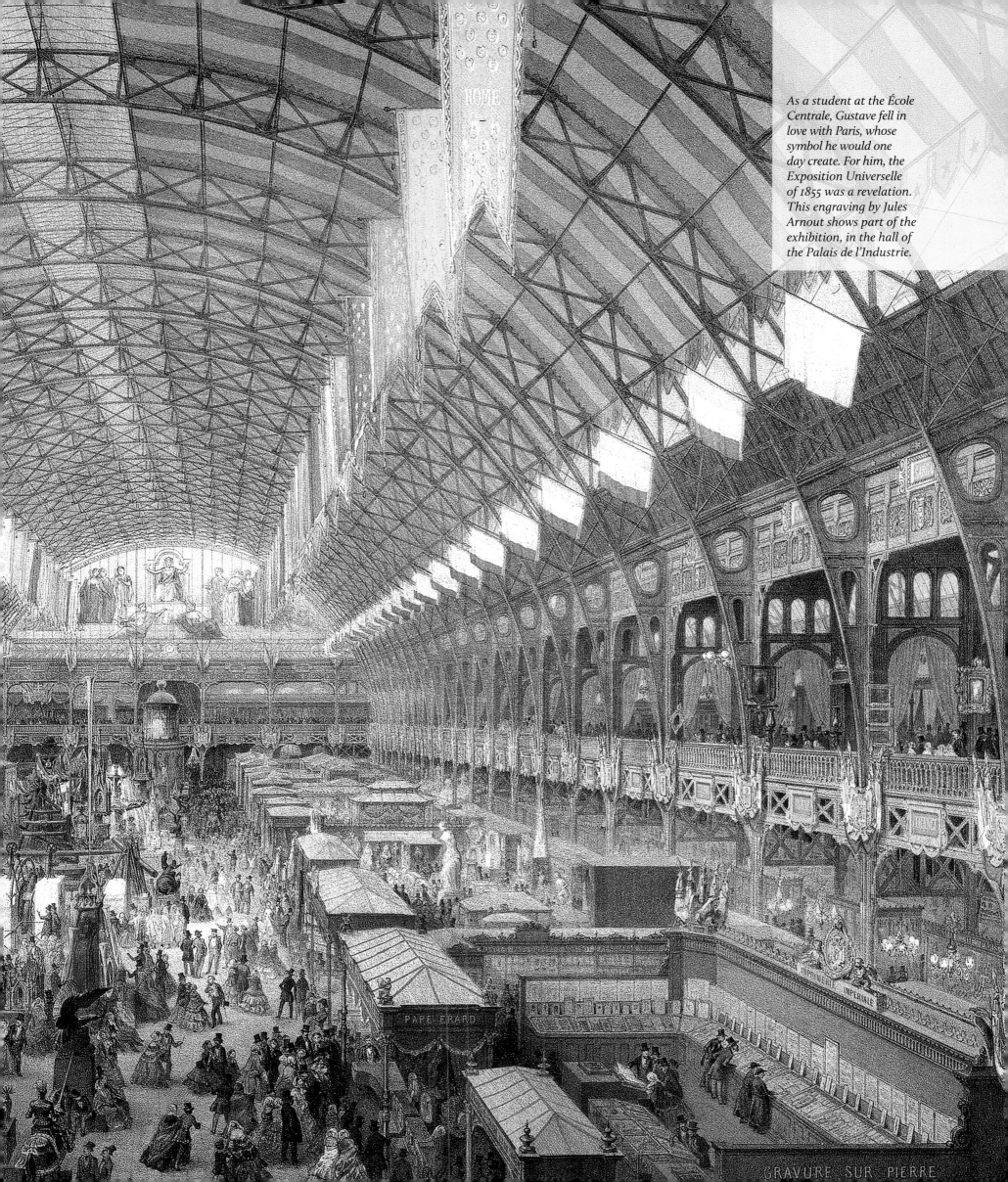

As a student at the École Centrale, Gustave fell in love with Paris, whose symbol he would one day create. For him, the Exposition Universelle of 1855 was a revelation. This engraving by Jules Arnout shows part of the exhibition, in the hall of the Palais de l'Industrie.

Genesis of a genius

Nepveu, the mentor

Below:
A sketch of a machine used by Eiffel in the construction of the Bordeaux rail bridge (right): "The idea was to transfer the force generated by counterweights, mounted on top of the metal tubes that were to be sunk into the river bed, using hydraulic pumps, so that it could either counteract the pressure created by the air inside the tubes or overcome the friction caused by the ground into which they were to be driven."

Through his mother's intervention, Gustave was granted an interview with the engineer and businessman Charles Nepveu, who specialized in public works, and he was engaged on the spot. As Eiffel himself later acknowledged in his autobiography, written shortly before his death, this, his first job, had a decisive influence on his future career. Nepveu was a friend of the bankers Isaac and Émile Pereire, who financed much of the development undertaken during the Second Empire; it was a friendship that brought him numerous orders. Nepveu took the young Eiffel under his wing and Gustave was overjoyed at having such a satisfying start to his career. Unfortunately, however, Nepveu was not a good manager and soon found himself facing bankruptcy. He could no longer afford to pay Eiffel, who nevertheless chose to continue working for him, out of loyalty to the man who had given him a chance to make his way. Nepveu responded by finding him a job in the design office of the Western Railway Company (referred to as the Southern Railway Company by Eiffel in his autobiography), on the understanding that Gustave would work for him on a voluntary basis in his spare time. Eiffel, already ambitious to become a successful engineer, took the opportunity to learn all about bridge-building, which would later stand him in good stead, but he soon realized that his semi-administrative role would not allow him to progress very rapidly. As soon as Nepveu's own business seemed to be recovering, Eiffel therefore abandoned the Western Railway Company and resumed his former position. But before long, Nepveu was forced to sell his business to the Pauwels company, becoming one of its employees. Pauwels also took on Eiffel, giving him a responsible position. He was in fact put in charge of the construction of a railway bridge in Bordeaux, a major project on which the young engineer broke his teeth and which turned out to be one of his masterpieces. Indeed, it was this bridge that made his name and established his reputation for efficiency and reliability; he was just 25 years old. Eiffel also proved his bravery by diving fully clothed into the river Garonne to save from drowning a workman who had fallen in.

It was here in Bordeaux that Eiffel first confronted the element that would fascinate him throughout his life: the wind. Invisible and immaterial, it nevertheless had the unpredictable capacity to destroy apparently solid structures. Progress on the bridge was hampered by delays in the production of its components. Eiffel's solution, which was to become one of the keys to his success, was standardization. Instead of having each piece made to measure, he designed a small number of parts that could be mass produced. This innovation was typical of the way Eiffel solved the problems posed by every construction project: by concentrating on the smallest details without losing sight of the overall objective, with a combination of common sense and pragmatism.

Nepveu's financial difficulties, which had been caused by inadequate accounting, also gave Eiffel food for thought. It was not enough, he realized, to generate orders; a business had to have a secure financial foundation. Eiffel also understood that he must look beyond the borders of France, that the market for French engineering extended to the whole world—which is why he learned Spanish, Italian and English. What is more, while working on the Bordeaux bridge, he established both commercial and personal relationships with his clients: relationships that would soon prove extremely fruitful.

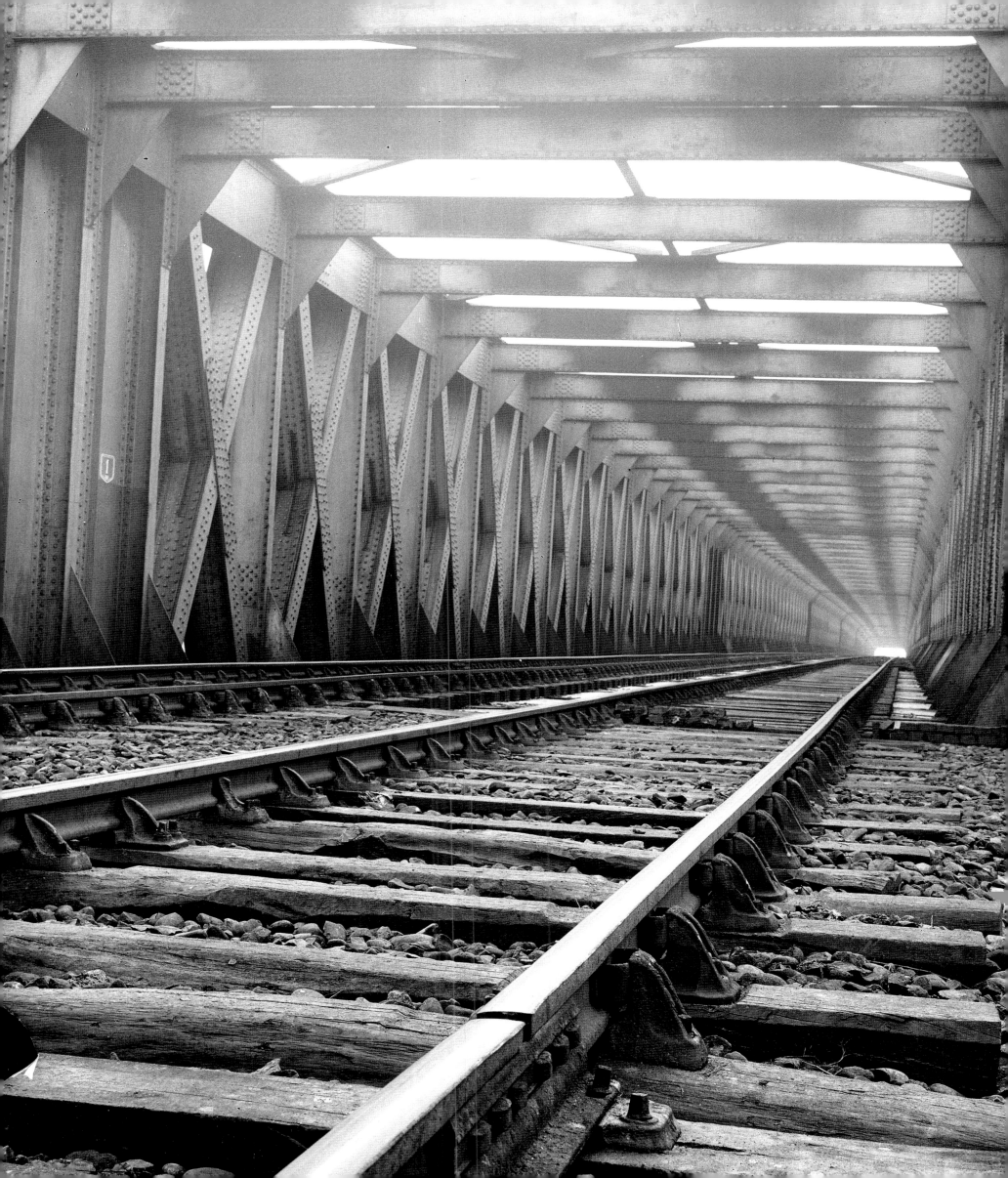

Above:
Eiffel began his career, alongside Paul Régnault, in the Atlantic resort of Arcachon, where he contributed to the design of the Sainte-Cécile Observatory—a "little tower" that foreshadowed a rather larger one...

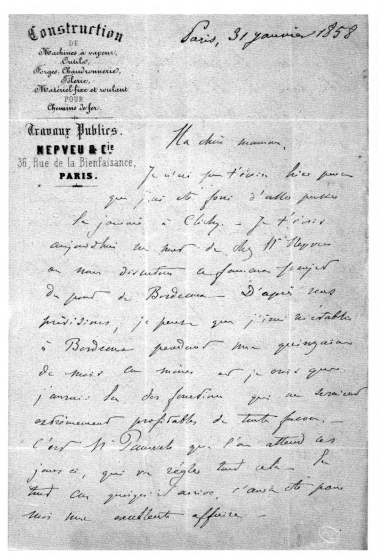

Left:
A letter on the headed paper of Nepveu & Compagnie that Eiffel sent to his mother on 31st January 1858. In it, he tells her about the discussions that had taken place regarding Nepveu's intention to entrust him with the Bordeaux bridge project, which would be "extremely beneficial".

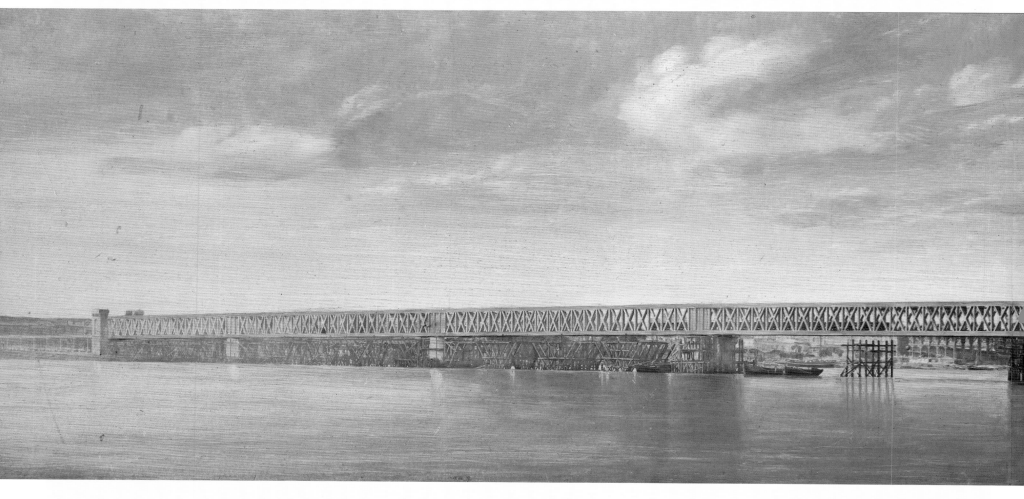

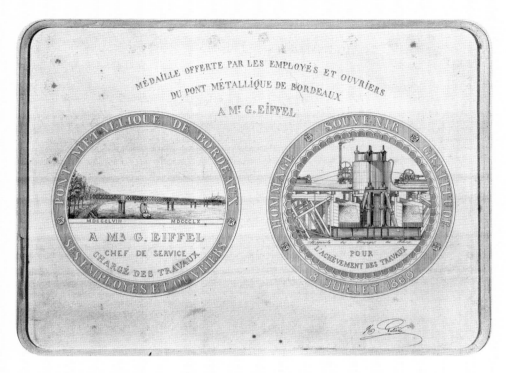

Above:
The certificate relating to the "medal given by the staff and workers of the iron bridge of Bordeaux to Mr G. Eiffel" on 8ᵗʰ July 1860.

"Thanks to the financial assistance of a large Belgian company, Mr Nepveu, who had been appointed managing director of the Parisian branch of the business, was able to obtain a contract with the Southern Railway Company for the construction of a bridge over the Garonne in Bordeaux that would link the network operated by the Orleans Railway Company to that of the Southern Railway Company.

The vast construction consisted of an iron deck 500 m in length, resting on six piles driven by compressed air to a depth of 25 m beneath the water.

It was not only an early example of the use of this method of laying major foundations, but also one of the largest iron constructions of the period.

In 1858, Mr Nepveu entrusted Eiffel with the execution of the project, which had a total budget of 3 million francs, although the latter was only 26 years old.

[...] Eiffel undertook the task with honour and completed the work within the appointed period of two years, thereby attracting the favourable attention of the engineering world."

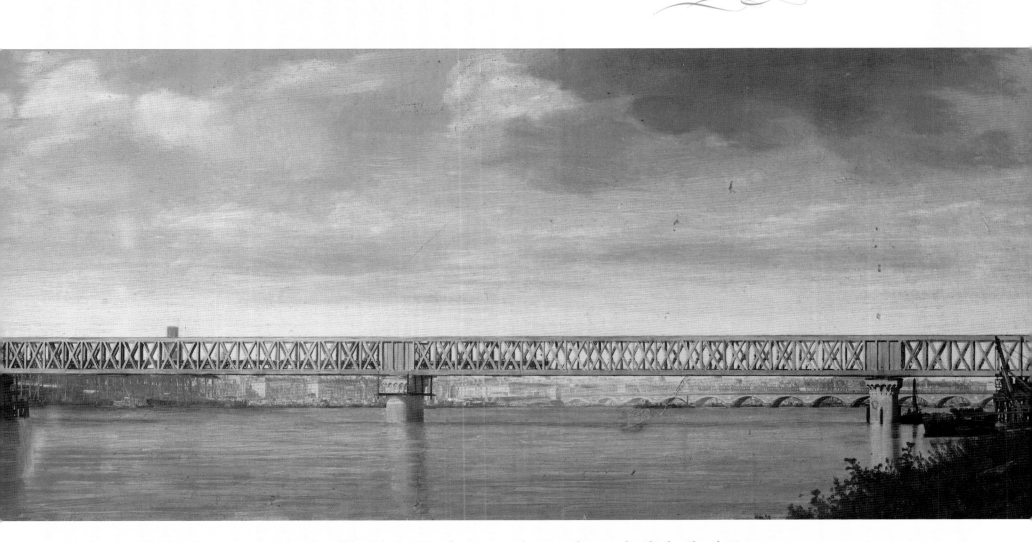

Above: *The bridge, known as the Passerelle Eiffel, in about 1860 (oil print using the Bromoil Process by Charles Chambon).*

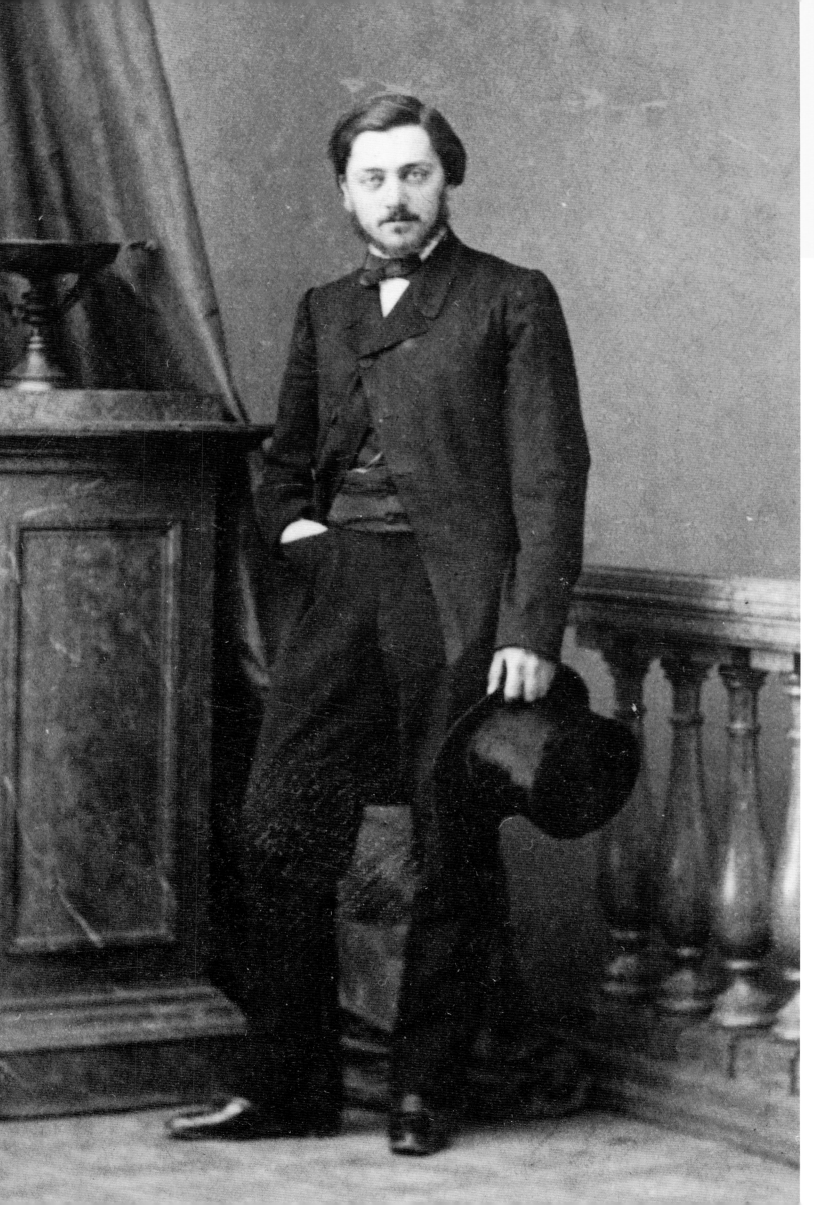

Left and right:
Gustave Eiffel alone and with his sister Marie (1834–1901) in Bordeaux in 1858.

Far right:
Laure Eiffel (1836–1864), Gustave's younger sister, who died at the age of 28.

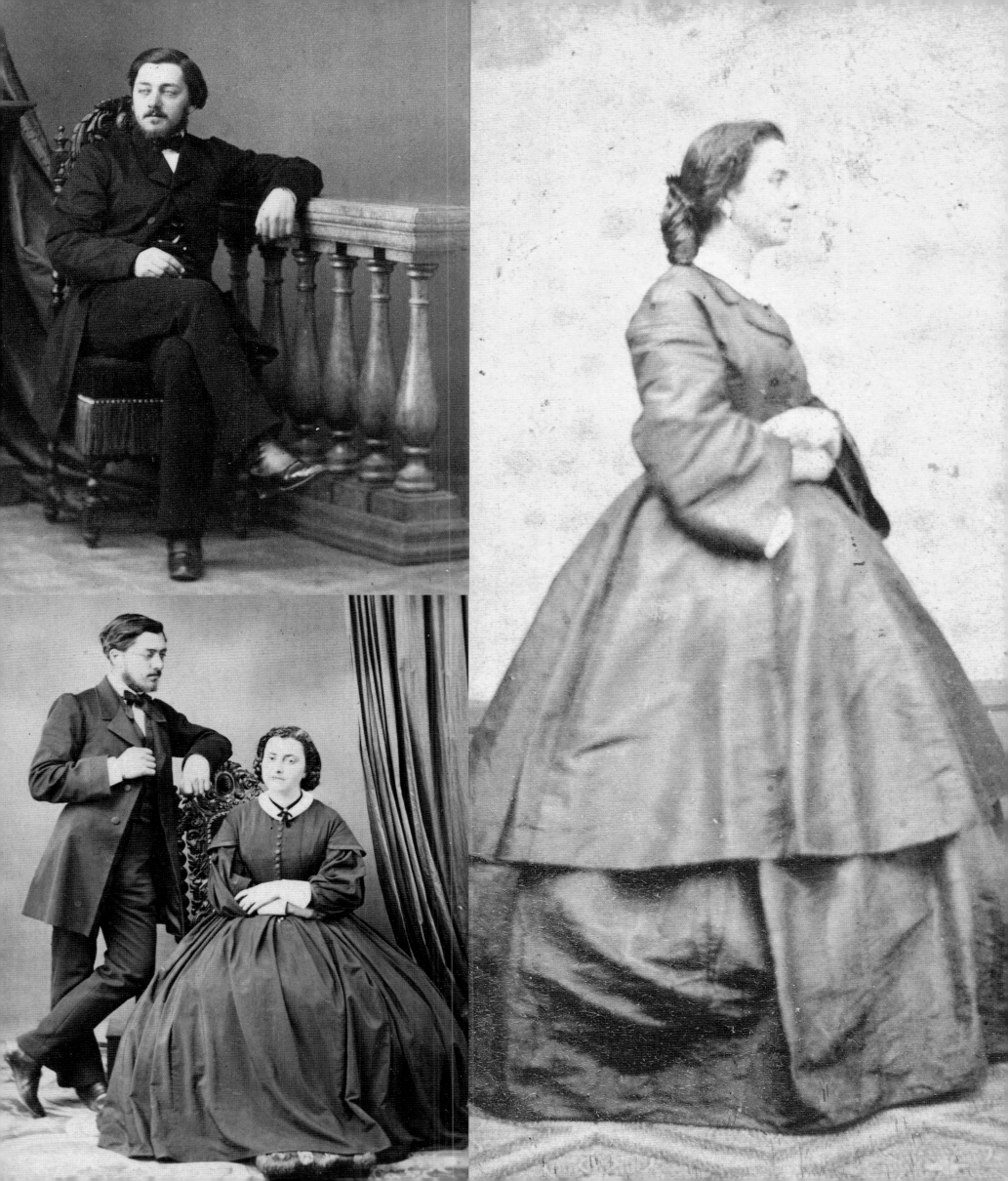

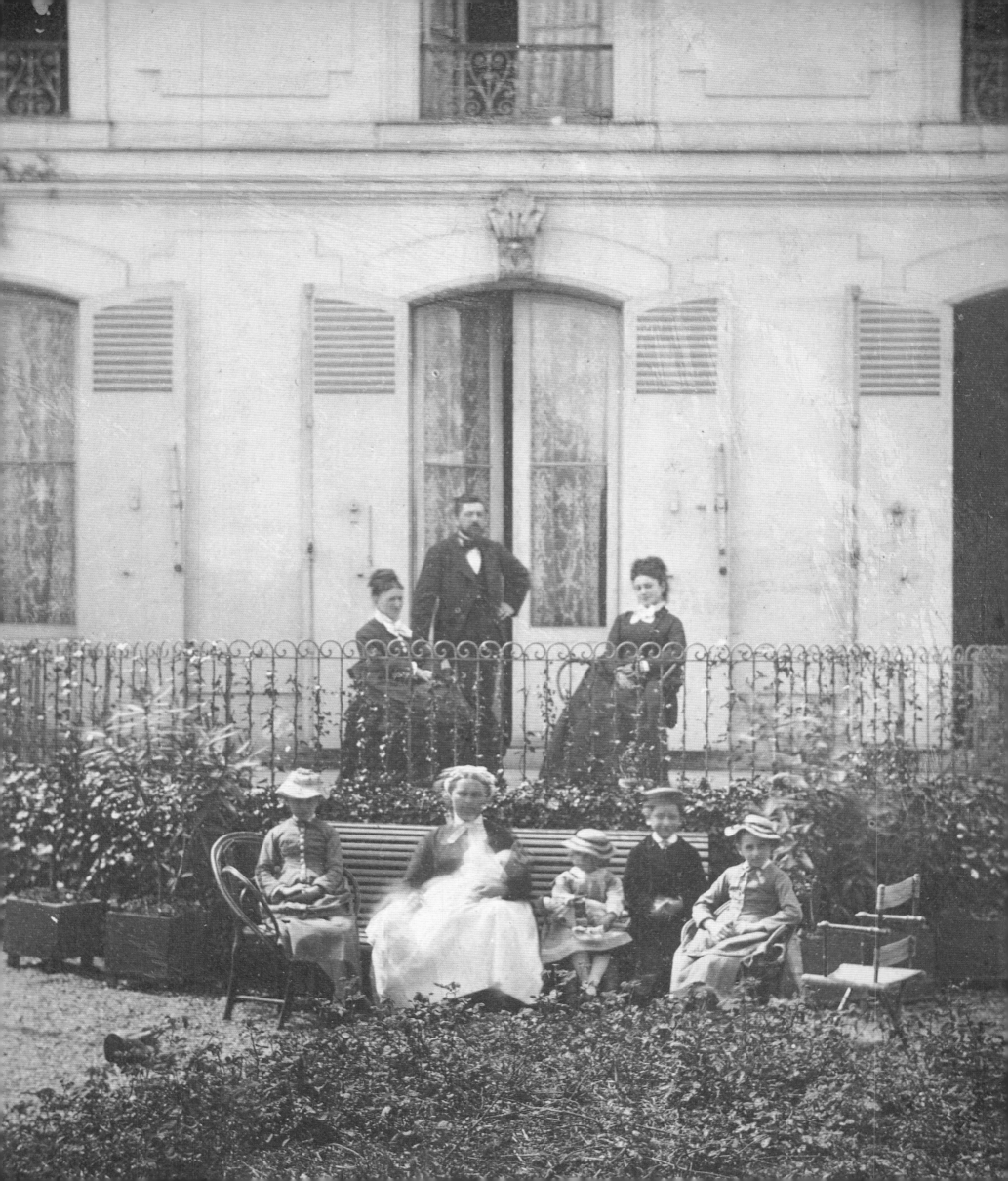

Genesis of a genius

Husband and father

Opposite:
The Eiffels' house in Levallois-Perret, in 1874. Gustave stands behind his wife Marguerite. Seated below are their five children; the youngest, Albert, is in the arms of his nanny.

Below:
Medal commemorating the marriage of Gustave Eiffel and Marie Gaudelet on 8th July 1862.

Gustave's favourite sister, Marie, went with him to Bordeaux to look after him while he worked on the bridge. It was Gustave's first real "home" since he had left Dijon, as he had previously lived either alone or with a sculptor friend. There he decided that it was time he settled down: he must find a wife and start a family. He and Marie therefore started looking for a girl in Bordeaux—a girl from the right sort of family, of course. They first considered a young lady called Louise, but although she had good qualities and a 60,000-franc dowry, the spark wasn't there. Gustave found her rather plain and was afraid that her volatile temperament would conflict with his more tranquil nature. They approached a second candidate, by the name of Adrienne. Gustave proposed to her but, just weeks before the wedding, she called it off. Undaunted, Gustave turned his attention to another young woman, but again the wedding was cancelled. Having found all doors in Bordeaux closed, Gustave decided to redirect his search towards his native region—and to considerably lower his sights. He was already on his sixth refusal and was approaching 30; he did not want to remain a bachelor. In a letter to his father, Gustave declared his matrimonial ambitions, setting out his intentions in terms devoid of all romanticism: "I would be content with a girl who has a modest dowry and a passable figure but on the other hand who is extremely kind and even-tempered and has quite simple tastes. To be perfectly honest, I would like someone who is a good housekeeper, who seldom makes me lose my temper, who is rarely unfaithful and who will give me fine, healthy children that I am confident are mine. If I could find a woman who meets all these conditions, I would gladly disregard everything else, including her fortune, her figure and her intelligence."

Gustave's parents duly initiated a search for a young woman matching their son's latest set of criteria. They did not have to look far. Marie Gaudelet was the granddaughter of one of their acquaintances, Mr Régneau, a brewer by trade. Gustave approved of their choice, on two conditions: that Mr Régneau would do his best to increase her dowry, which he currently found somewhat meagre, and that his parents would sound out the family so that he did not suffer yet another refusal. He was particularly attracted by the girl's naivety, on the basis that she would therefore be easily contented. Agreement was reached between the two families and the wedding took place on 8th July 1862. It was a simple ceremony and there was no honeymoon; the young bride would be travelling quite enough with her husband as he moved from one construction project to another. For the time being, Gustave took Marie to Paris, where they were to live from then on, and he renamed her Marguerite to avoid confusion with his sister.

Gustave seemed well pleased with his new wife: "Marguerite is splendidly round and fat, and is as strong as several oxen." In late October, the couple moved into a house in Clichy-la-Garenne in northern Paris. Early the following year, Marguerite began to show, and on 19th August she gave birth to a daughter, Claire Françoise Alexandrine, who rapidly transformed Gustave into a doting father. But their happiness was soon overshadowed by the news that Gustave's younger sister, Laure, had been diagnosed with a malignant tumour. Laure's daughter, Jeanne, was sent to the country and Laure moved in with her brother and Marguerite, where she passed away on 11th August 1864.

Gaudelet Geneviève Emélie Marie.

Suivant jugement rendu par le tribunal de première instance de Dijon le quinze Décembre mil huit cent quatre vingt, il a été ordonné que l'acte de mariage ci contre serait rectifié en ce que le nom de Eiffel serait substitué à celui de Bonickhausen dit Eiffel.

La présente mention faite par le Commis Greffier du Tribunal soussigné.

S. Bernier

M. Alexandre Gustave Bonickhausen dit Eiffel, âgé de vingt neuf ans, ingénieur civil, natif de Dijon, et demeurant à [...]

Bordeaux, 22 Janvier 1862.

Mon cher papa,

Je n'ai pas encore répondu à tes dernières lettres relatives à mes négociations matrimoniales qui ont toutes avorté même une dernière dont je n'avais pas encore parlé. — Quoiqu'il en soit tu peux admettre qu'il y a à Dijon un mal de gens qui nous sont hostiles et qui se prêtent volontiers à se faire l'écho de toutes sortes de sottises. — Aussi ai-je résolu de la manière la plus formelle et complète à tout projet de mariage dans ces conditions. — Si je trouve femme, tu peux admettre de la manière la plus complète sans en excommunier les motifs, que ce ne sera qu'à Dijon même. Or à dire le vrai, je serais heureux de me marier à présent mais ce ne serait pas dans les conditions de fortune que j'avais cherchées d'abord; je serais satisfait d'une fille ayant une dot médiocre, une figure passable mais en revanche d'un grand tact, et d'une heureuse...

Bordeaux, 21 février 1862.

Ma chère maman,

J'ai reçu hier ta lettre et j'y réponds un peu à la hâte, car revenu depuis deux jours seulement, je repars pour Toulouse puis pour Dax; depuis quelques mois je mène vraiment une vie de chevalier errant.

Ce que tu me dis de P. Chaufette m'étonne un peu car j'ai eu depuis occasion de correspondre avec lui et il m'a répondu toujours très affectueusement. Enfin tu es là-dessus meilleur juge que moi, mais cependant à moins de circonstances spéciales telles que de nouveaux projets, je ne crois pas que ses dispositions soient beaucoup modifiées, car j'ai toujours été censé ignorer complètement ce dont il avait été question.

Relativement à Marie Gaudelet, elle ne me déplairait pas plus pour femme que bien d'autres et je suis convaincu qu'il sera facile d'en faire une très gentille petite femme très disposée à se montrer sensible et reconnaissante pour l'affection qu'on aura pour elle. Je prendrais également ma part du beau père et de la belle mère, mais la grosse difficulté réside dans le très peu de fortune de la dite demoiselle; je me souviens...

Levallois le 8 Septembre 77

Mes chers parents

Ma pauvre et chère Marguerite est morte cette nuit à 4 heures en quelques instants à la suite d'une hémorragie interne foudroyante. — Depuis quelques jours elle allait très bien et nous nous réjouissions du repos qu'elle ressentait. — Jeudi soir, c.a.d. environ 36 heures avant sa mort, il y a eu une consultation avec M. Potain, à laquelle assistait Albert Robin — M. Potain avait été très rassurant et parlait pour le mois de Novembre d'un voyage dans le Midi. Hier Vendredi elle a bien...

...été toute la journée, à dîné avec nous de bon appétit, et elle s'est couchée à 9h½ bien portante. —

La nuit vers 4 heures, elle m'a appelé, je suis allé vers elle et je l'ai trouvée vomissant le sang. Après quelques minutes elle a été prise d'une syncope et elle est morte sans reprendre un instant connaissance malgré tous mes efforts —

Je suis frappé de stupeur et je ne peux pas me faire à l'idée de cet horrible malheur — quel avenir pour mes pauvres enfants et pour moi — Je vous embrasse tendrement G. Eiffel

Background:
Gustave Eiffel and Marie Gaudelet's marriage certificate, superimposed on a photograph of Marie taken in 1863 by Bayard et Bertall.

Opposite:
Above, two letters sent by Gustave from Bordeaux to his parents, dated 22ⁿᵈ January and 21ˢᵗ February 1862. In the first, he confides to his father that he would be content "with a girl who has a modest dowry and a passable figure but on the other hand who is extremely kind…", while in the second, to his mother, he sings the praises of Marie Gaudelet, whom he is convinced he will "easily make into a lovely little wife", before expressing his concern over "the said young woman's paltry dowry".

Below, 15 years later, on 8ᵗʰ September 1877, he breaks to his parents the terrible news of the death of his "poor dear Marguerite", whose painful final hours he describes in detail. "What will become of my children and of me?" he asks, "overcome with disbelief". (See translations on pp. 168–169.)

Genesis of a genius

Marguerite soon fell pregnant again and, on 16th October 1864, she gave birth to another daughter, who was called Laure in memory of Gustave's sister. The Eiffel family was growing and needed to find a new home. They moved to a large apartment at 14 Rue de Presbourg, which had a spare room that Gustave could use as an office. In the autumn of 1865, Marguerite began her third pregnancy and, this time, Gustave hoped that it would be a boy. His wish was granted on 27th April 1866 with the birth of Édouard. It was a decidedly productive period for Eiffel, who was also busy preparing for the Exposition Universelle of 1867 and had just launched his own engineering and construction business.

The year 1870 was marked by the birth of a fourth child, Valentine—my great-grandmother—on 25th February. Marguerite and her children spent that summer in Étretat on the Normandy coast, where Gustave joined them when he could. The family returned to Paris on 2nd September, two days before the surrender of Napoleon III at Sedan. The Prussian army advanced on Paris and besieged the capital, but Eiffel had sent his family south to Montpellier, while he himself abandoned his factory in Levallois and set himself up in Paris itself in order to manufacture munitions for national defence. The signing of the armistice on 28th January 1871 allowed him to travel to Montpellier to collect his loved ones.

A second boy, Albert, was born on 6th August 1873, and Eiffel's business continued to prosper. He was called away to various sites, including one in Portugal, where he stayed for three months, sending news only intermittently to his poor wife, left alone with the five children. It was a situation she would have to get used to; Gustave loved Marguerite and the children dearly, but most of his time was devoted to his work.

The infant Albert had yet to celebrate his fourth birthday when his mother fell ill. Initially, it was thought that she was suffering from bronchitis, but her condition deteriorated and the dreaded verdict soon came: the poor woman had contracted what was then called consumption—tuberculosis—and it was already at an advanced stage. There was no hope of recovery and for the second time Gustave had to watch a woman he loved with all his heart fade away and die. Marguerite died, aged just 32, on 8th September 1877.

The letter Eiffel sent to his parents to tell them the terrible news betrays his distress and his concern for his children. Not knowing which way to turn, he wondered who would take care of his offspring. His father advised him to enlist the help of Claire, who was now 14. Gustave followed this advice, rejecting out of hand the idea of remarrying, which he was afraid would both upset his beloved children and complicate his own life. As a result, he became almost as close to his eldest daughter as he had been to his sister Marie. She accompanied him to Portugal, along with Laure and Édouard, while Valentine and Albert were left in the care of Marie. Gustave even went as far as making his daughter promise never to leave him, since the prospect of spending his old age in solitude was the thing he feared most, even then.

His relationship with Marguerite was, it seems, Gustave Eiffel's last romantic attachment. As far as we know, for the rest of his life, he did not become involved with any other woman, even briefly. Nor was any trace of such a liaison found among his personal effects after his death.

Below:

Gustave and Marguerite Eiffel on the terrace of their home in Levallois-Perret in 1874.

Opposite:

From left to right, starting at the top, their five children, Claire (1863–1934), Laure (1864–1958), Albert (1873–1941), Valentine (1870–1966) and Édouard (1866–1933).

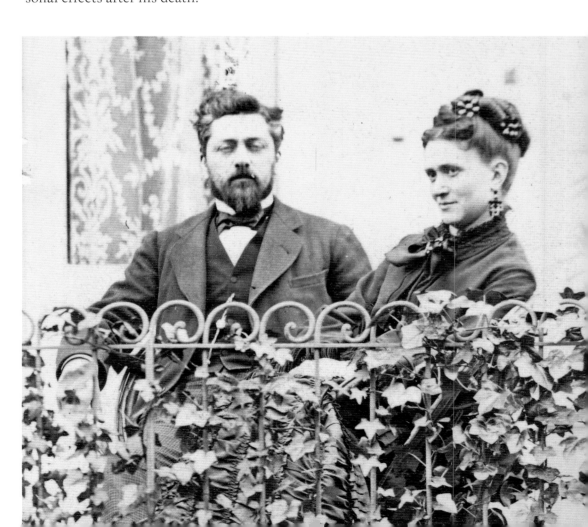

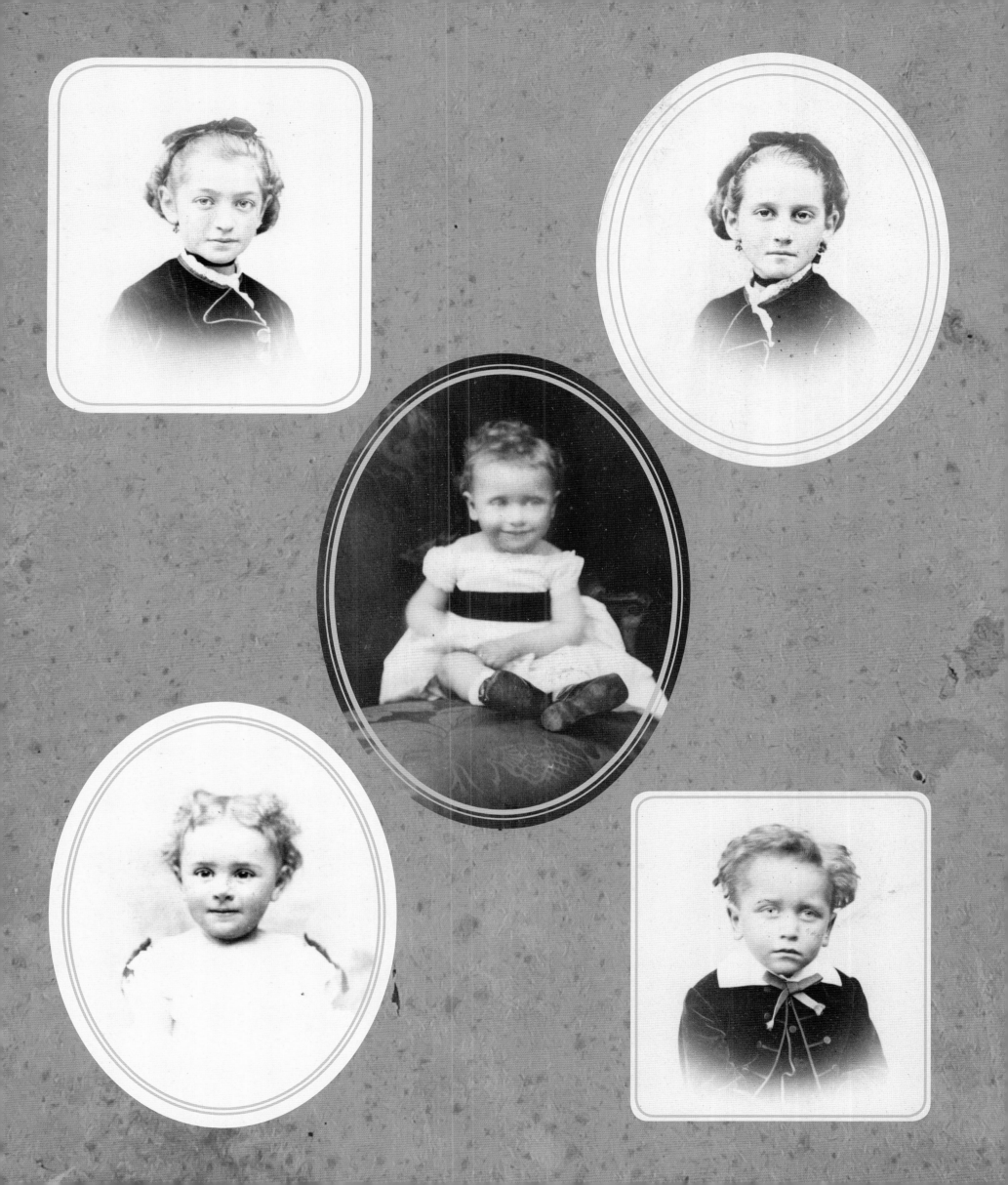

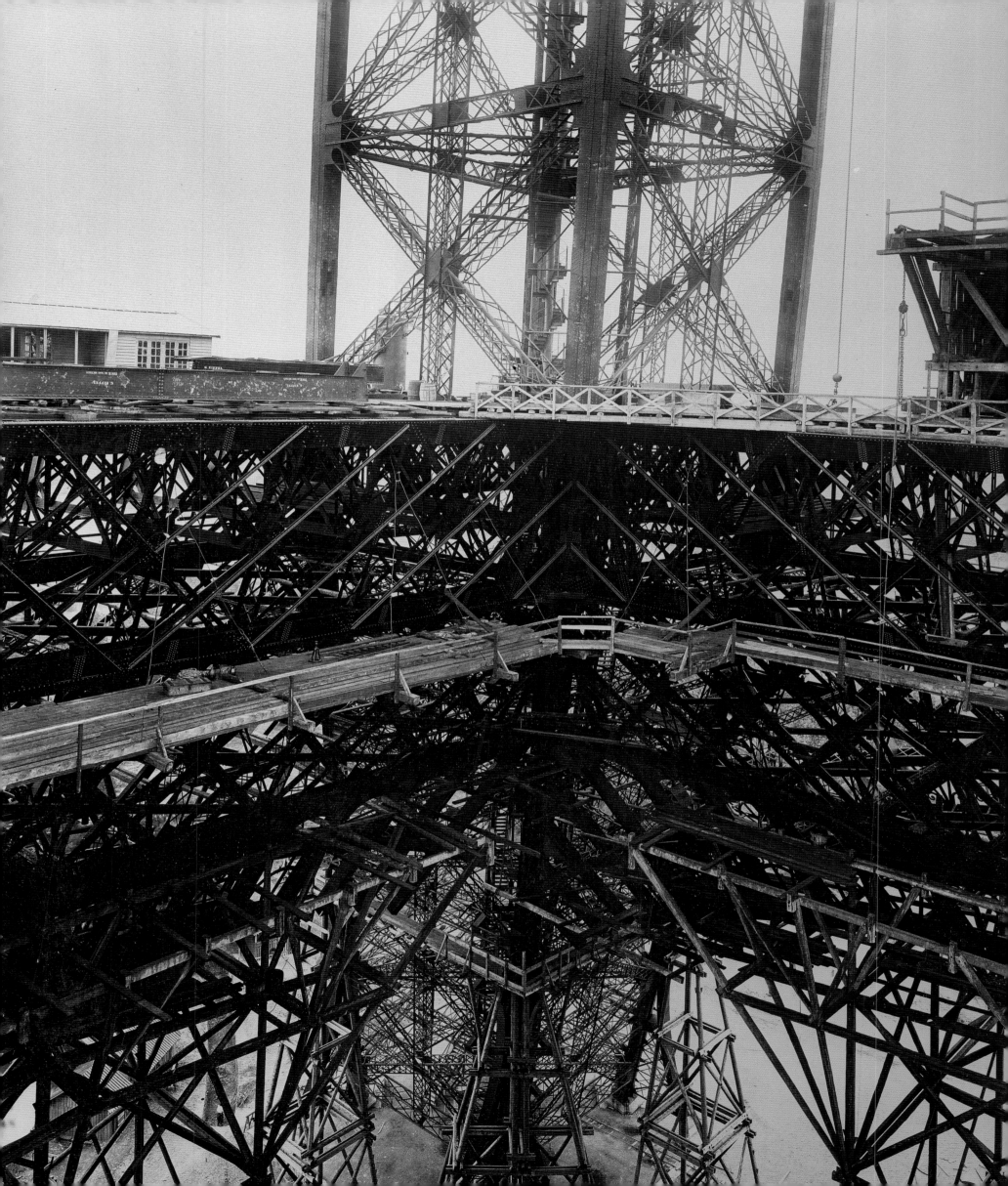

CHAPTER II

EIFFEL & CO.

His name becomes increasingly known and respected until his renown spreads to the four corners of the globe. It is the start of a great adventure...

N° DE LA MINUTE 18429

N° DE L'EXPÉDITION 7422

5 JUIN 1900

Répondu le

6

Pont sur la rivière de Saïgon à Binh-Loï.

Travée de 62 mètres.

Épures de résistance

SOCIÉTÉ DE CONSTRUCTIONS DE LEVALLOIS-PERRET
ENTREPRISES GÉNÉRALES & CONSTRUCTIONS MÉTALLIQUES
SOCIÉTÉ ANONYME AU CAPITAL DE 2.250.000 FRANCS
42, Rue Fouquet, à Levallois-Perret (Seine)

Entering the business world

Opposite:
In 1890, the firm G. Eiffel et Cie ceased to exist and Eiffel founded a new company, the Compagnie des Établissements Eiffel, based at his workshops in Levallois-Perret. In 1893, the firm became known as the Société de constructions de Levallois-Perret, but the change of name had no effect on the activities of the business, which simply took over the projects the workshops had already undertaken and continued to patent new designs. In effect, Eiffel had decided to withdraw his name from the company name, much to the displeasure of its shareholders.

These contracts relating to the construction of a road bridge across the Saigon River in 1899 bear the new company name.

Below:
The bronze medal awarded to Eiffel to commemorate the opening of the Maria Pia Bridge over the River Douro on 4th November 1877.

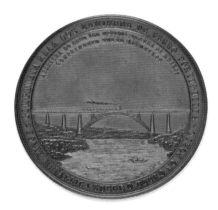

In 1863, the Pauwels company fell into difficulties and Eiffel considered himself sufficiently seasoned to launch his own business, with the financial and moral support of his parents. He won a number of orders, including one for the construction of windmills in Egypt, where he was greatly impressed by the work in progress on the Suez Canal. But his new enterprise was far from flourishing. Fortunately, Napoleon III had the idea of organizing another Exposition Universelle, which was scheduled for 1867. It so happened that the exhibition director was a man by the name of Krantz, whom Eiffel had met while making art installations for Pauwels. Kranz entrusted him with the design of the iron framework for the Pavillon des Beaux-Arts. Not only was this a substantial commission, but it was one that would expose Eiffel to the eyes of the world. Another consequence was that Eiffel needed a factory, which he chose to set up in Levallois-Perret, a town that had the twin advantages of being by the Seine and close to a railway line.

From that moment on, Eiffel was prey to the trials and tribulations of running a business: filling the order book and controlling the cash flow. His parents helped him to meet his commitments, but it was a stopgap, not a long-term solution to the problem of developing his business. He needed a partner who could contribute both funds and technical expertise. As it happened, Théodore Seyrig, like Eiffel a graduate of the École Centrale, had the necessary finances and knowledge and he joined the firm as co-director, although Eiffel remained its president and retained the majority of the shares and therefore overall control.

In 1868, Eiffel had an experience that was to have considerable repercussions. He bid for a contract to supply lighthouses to the Suez Company, but despite his best efforts and the quality of his proposal, the contract eluded him. As far as Eiffel was concerned, there was no doubt that the failure was due to favouritism on the part of the head of the canal company, Ferdinand de Lesseps. It was the beginning of Eiffel's bitter dislike of the man.

Nevertheless, Eiffel et Cie began to expand. Gustave won contracts in France, Switzerland, Portugal, Romania, Bolivia, Egypt, Russia and even the Philippines. He built bridges, a dam and a power station as well as churches. His success cannot be explained purely in terms of the classical precision of his drawings, nor by Eiffel's ability to charm the decision-makers and convince them of his integrity. The chief reason was financial: Eiffel et Cie's quotations were significantly lower than those of the competition, and this was thanks to Eiffel's rigorous organization, his reliance on standardized parts—a technique he had perfected during the construction of the Bordeaux bridge—and his use of local subcontractors, which helped to reduce his costs. In 1875, he secured two contracts of major importance: Pest station in Hungary and the Maria Pia Bridge over the Douro in Portugal. It was also the year in which he began to amass his impressive collection of medals and decorations, listed in his autobiography, which he completed a few months before his death and in which he also detailed his scientific and technological achievements. On the day Pest station was opened, 27th October 1877, the Emperor Franz-Joseph personally awarded Eiffel the country's highest honour: Knight of the Order of Franz-Joseph.

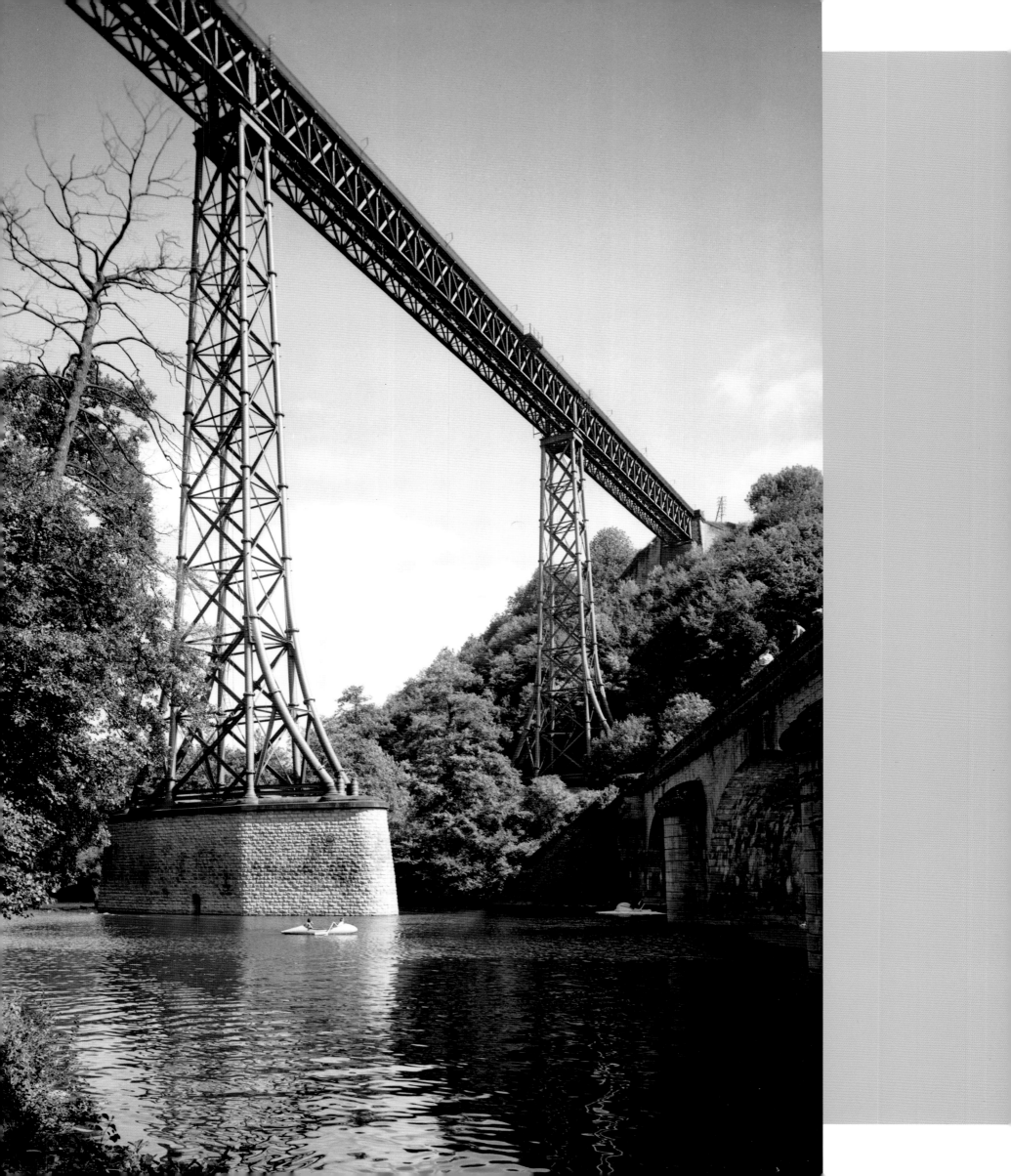

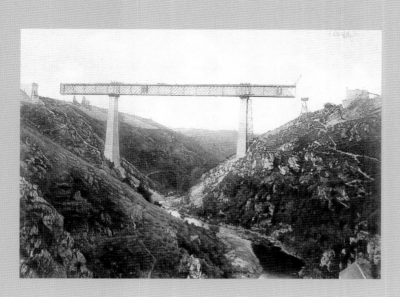

The construction of viaducts supported by iron piers enabled Eiffel to study and perfect the technique of launching, which was in common use at the time. Launching, as is well known, is the procedure by which each section of deck, prefabricated at the side of the space to be spanned, is extended across it until it reaches the next pier.

Eiffel used the lever method, which involves applying leverage directly to rollers on which the deck of the bridge rests, in order to eliminate the risk of toppling the piers, and he invented cradles on which the rollers sat, which were soon used in all such installations.

The mechanism, which allows horizontal movement, ensures that the weight of the deck is distributed evenly across the rollers, so that no point load exceeds the predicted value. This arrangement is of great importance, since the lower part of the deck is not horizontal and, thanks to the cradles, the rollers push down on the steps formed by the variable width of the iron plates supporting the roller mechanism.

The first time such cradles were used was in 1869, in the construction of the viaduct over the Sioule, and the last time in 1883, on the Tardes viaduct (on the Orleans railway line between Montluçon and Eygurande).

Opposite:
The Rouzat viaduct, a rail bridge constructed in 1869 across the Sioule valley in the department of Allier, France.

Above:
The Évaux viaduct over the Tardes (Creuse) under construction in 1881.

Right:
Detailed cross section showing the stages in the construction and launching pattern of the Tardes viaduct.

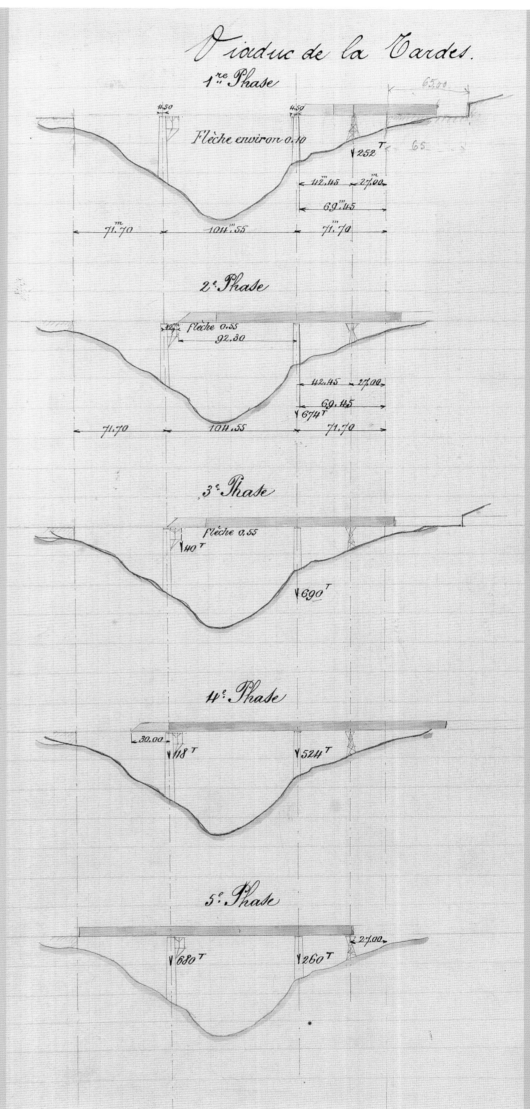

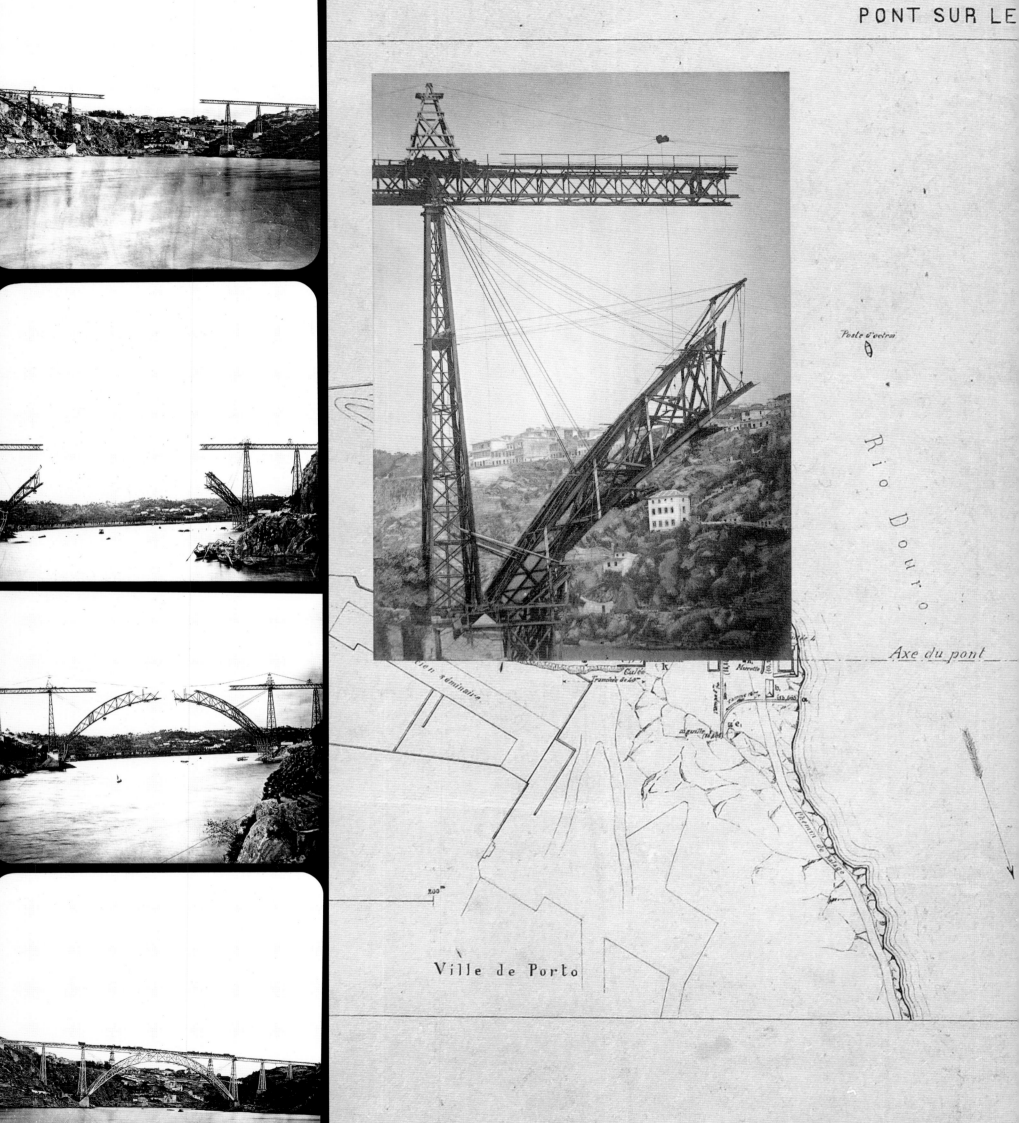

PONT SUR LE

Rio Douro

Axe du pont

Ville de Porto

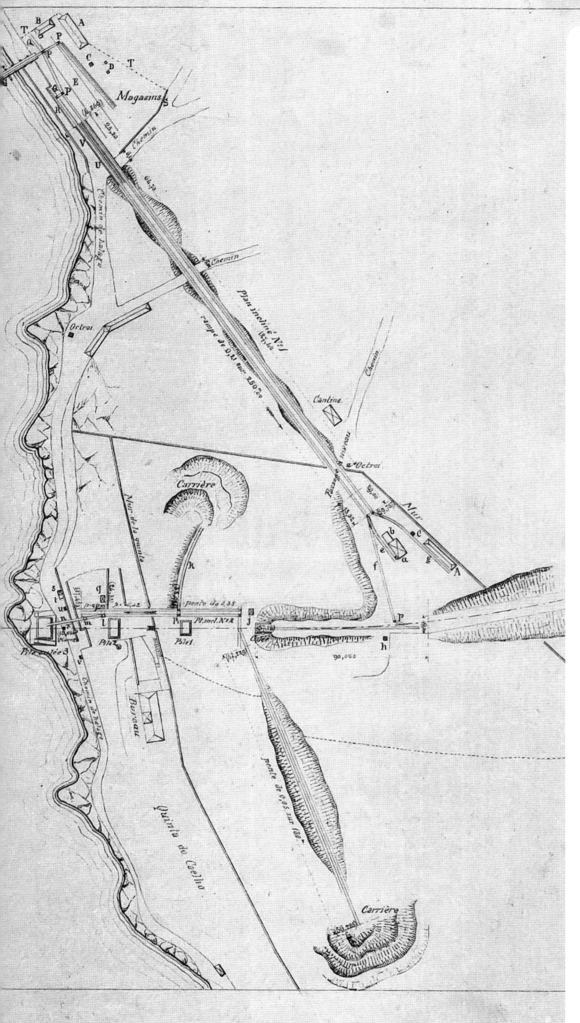

Eiffel's famous design for the bridge over the Douro in Porto was the winner of an international competition in 1875; here are its essentials.

The railway line from Lisbon to Porto needed to cross the Douro at a height of 61 m above the level of the river, whose great depth at this point precluded the construction of any intermediate support. The full width of the river, 160 m, thus had to be traversed by a single span.

Eiffel therefore proposed a design consisting of an arch with an average height of 42.5 m and a 160 m deck, which, beyond the span of the arch, would rest on simple iron piers. The arch itself was a most unusual shape: at its base it rested on simple supports consisting of a ball and socket, and as it curved towards the apex it became progressively wider, the whole thus forming a crescent. It is a shape that is particularly effective in absorbing unequal forces, as its widest point is that at which it is under the greatest strain.

An innovative, and no less important, part of the design consisted in setting the two sides of the arch at a slight angle, in order that they should be 15 m apart at the base, providing the structure with the necessary stability and wind resistance, but only 4 m apart at the top, to match the spacing of the beams supporting the deck.

A third and final innovation was to be found in the method of construction, which would be done entirely by the use of cantilevers, with no internal support. This meant that the arches would be built from the base upwards and supported at each stage in construction by steel cables attached to the deck above. Each section of the bridge would serve as the support for the next. Thus the two sides of the arch would gradually stretch towards each other until they were joined in mid-air by the key section at the apex.

This procedure, which was as complex as it was novel, proved to be a complete success. The boldness of the design and the width of the span, which exceeded anything previously achieved except by suspension bridges, drew the attention of scientists all around the world to the name Gustave Eiffel.

Opposite page:
The various stages in the construction of the Maria Pia Bridge over the Douro (Portugal) in 1876. Steel cables supported the sections of arch as they reached across the river.

Background:
The drawing that accompanied the report on the project by Eiffel et Cie.

Following pages:
Photochrome print showing the Maria Pia Bridge in Porto in around 1890.

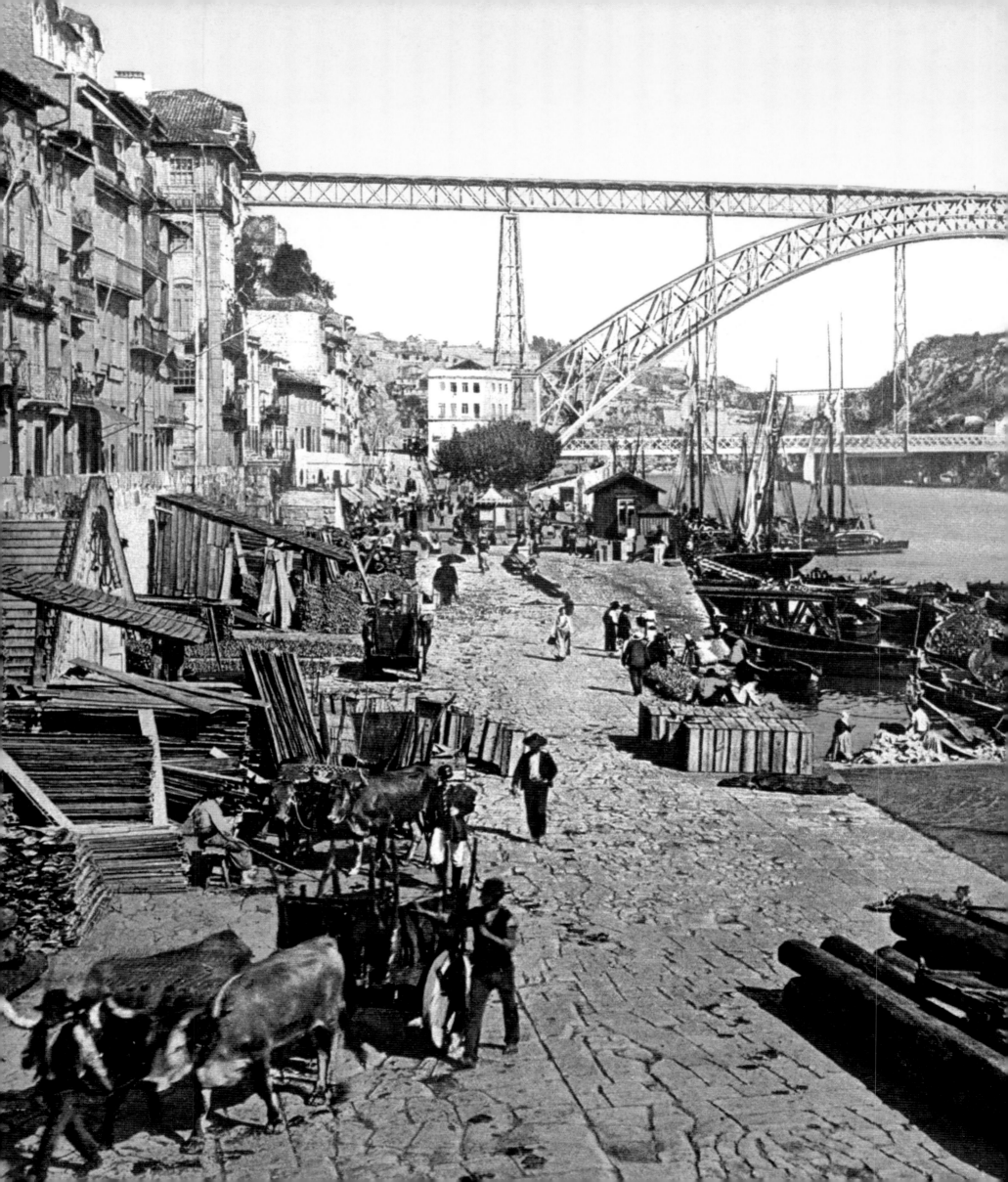

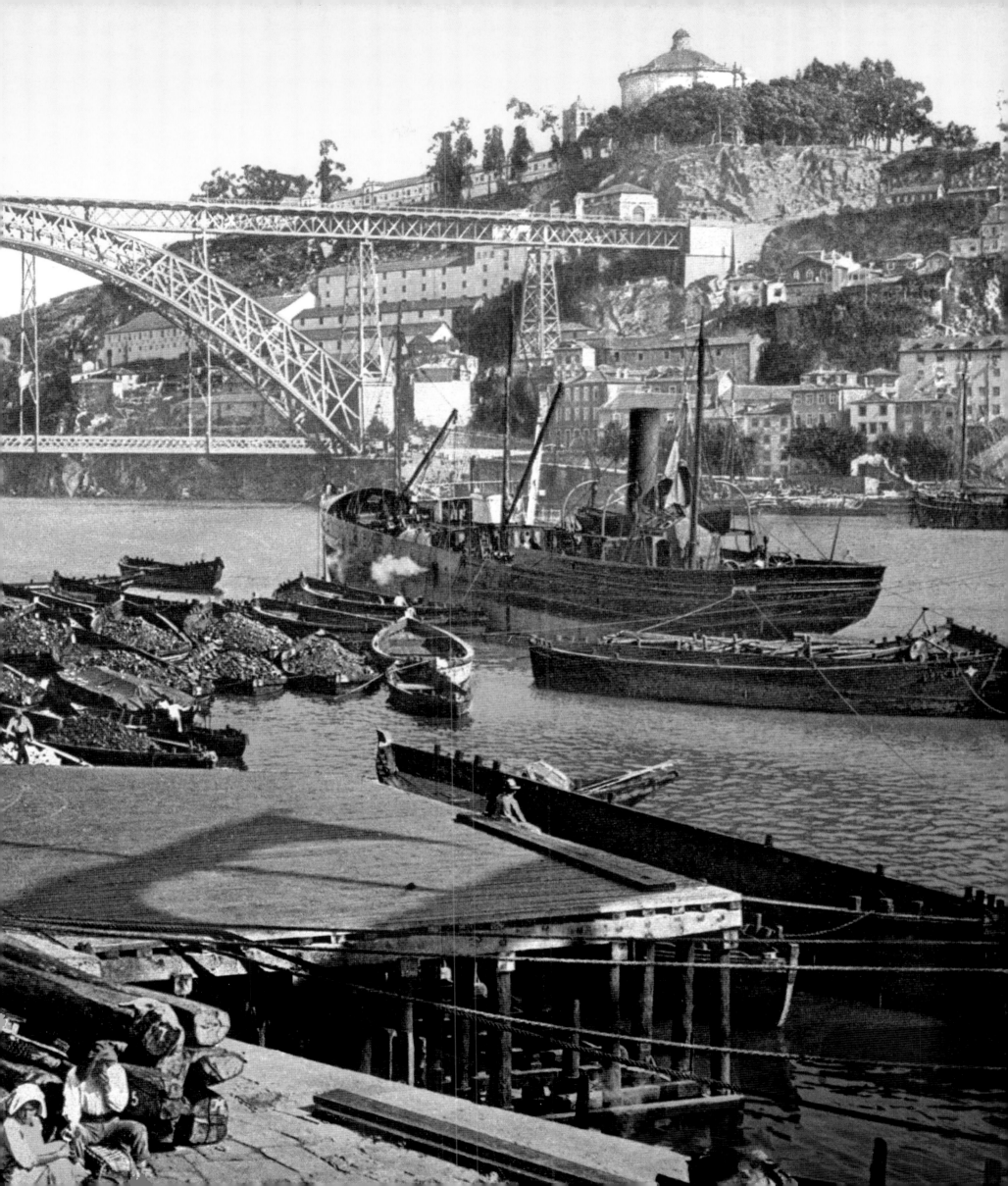

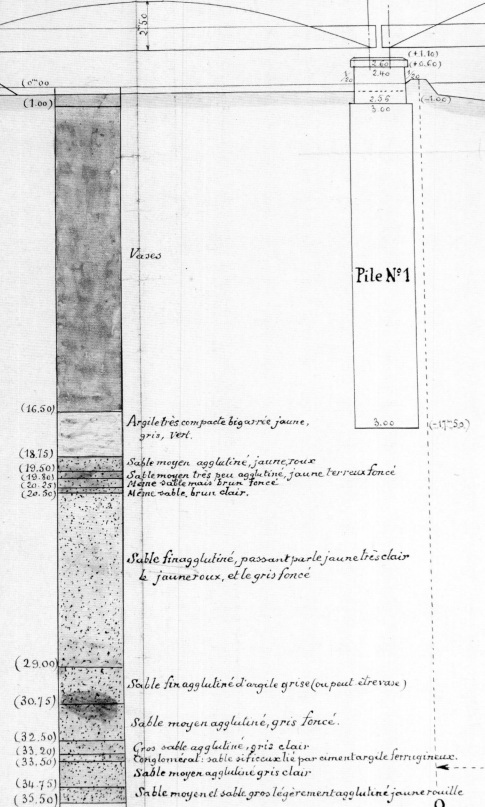
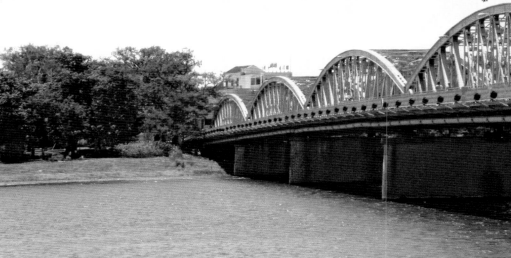

Left and far right: The file relating to the Binh Loi bridge project (1899) in Saigon included a soil study, a detailed costing and press cuttings.

Above: The Trang Tien Bridge (originally the Thành Thái Bridge and later the Clemenceau Bridge, built in 1897) in Hue, Vietnam, today.

Eiffel & Co.

Although Vietnam had been under French control for only a decade, Eiffel set up an office there, in the Cochinchina region, in 1872. To run it, he appointed Jules Puig, an outstanding engineer who was just 19 years old. From then on, Eiffel made a point of sending his most able colleagues to Indochina.

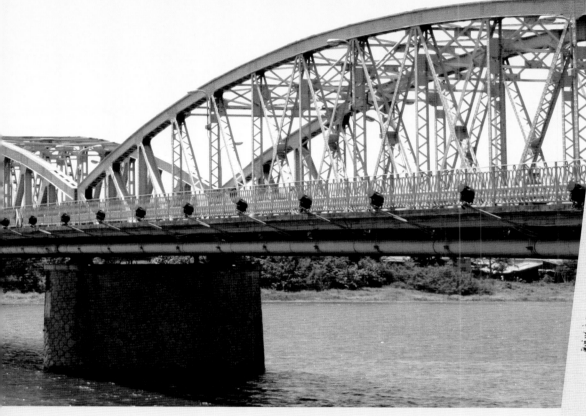

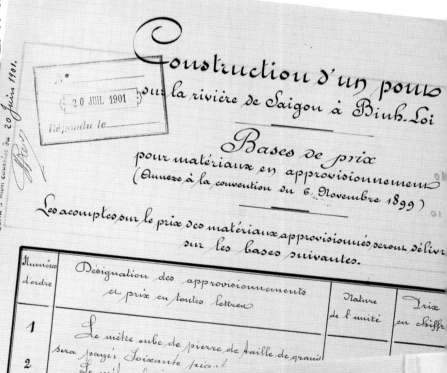

Below: *Cross section of the piling in the port of Saigon showing the progress of the work at 30th March 1905.*

Following pages: *The iron framework of Saigon's Central Post Office was designed by Eiffel in 1886.*

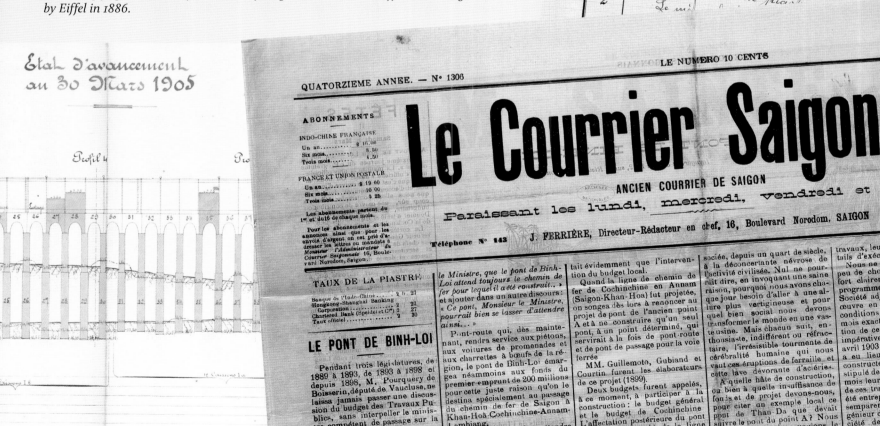

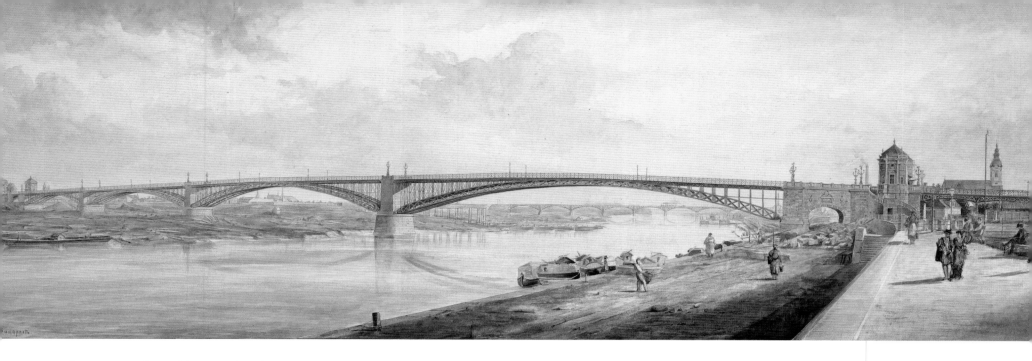

Above: *Watercolour of the Szeged Bridge over the Tisza (Hungary) by Albert Schickedanz (1880–1883).*
Below: *Budapest station (built in 1877) today.*

Opposite: *The file on the Senegal bridges (1883), a rare photograph of Eiffel, looking a little unkempt, by Lesuvre dating from the 1880s, and a cross section of the floating bridge on the River Salee in Guadeloupe (1904).*

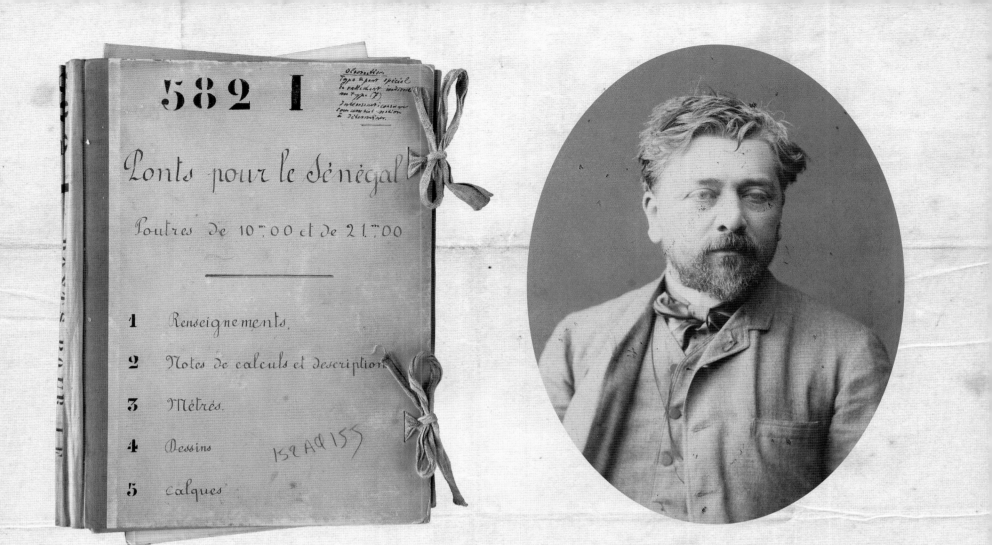
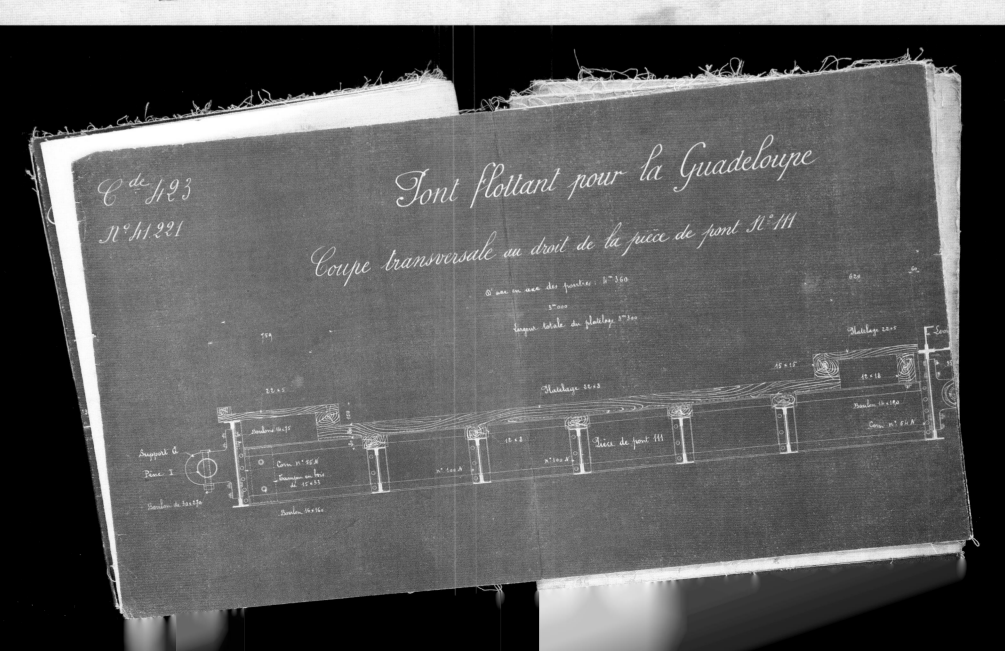

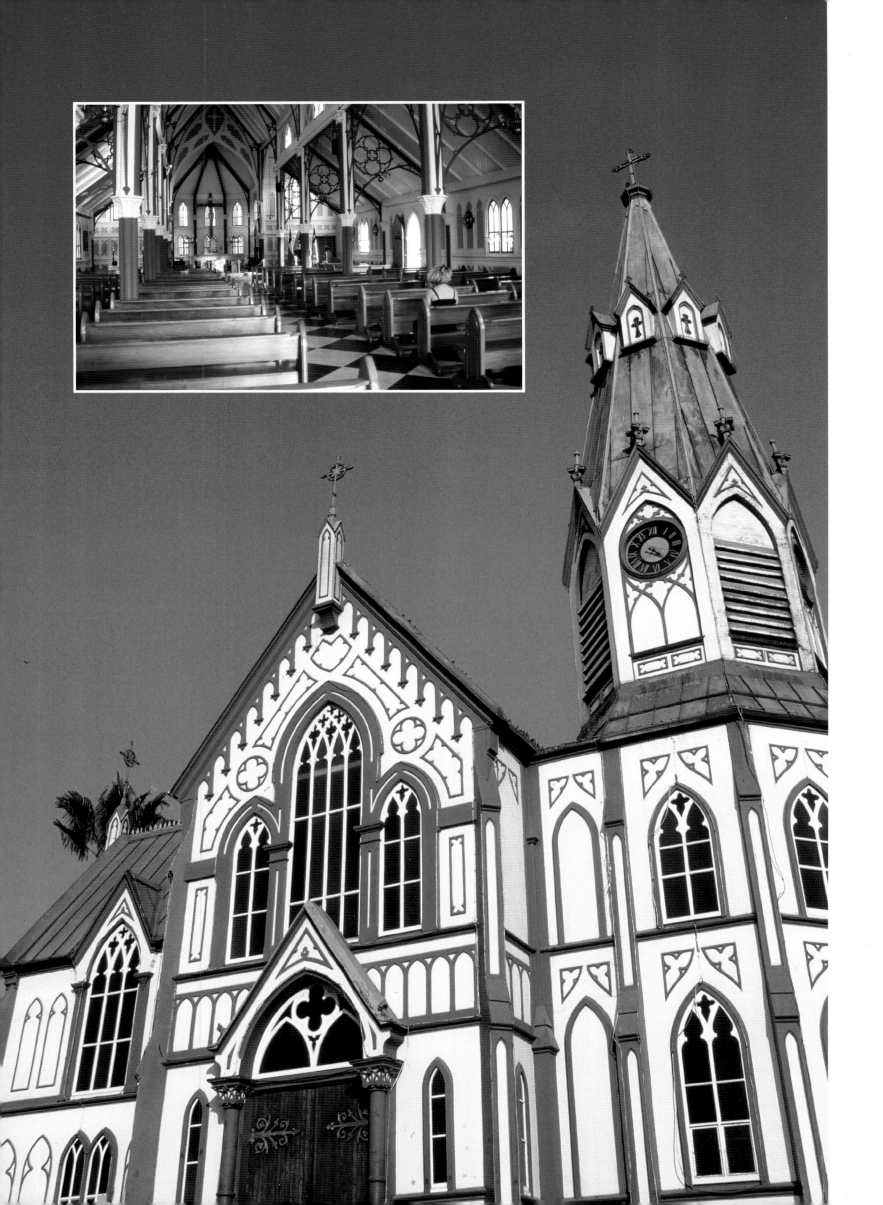

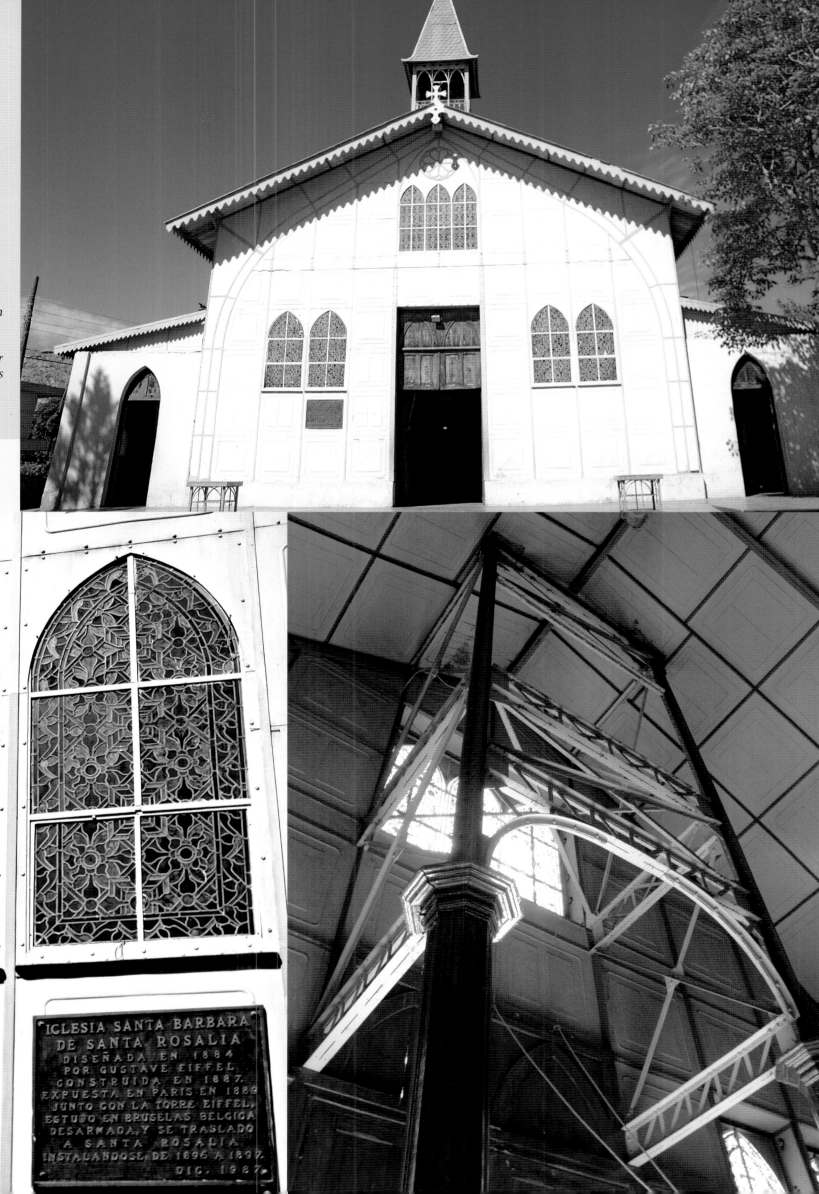

Opposite:
San Marcos Cathedral in Arica, Chile, designed by Gustave Eiffel and completed in 1876.

This page:
The Santa Barbara Church in Santa Rosalia, Baja California. The plaque indicates that it was designed by Eiffel in 1884, built in 1887, shown at the 1889 Exposition Universelle in Paris alongside the Eiffel Tower and then sent via Brussels to Santa Rosalia, where it was finally erected in 1896–1897.

Eiffel & Co.

On the up

Opposite:
Cross section of the former Le Bon Marché department store in Paris (1876) showing the staircase. Eiffel designed the metal framework.

Below:
Winch mechanism for the sliding panels on the great dome of the Nice Observatory.

In 1879, Eiffel's company undertook a major extension to the Le Bon Marché department store, run by the Boucicaut family, in Paris, for which it devised a system of tubes to house the various pipes and cables and a method of construction that prevented the plaster from cracking. The rebuilding of the Cubzac Bridge in Gironde, which had been partly destroyed by a storm, required a particularly complex launching process, for which Eiffel came up with an entirely novel system of cantilevers.

The contract for the Garabit Viaduct in Cantal was awarded to Eiffel et Cie without a competitive tendering process, which was extremely unusual. But there was a good reason for it: the site was similar to that of the Maria Pia Bridge over the Douro. However, the Administration des Ponts et Chaussées, which had issued the contract, insisted that Eiffel take full responsibility for the project; in other words, that he personally assume the entire risk associated with the technical procedure he was being asked to undertake. Eiffel accepted. He repeated all the calculations and checked and double-checked the drawings. Among his innovations for this project was the lowering of the railway within the deck, with the aim of providing the trains with a safety barrier, and the provision of channels inside the piers from which the structure could be checked and maintained—a system he would patent and reuse in the Eiffel Tower. The success of the Garabit project earned Eiffel considerable prestige in the engineering world and strengthened his standing among investors. It should be noted that he took care to nurse his reputation by sending releases and copies of his designs to engineering societies and the press. In particular, the *Génie civil*, a journal he had helped to found, published detailed and eulogistic articles on his more spectacular achievements. One such report made much of the construction of the metal framework of the Statue of Liberty. Although Bartholdi had decided to use copper for the exterior of the statue, for aesthetic, financial and practical reasons, the interior structure had to be made of iron, which was much stronger. However, the difference in the rates at which the two materials expanded and contracted presented a particular problem. Another significant challenge was to make the statue wind-resistant, given its exposed position as New York's "figurehead". Eiffel was undoubtedly the man for the job, as he had already faced and overcome this doughty adversary in his bridge-building activities: from the Bordeaux bridge to the Garabit Viaduct, 880 m above sea level and linking two wind-swept plateaus. The Statue of Liberty was financed by the sale of shares to the public, first in France, since the monument was a present from the French to the United States, and then on the other side of the Atlantic. The official acceptance of the gift took place on 28th October 1886. On the Statue is an inscription thanking Bartholdi and Eiffel in the name of the American people.

In 1884, Eiffel was entrusted with the design of the great dome of the Nice Observatory, in collaboration with Charles Garner, designer of the Paris Opera. Once again, Eiffel took the opportunity to prove his creative genius, by contriving to float the structure, then the largest iron-framed dome in the world, on a circular rim filled with liquid, so that it could be turned by hand using a simple winch.

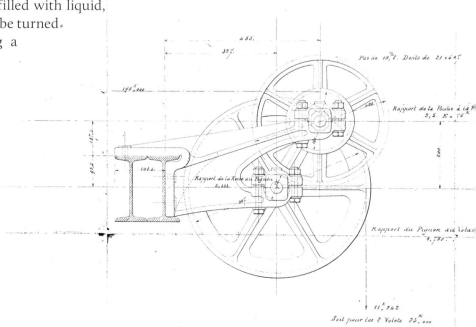

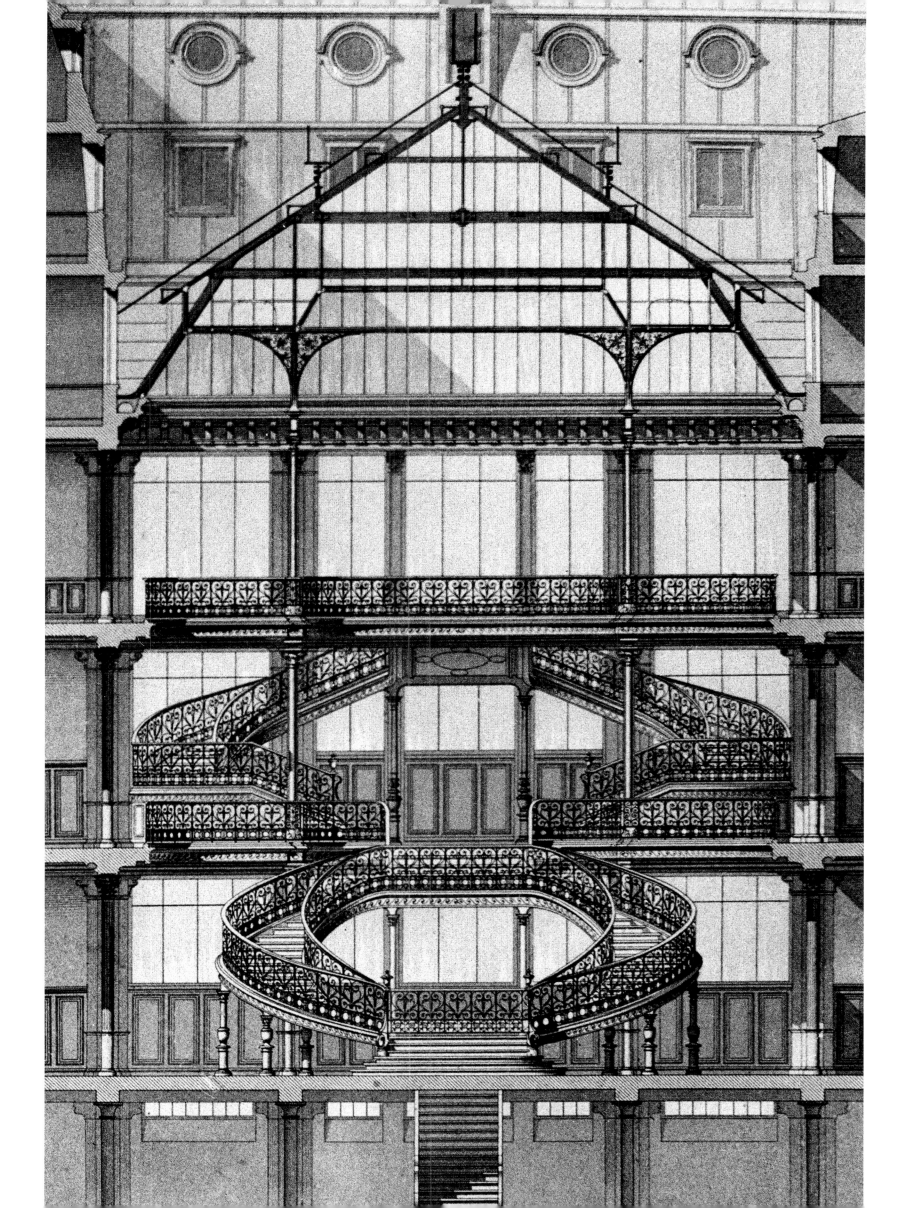

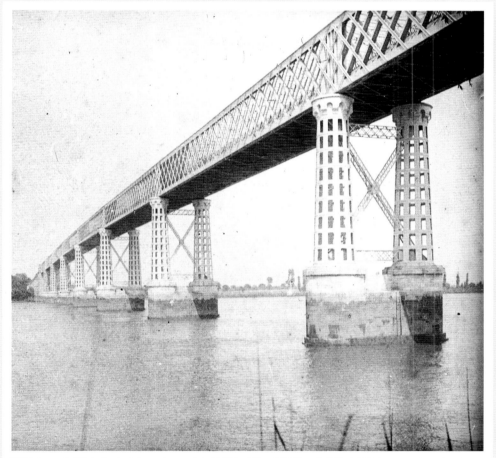

The reconstruction of the Saint-André-de-Cubzac Bridge, over the Dordogne, seemed to combine all the problems associated with projects of this type. It had been stipulated that the new bridge should retain the exterior outline of the old suspension bridge by standing on iron piers with a distinctive latticework design. Furthermore, it should be joined at each end to the existing stone abutments, which determined the level of the road surface.

This meant that the deck of the bridge would have to follow the slope of the previous bridge, namely 1 in 100, which caused considerable complication, since the launching process was of necessity horizontal. It would therefore be necessary to use wooden blocks of various thicknesses, which would cause a dangerous loss of stability.

The bridge was 552 m long and it was divided into eight spans: two end spans of 57.20 m, and six central spans of 72.80 m. It weighed 3,000 tonnes.

The launching presented the greatest possible difficulty on account of the unusual shape of the piers, which lacked stability in relation to the tipping force involved in the launching process. The six outer sections of the bridge were nevertheless launched from each bank.

For the two central spans, where the slope was different, a new method of construction was employed, which Eiffel was the first to use in France. It made use of cantilevers, in the following way: to the last sections of deck, which had been fixed in their final positions, were bolted the first parts of the next section; these were then swung out into space and, once riveted in place, used as fixtures for the following parts, and so on. By progressing thus from piece to piece, it was possible to construct the entire sections of bridge in mid-air until they reached the next pier, where hydraulic jacks were used to raise them by the amount by which they had sagged under their own weight.

To complete the Cubzac Bridge, then, the two central spans were cantilevered over a distance of 72.8 m until they met over the central pier.

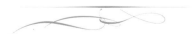

Opposite and left:
Monochrome photographs on glass plates showing the completed Saint-André-de-Cubzac Bridge across the Dordogne in around 1900. It was built between 1879 and 1883.

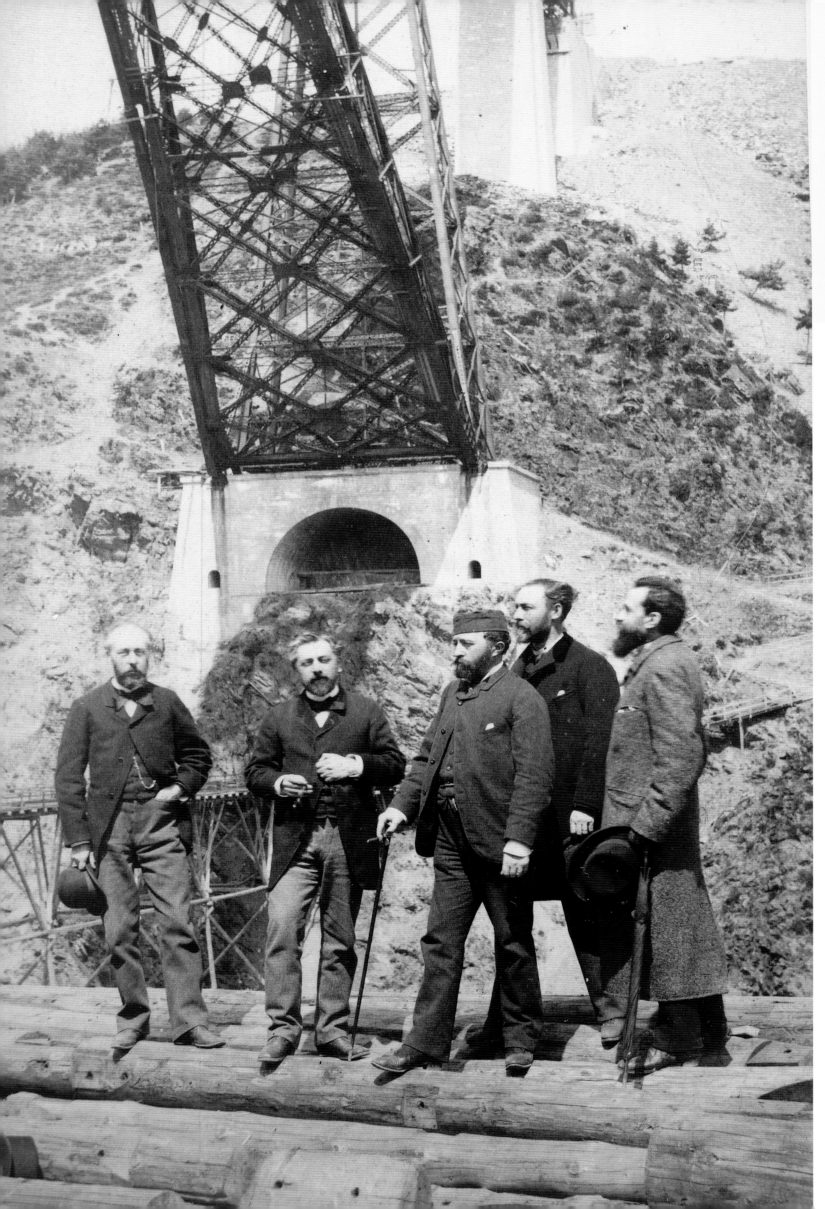

Left:
Gustave Eiffel (second from the left) beneath the Garabit Viaduct in about 1882. To his right is Jules Charton (1840–1921), the engineer employed by the Southern Railway Company, to which the Administration des Ponts et Chaussées officially handed over the viaduct in 1892.

Above:
The Garabit Viaduct under construction. The photograph dates from 18th April 1884.

Below:
Visitors to the Garabit Viaduct in the early 20th century.

When a great viaduct was needed to carry the railway line between Marvejols and Neussargues across the Truyère valley at a height of 122 m, it was the skills of Gustave Eiffel that were called upon.

An idea of this great height can be given by the simple fact that it significantly exceeds the combined height of the towers of Notre Dame and the Vendôme column in Paris.

[...] The total length of the viaduct was 564 m, the ironwork extending over 448 m, and it rested on five piers, the tallest reaching a height of 89.64 m and resting on a stone pedestal 25 m across and 28.9 m high, the metal part rising some 61 m above it.

The central arch was shaped in a form now known as a parabolic arc, an innovation of Eiffel et Cie. [...] These impressive dimensions made the bridge the largest structure yet erected in France. The ironwork weighed a total of 3,254 tonnes and the total cost of the construction, including the stonework, was 3,137,000 francs.

[...] The construction procedure was the very same as had been so successful for the Douro bridge, namely suspending each half of the arch from steel cables fixed to the deck and extending it into space piece by piece. The outer ends of the deck were attached to the abutments by other cables, whose adjustment allowed the inner ends of the deck to flex as the arch was constructed.

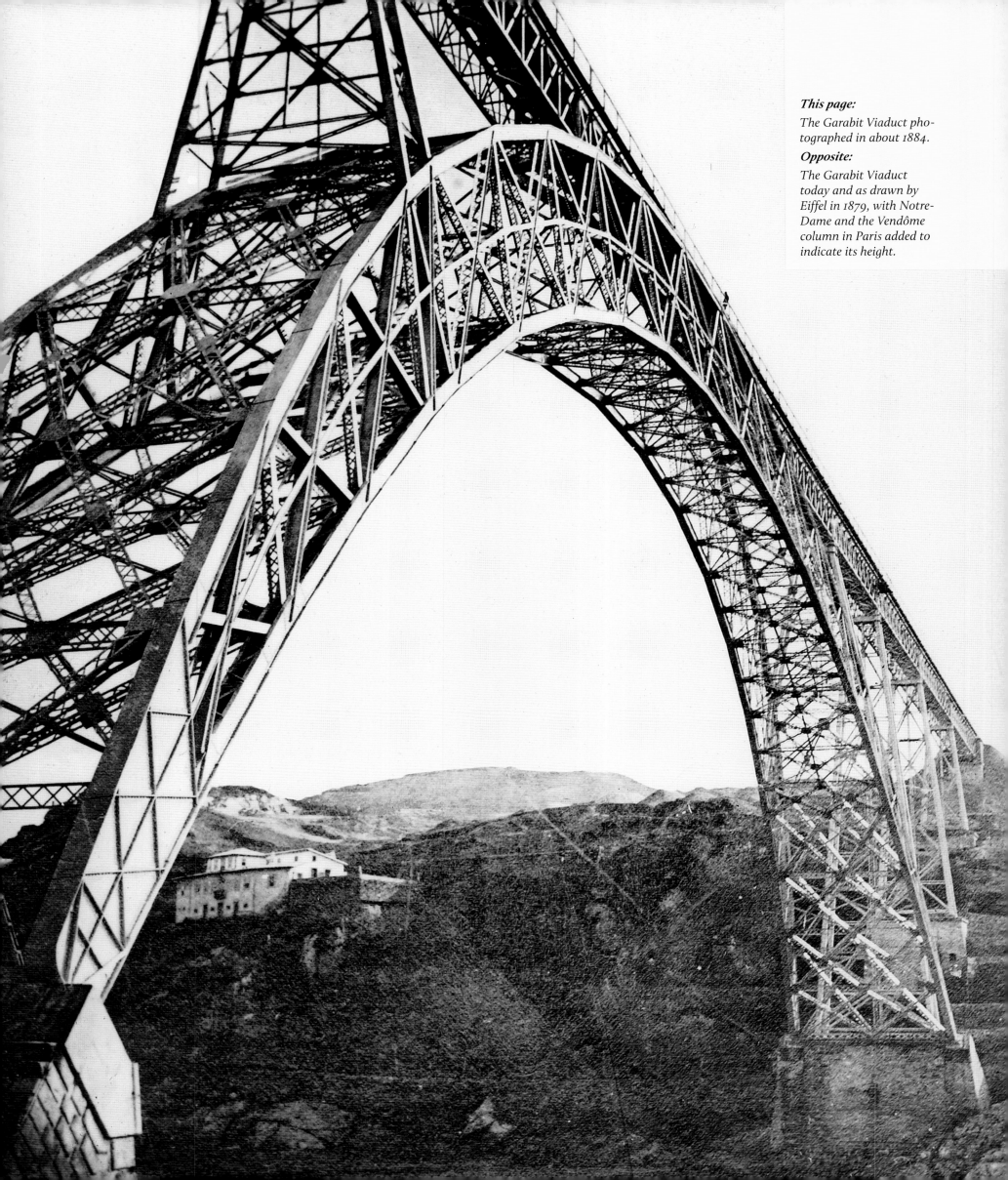

This page:
The Garabit Viaduct photographed in about 1884.

Opposite:
The Garabit Viaduct today and as drawn by Eiffel in 1879, with Notre-Dame and the Vendôme column in Paris added to indicate its height.

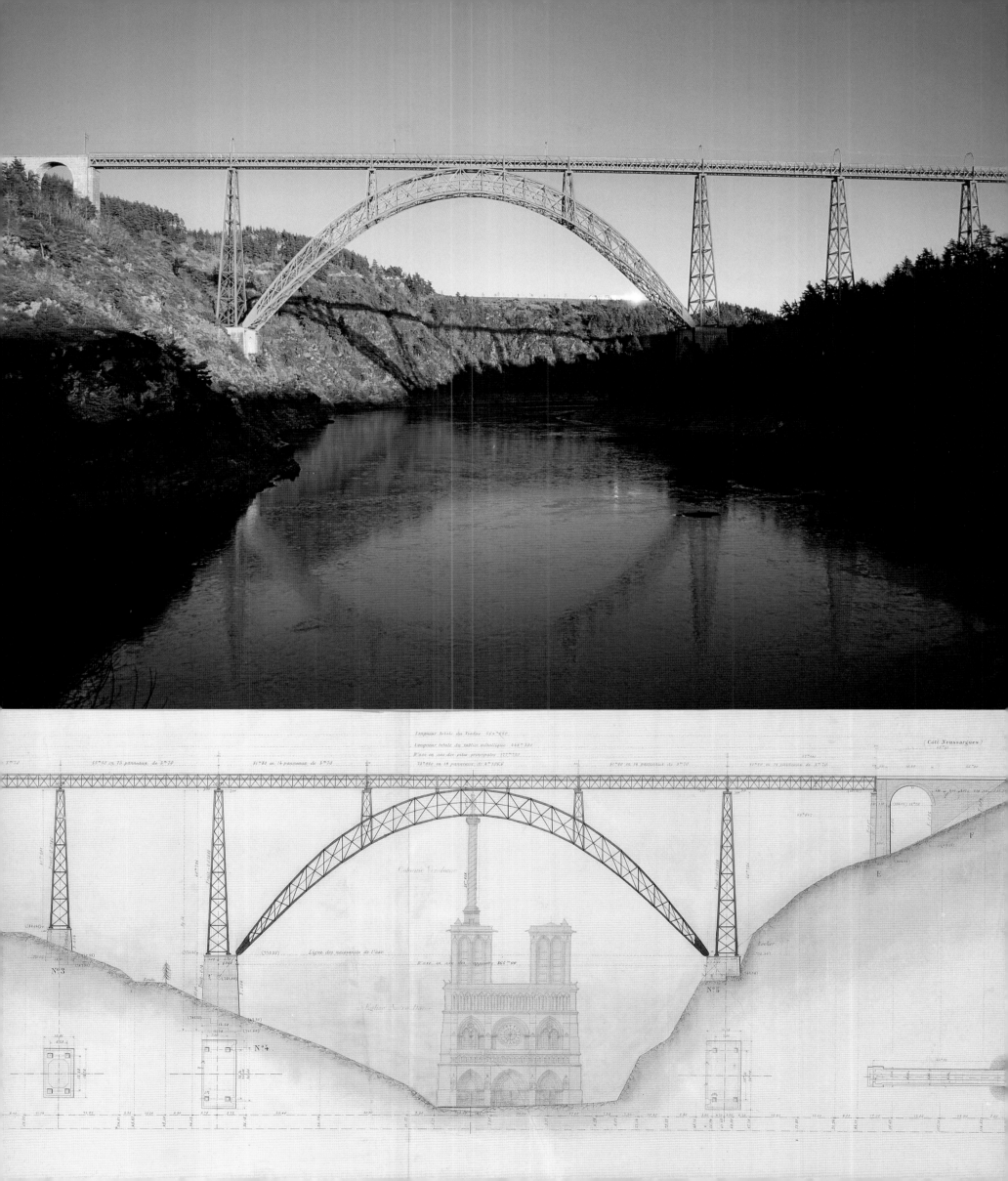

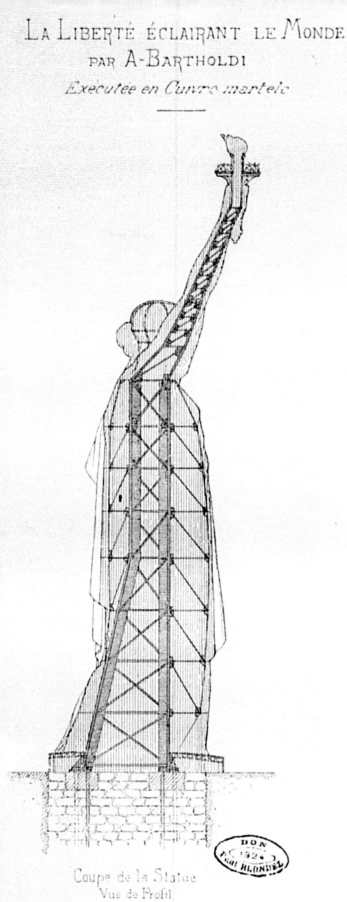

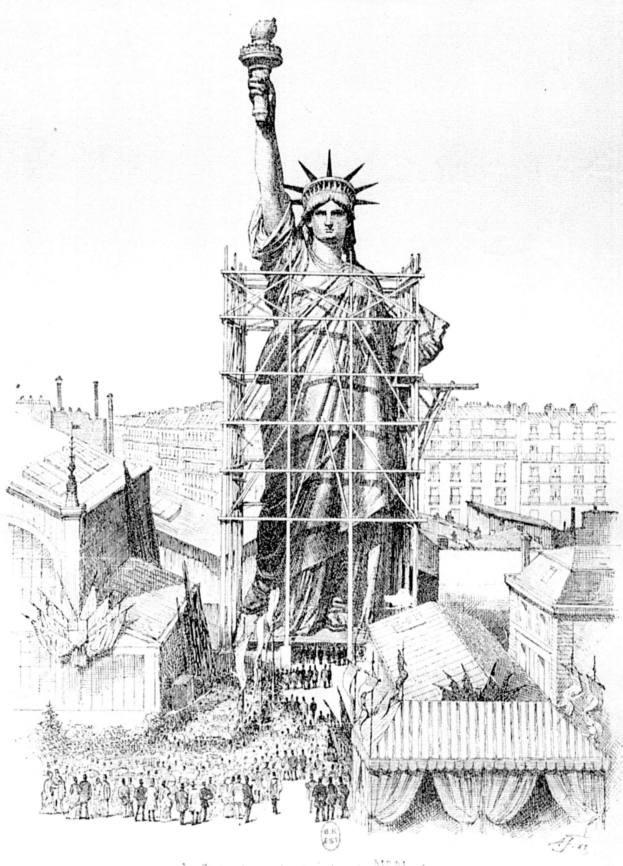

Above:

Liberty lighting up the world by Auguste Bartholdi, who made the statue between 1876 and 1884 in the Gaget foundry at 25 Rue de Chazelles in Paris. The construction of the supporting framework was entrusted to Eiffel, who recalled in his autobiography: "Eiffel's study of the effect of wind resistance on iron structures made him the first choice for the construction of the iron framework for Bartholdi's 46-metre-high Statue of Liberty, which was to be erected in New York Harbor. It was therefore he who carried out the work for Bartholdi in 1881 and, despite the strict financial limitations imposed on the project, the structure has withstood the dreadful storms to which it has since been exposed."

Right:

The certificate of authenticity signed by Bartholdi that accompanied the limited edition scale model of the Statue of Liberty given to Eiffel by the artist.

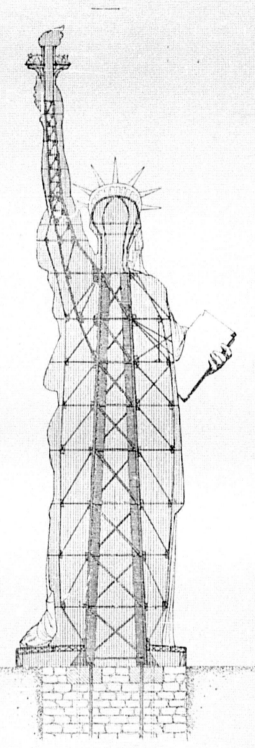

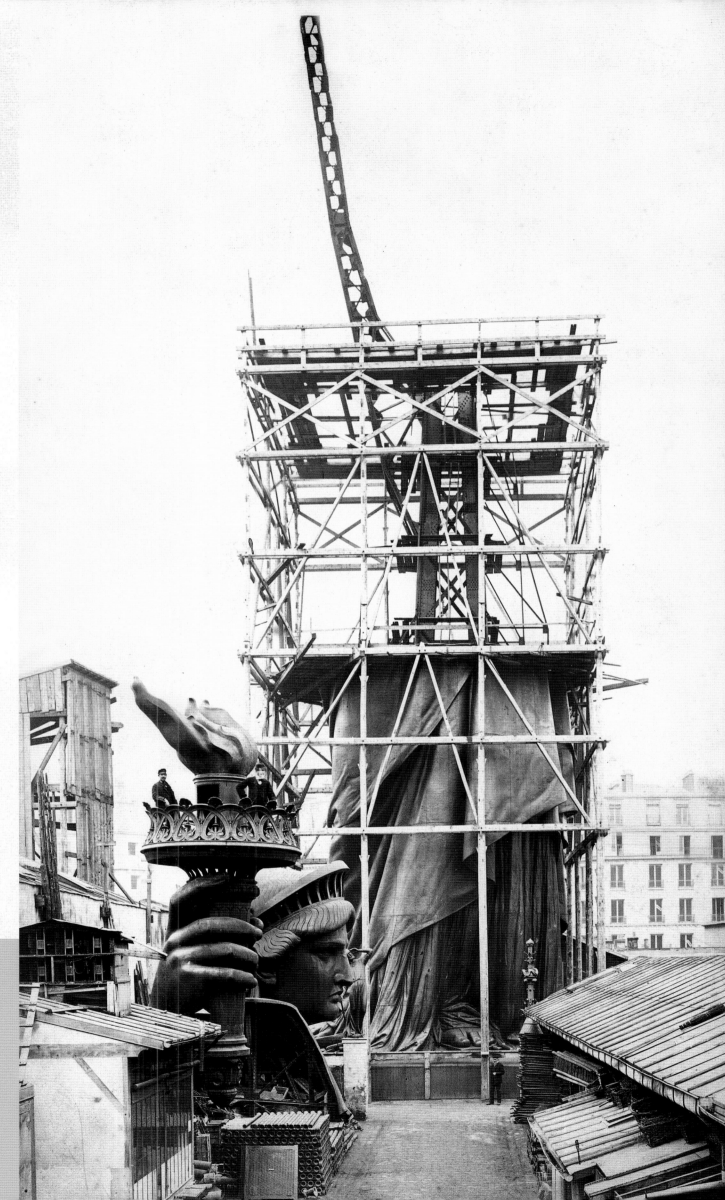

Right:

The Statue of Liberty under construction, photographed in about 1882 by Pierre Petit.

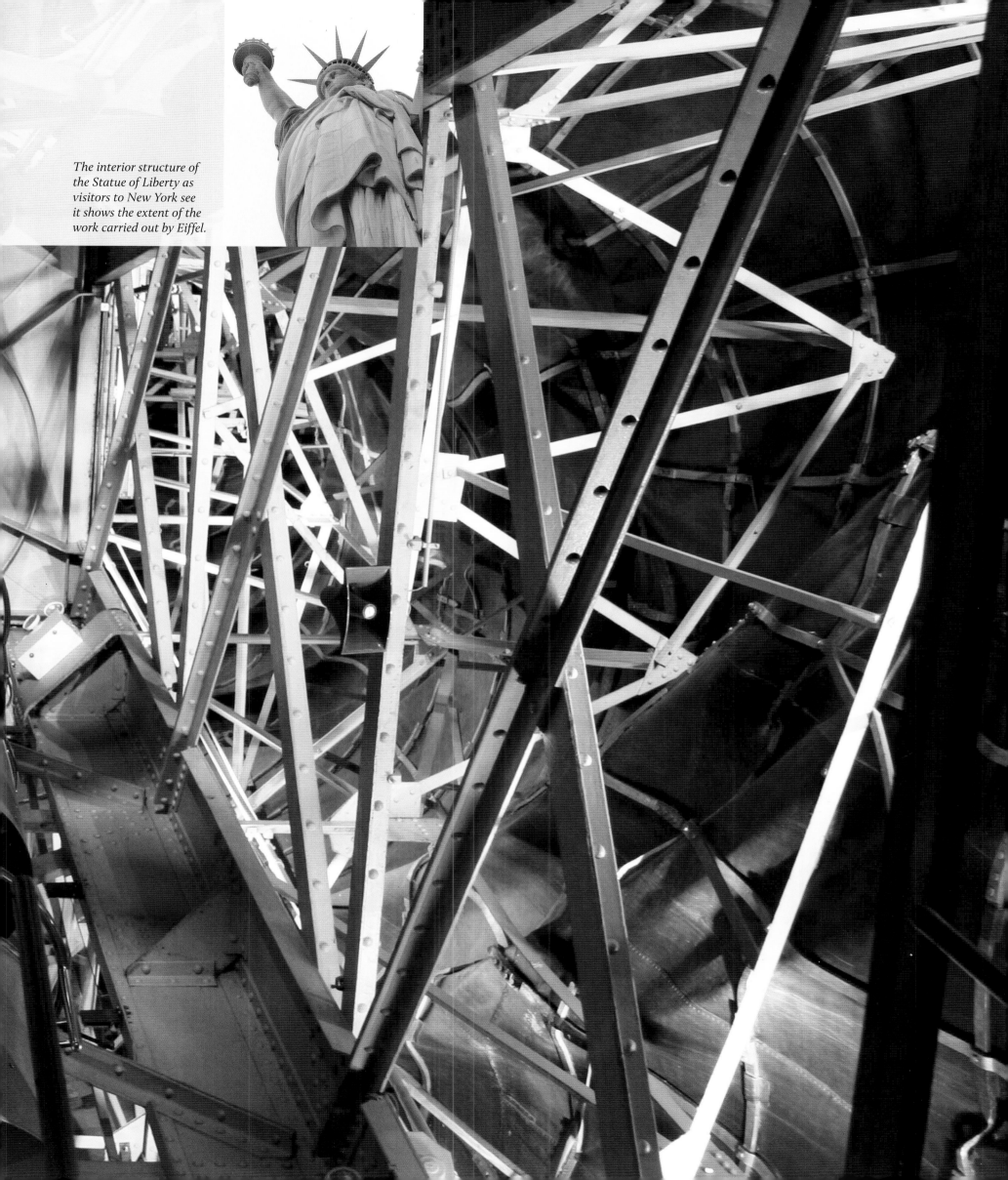

The interior structure of the Statue of Liberty as visitors to New York see it shows the extent of the work carried out by Eiffel.

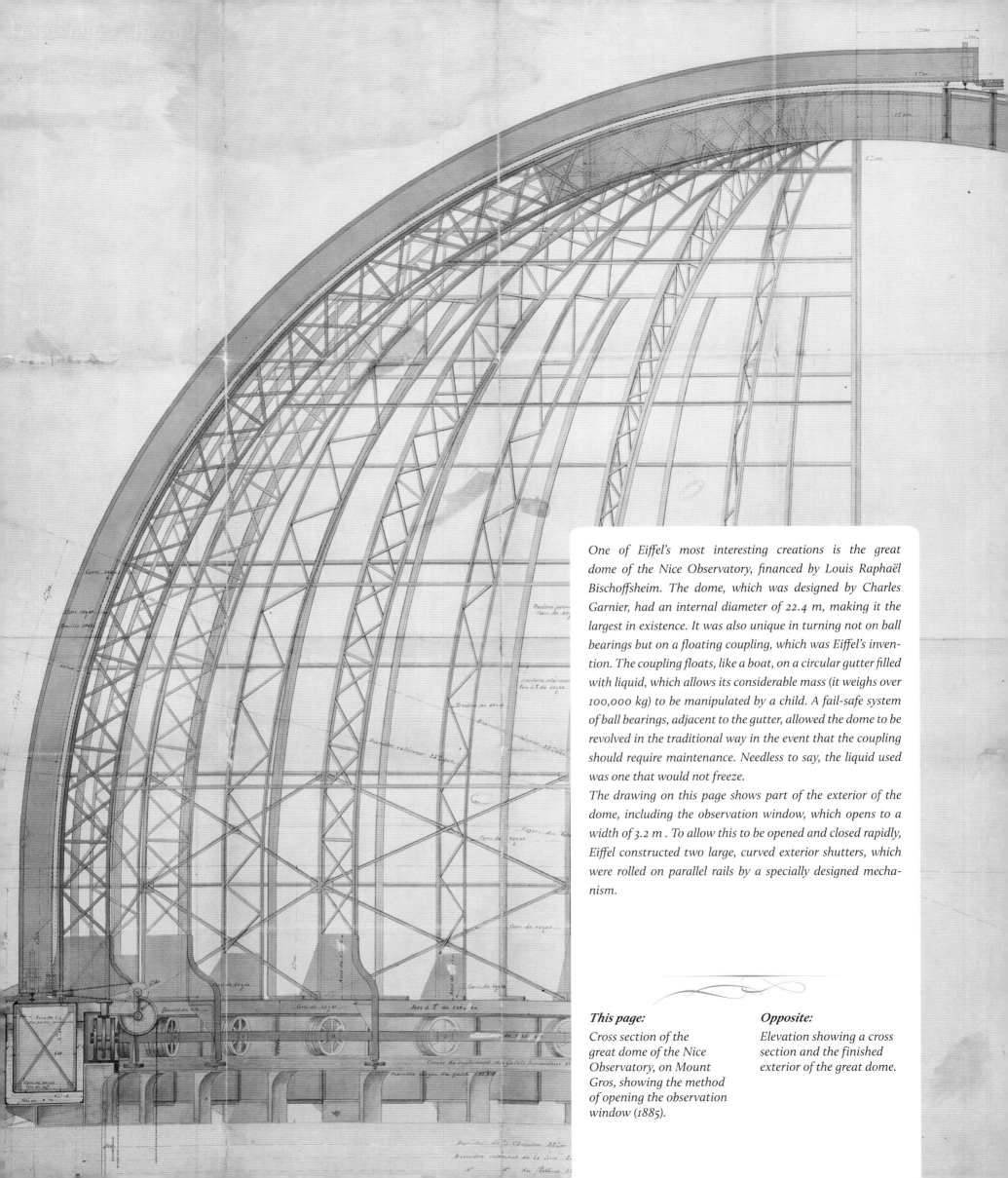

One of Eiffel's most interesting creations is the great dome of the Nice Observatory, financed by Louis Raphaël Bischoffsheim. The dome, which was designed by Charles Garnier, had an internal diameter of 22.4 m, making it the largest in existence. It was also unique in turning not on ball bearings but on a floating coupling, which was Eiffel's invention. The coupling floats, like a boat, on a circular gutter filled with liquid, which allows its considerable mass (it weighs over 100,000 kg) to be manipulated by a child. A fail-safe system of ball bearings, adjacent to the gutter, allowed the dome to be revolved in the traditional way in the event that the coupling should require maintenance. Needless to say, the liquid used was one that would not freeze.

The drawing on this page shows part of the exterior of the dome, including the observation window, which opens to a width of 3.2 m. To allow this to be opened and closed rapidly, Eiffel constructed two large, curved exterior shutters, which were rolled on parallel rails by a specially designed mechanism.

This page:
Cross section of the great dome of the Nice Observatory, on Mount Gros, showing the method of opening the observation window (1885).

Opposite:
Elevation showing a cross section and the finished exterior of the great dome.

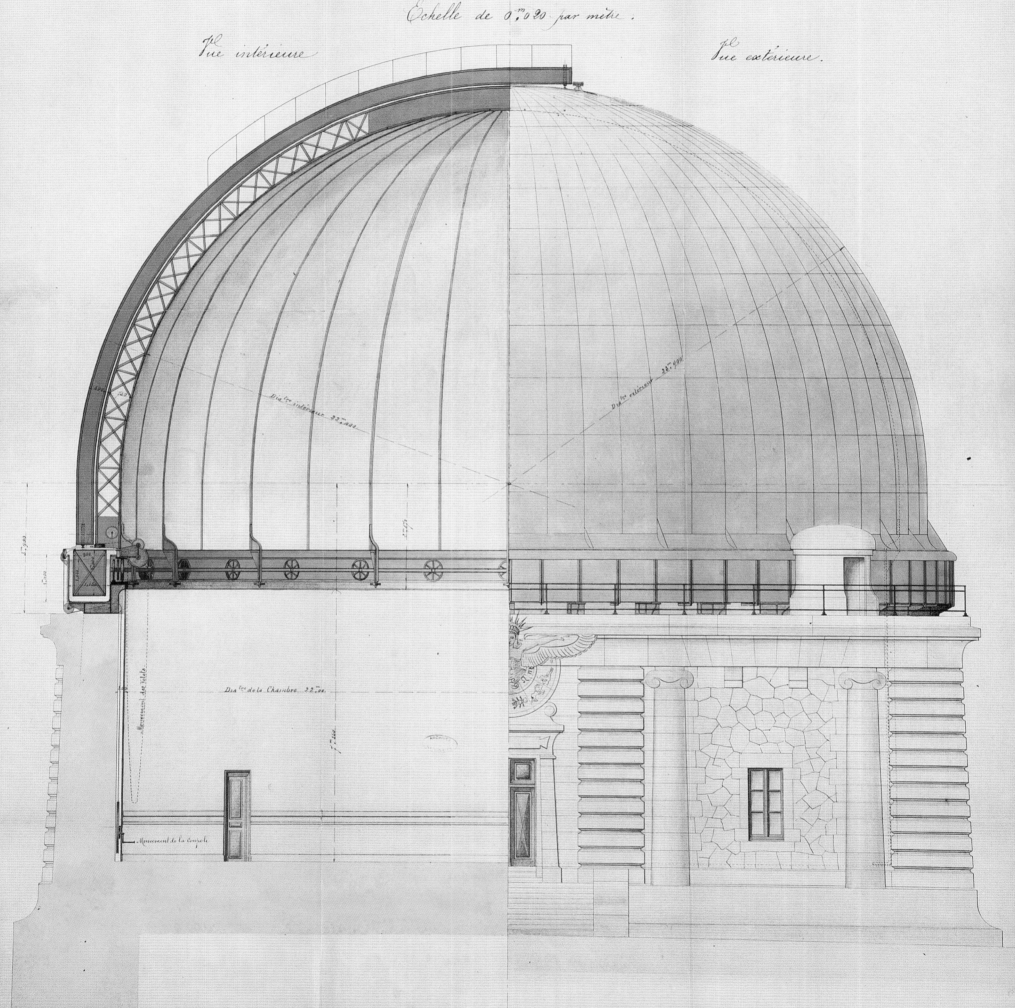

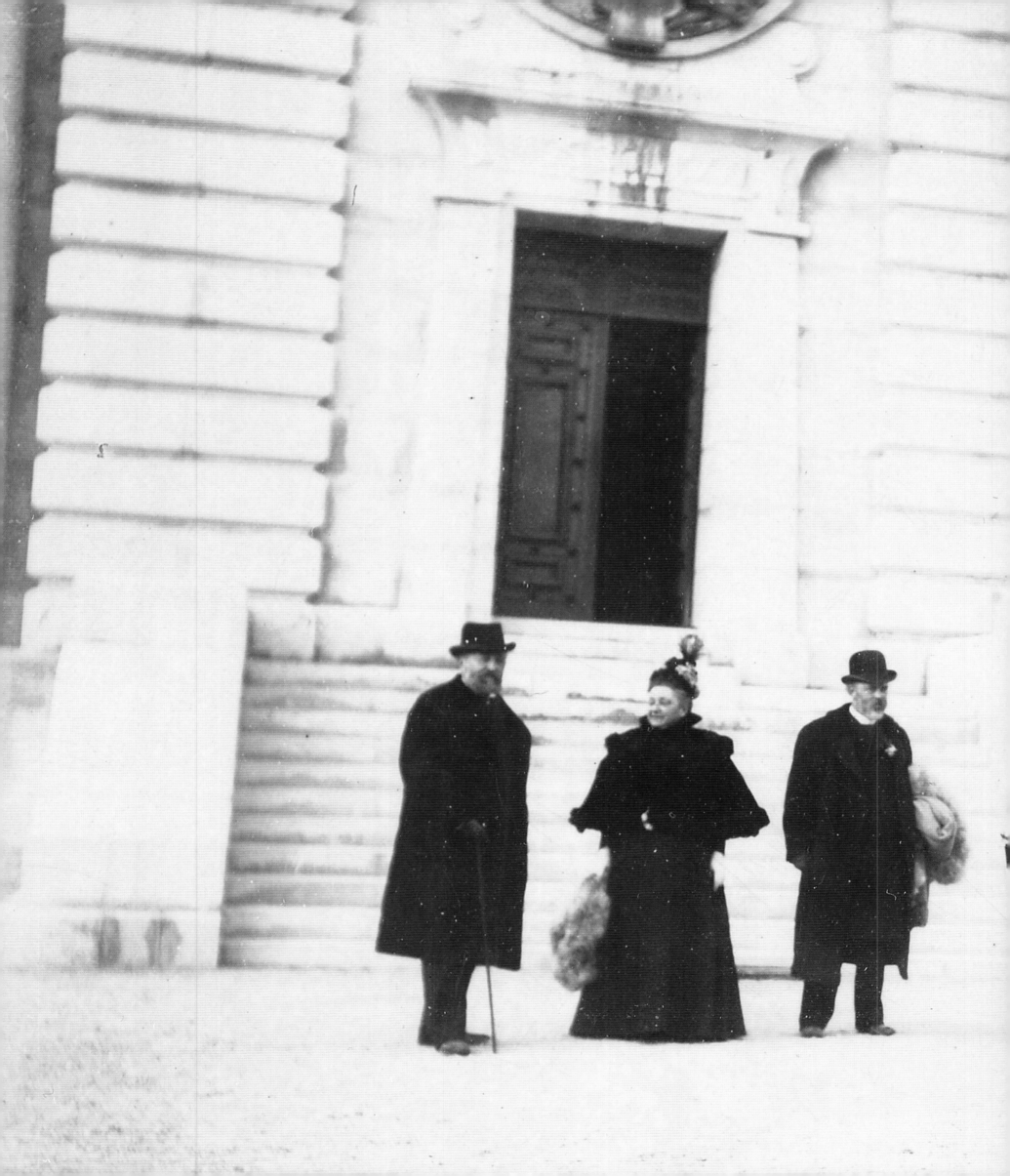

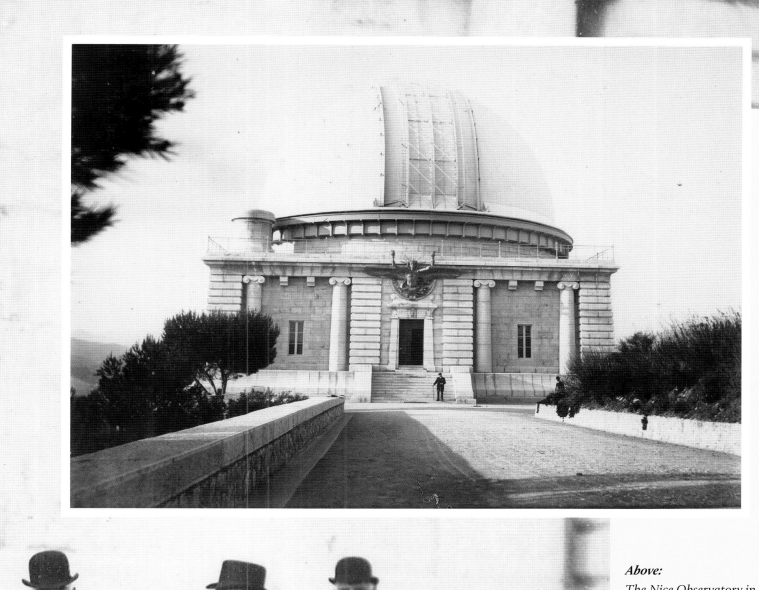

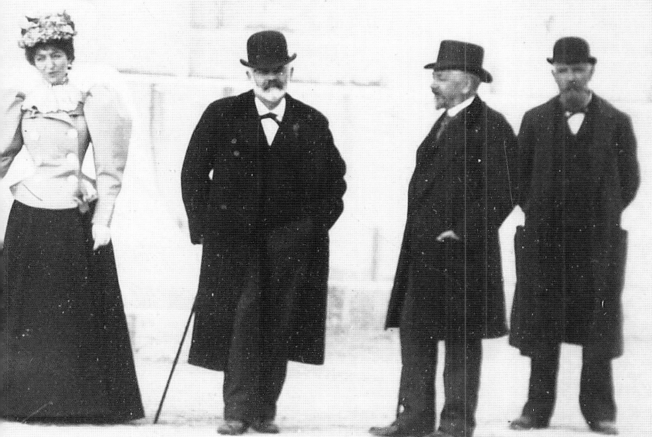

Above:
The Nice Observatory in 1896.

Main image:
Gustave Eiffel (second from right) in front of the Observatory in the same year.

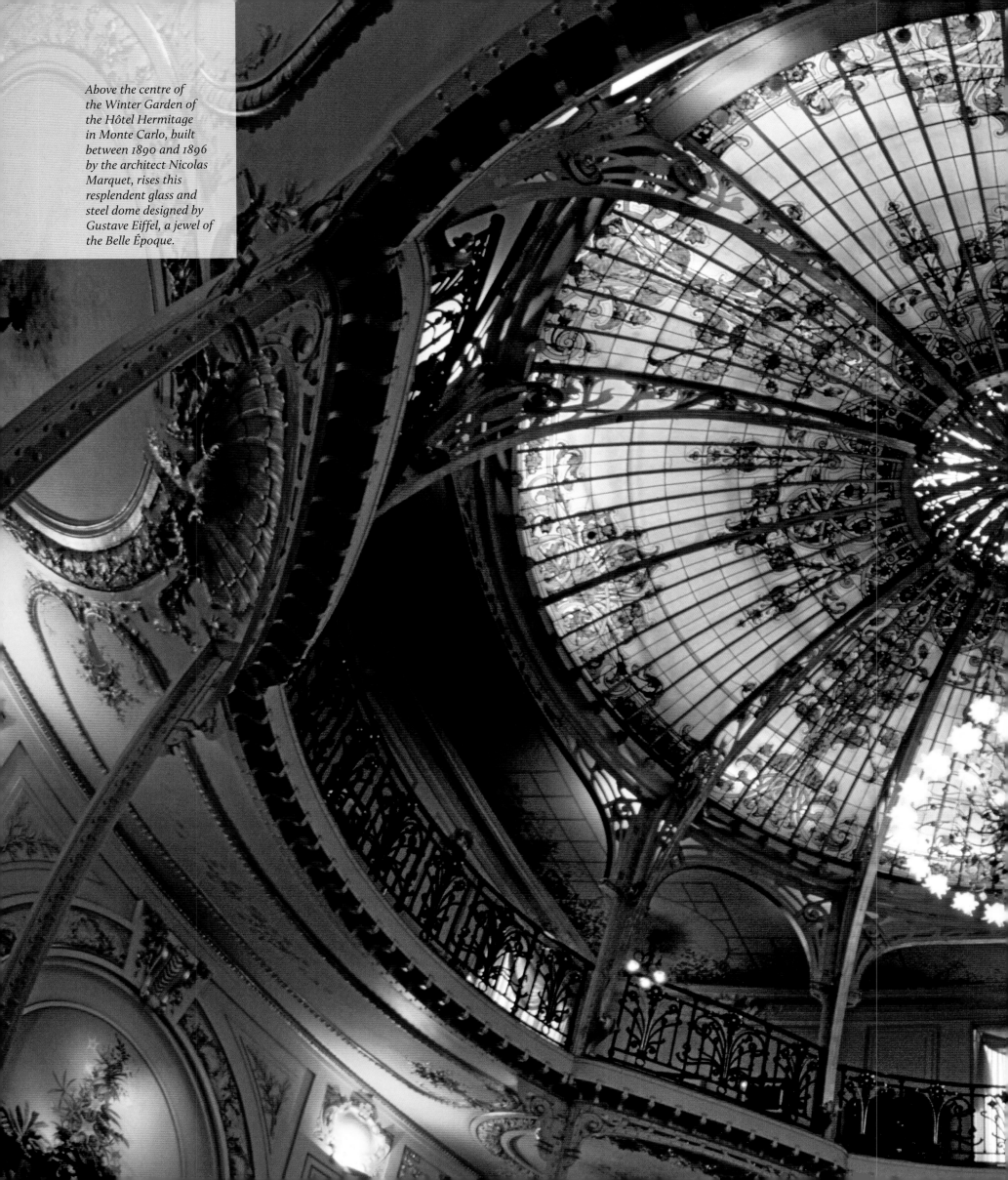

Above the centre of the Winter Garden of the Hôtel Hermitage in Monte Carlo, built between 1890 and 1896 by the architect Nicolas Marquet, rises this resplendent glass and steel dome designed by Gustave Eiffel, a jewel of the Belle Époque.

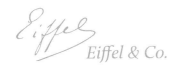
Eiffel & Co.

In 1884, Eiffel published a brochure promoting his "kit" bridges, which he had also patented. This invention is typical of the way Eiffel took an interest in all sort of problems, adopted a practical approach to them and devised not only imaginative but also solidly pragmatic solutions. In the case of his kit bridges, his thinking was far ahead of that of a certain Swedish furniture manufacturer. The component parts were stored in a warehouse so that they could be delivered, in crates, as soon as they were ordered. Moreover, the bridges could be put together by unskilled workers, using the instructions supplied. Making the bridge fit the space was simply a matter of assembling the requisite number of pieces. Either concrete slabs or rails could then be fixed to the bridge according to whether it was to be used for vehicles or trains. Eiffel's kit bridges therefore presented a quick, simple and inexpensive solution to communication problems, whether for the army or railway companies, in the colonies or in developing countries. They also proved highly profitable for Eiffel himself.

Right:
One of Eiffel's "kit" bridges, erected in the centre of a village in around 1890.

Below:
A train crossing a kit bridge, probably in the United States. This photograph, from Eiffel's private collection, may have prompted him to patent the idea.

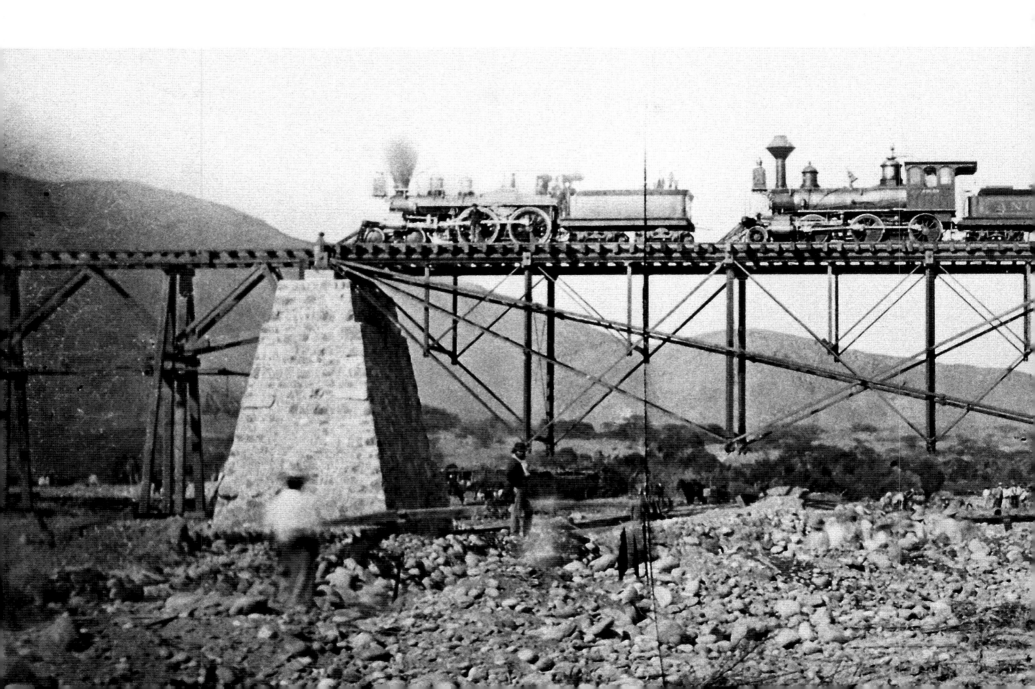

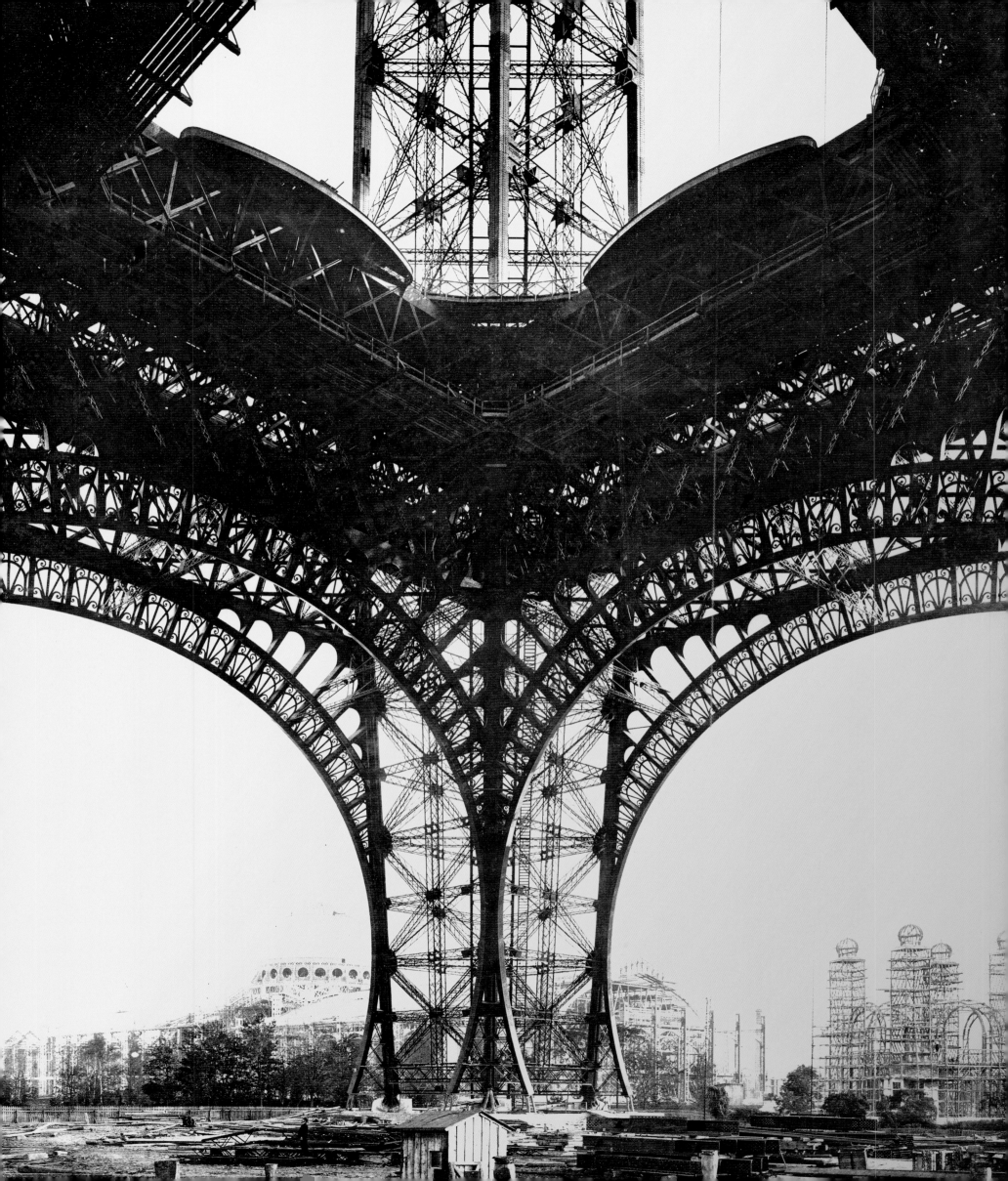

CHAPTER III

A 300-METRE TOWER

A petition against the construction of the Tower is signed by the leading artists of the day.
Eiffel's response: "We should be wary of the opinions of great men."

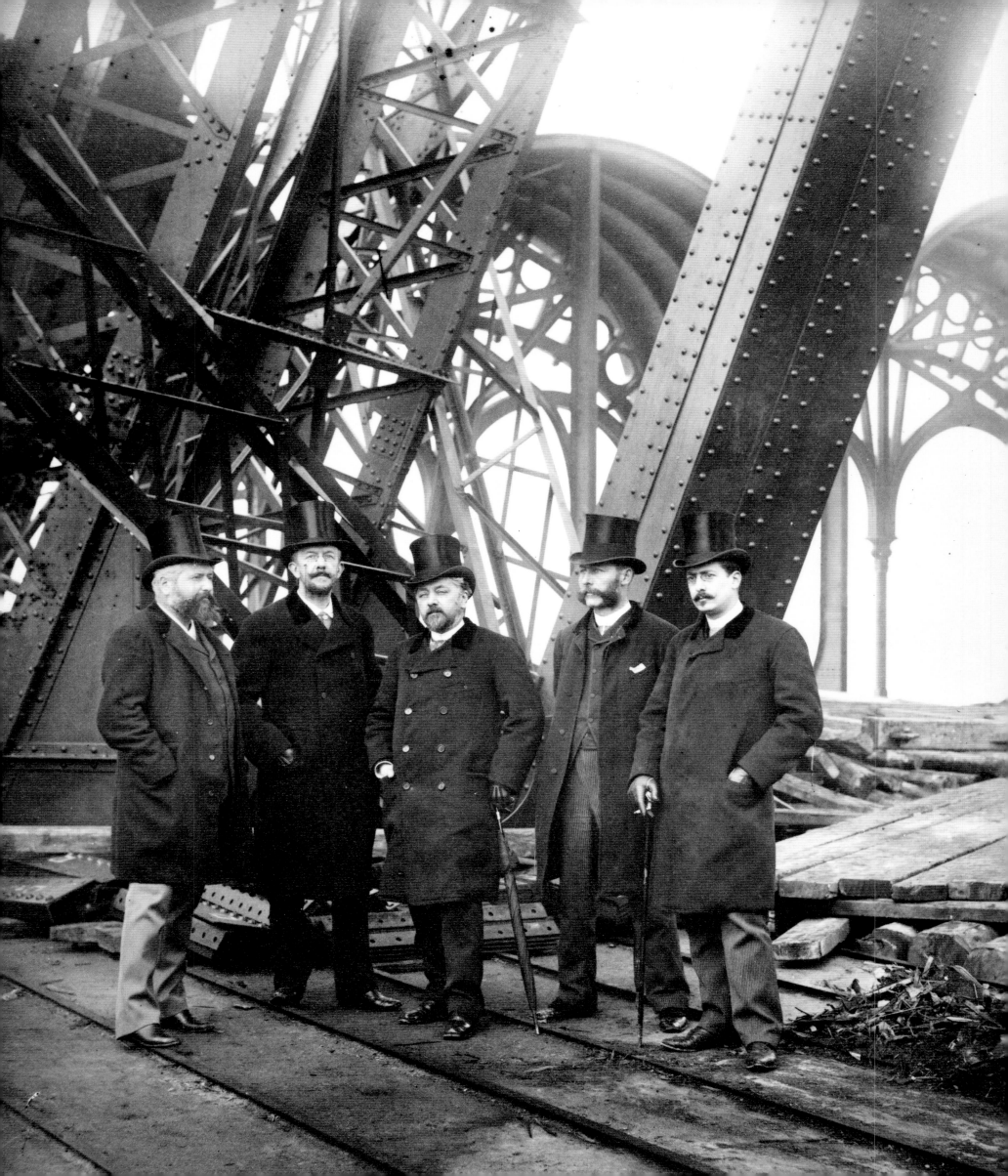

A 300-metre tower

Opposite:
From left to right: Ernest Sauvestre, Michel Angot, Gustave Eiffel, Arthuis Poirier and Adolphe Salles on the first-stage platform of the Eiffel Tower during construction.

Below:
The cast medal, dated 1893, which could be purchased by visitors as a souvenir of having reached the top of the Tower.

Bottom right:
Drawings from The 300-metre Tower *(1900), a two-volume work by Gustave Eiffel, showing the structure of the Tower in four sections of equal height.*

Into the wind

In around 1885, the French Government began to contemplate holding an Exposition Universelle in 1889, both to celebrate the centenary of the Revolution and to give a boost to the country, which had been debilitated by an economic crisis and a series of political scandals. Needless to say, Gustave Eiffel was invited to contribute to the project, and he asked his team of engineers to come up with an idea worthy of the occasion. Within days, two of them, Maurice Koechlin and Émile Nouguier, presented him with a design for a kind of gigantic metal pylon, 300 m high—this at a time when the world's highest structure was no more than 170 m. Eiffel pulled a face, pointing to the problems such a structure would inevitably present, but since it was the only proposal his engineers had put forward, he presented it to the Paris Council, which wanted something spectacular as well as novel. Koechlin and Nouguier then asked Stephen Sauvestre, Eiffel's chief architect, to develop their concept into something that would win him over. It was not long before Eiffel was convinced that this 300-metre Tower, as it was initially called, would constitute a fantastic ode to progress, the Republic and engineering—values that he held to be as solid as steel itself. The Tower could also be of scientific use as a laboratory for all sorts of experiments.

From then on, Eiffel put all his efforts behind the project, patenting his engineers' concept and tapping into his vast network of contacts in the engineering, financial and political worlds. The decisive backing came from Édouard Lockroy, Minister for Commerce and Industry, who fell in love with the idea of a 300-metre-high tower and did everything he could to promote it. The agreement he signed with the Prefect of the Seine district, Eugène Poubelle, and Gustave Eiffel entitled the latter to all the profits that would accrue from the construction of the Tower not only during the period of the exhibition itself but also for the following 20 years. After that, the City of Paris would become the beneficiary.

However, as always in France, things did not run smoothly, and the project ran into a wall of objections raised by a conglomerate of artists, writers, journalists and politicians, led by no less a figure than Charles Garnier, who denounced it as at once aesthetically sacrilegious, financially disastrous and environmentally damaging. The Tower was decried as both ugly and useless. It was the eternal dispute between traditionalists and modernists, between those who wanted a retrospective of the previous century and those who wanted to look forward to the coming century. As for the Parisians themselves, they took to the streets in an attempt to prevent the construction of an edifice they considered excessive, dangerous and offensive. Eiffel assured the Council that he would take responsibility for all eventualities, which greatly reassured them.

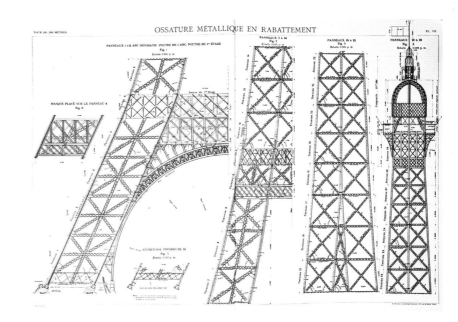

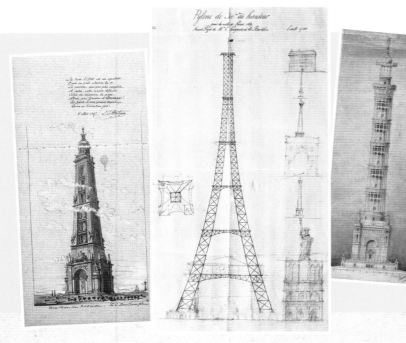

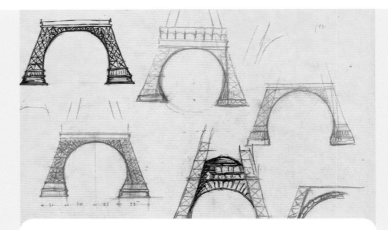

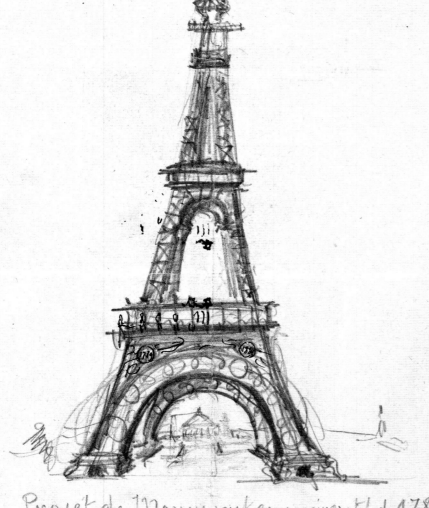

The Tower is Eiffel's principal achievement and stands as a symbol of strength and the surmounting of difficulties.

Its very construction was a marvel of precision, all the more so as its height was far greater than that of any building hitherto erected. It weighed no less than 7 million kilograms and cost some 8 million francs.

The Eiffel Tower, which was constructed on the Champ de Mars for the 1889 Exposition Universelle, was the exhibition's principal attraction, as it was for the 1900 exhibition. Millions of people from all over the globe came to see it, and models of it in every size and style can now be found throughout the world.

It is therefore unnecessary to describe the Tower and I shall give only a general outline of its history, importance and usefulness.

In 1886, in collaboration with Messrs Nouguier and Koechlin, both engineers with Eiffel et Cie, and its architect Mr Sauvestre, Eiffel submitted to Mr Lockroy, Minister for Commerce and general manager of the 1889 exhibition, a draft proposal for a 300-metre-high tower, accepting responsibility for its construction under strictly determined conditions regarding its cost and completion date.

After due consideration, this draft proposal was accepted and definitively agreed upon. According to the contract that was signed the following November by the Minister, the Prefect of the Seine district and Mr Eiffel, the last was to be awarded a grant of 1.5 million francs and granted the right to exploit the Tower for commercial purposes both for the duration of the exhibition and for 20 years from 1st January 1890. At the end of this period, the City of Paris, in lieu of the State with regard to the ownership of the monument after the exhibition, would acquire this right.

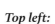

Top left:

A 300-metre-high Pylon for the City of Paris (1884), a draft proposal by Nouguier and Koechlin, flanked by two rival proposals: a tower designed by L. A. Boileau (left) and Jules Bourdais's gigantic lighthouse (right).

Above:

Studies for the Arches (ca. 1884), attributed to Ernest Sauvestre.

Left:

Gallia, Proposal for a Monument to Commemorate the Year 1789 (1884) by Koechlin, Nouguier and Sauvestre.

Right:
The Eiffel Tower Compared with the World's Highest Monuments (1889) by Deroy for the Revue illustrée.

Following pages:
After the Eiffel Tower project had been approved, another competition was launched, in 1886, for the design of the buildings that would surround it. This series of engravings shows several architects' proposals for other constructions to complement the Tower. The eventual layout did not exactly match any of these proposals. On the left are the winning proposals, on the right the runners-up, which included that of de Perthes, who envisaged the Eiffel Tower bestriding the Seine—an idea that proved technically impracticable.

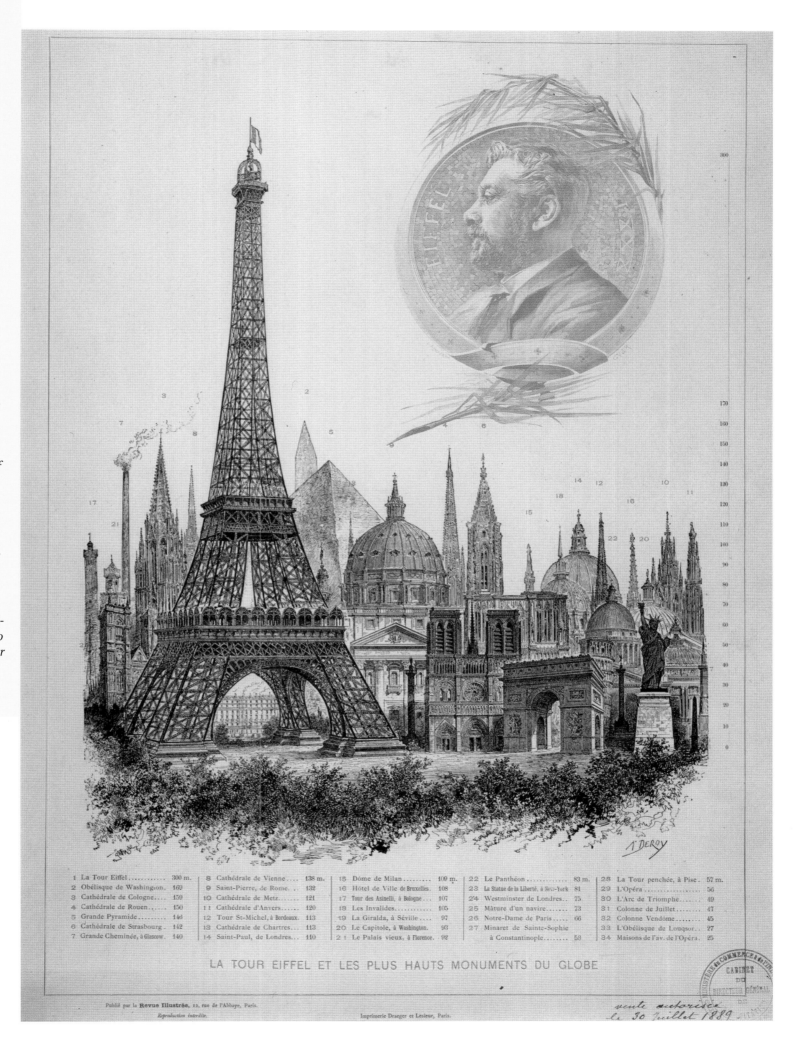

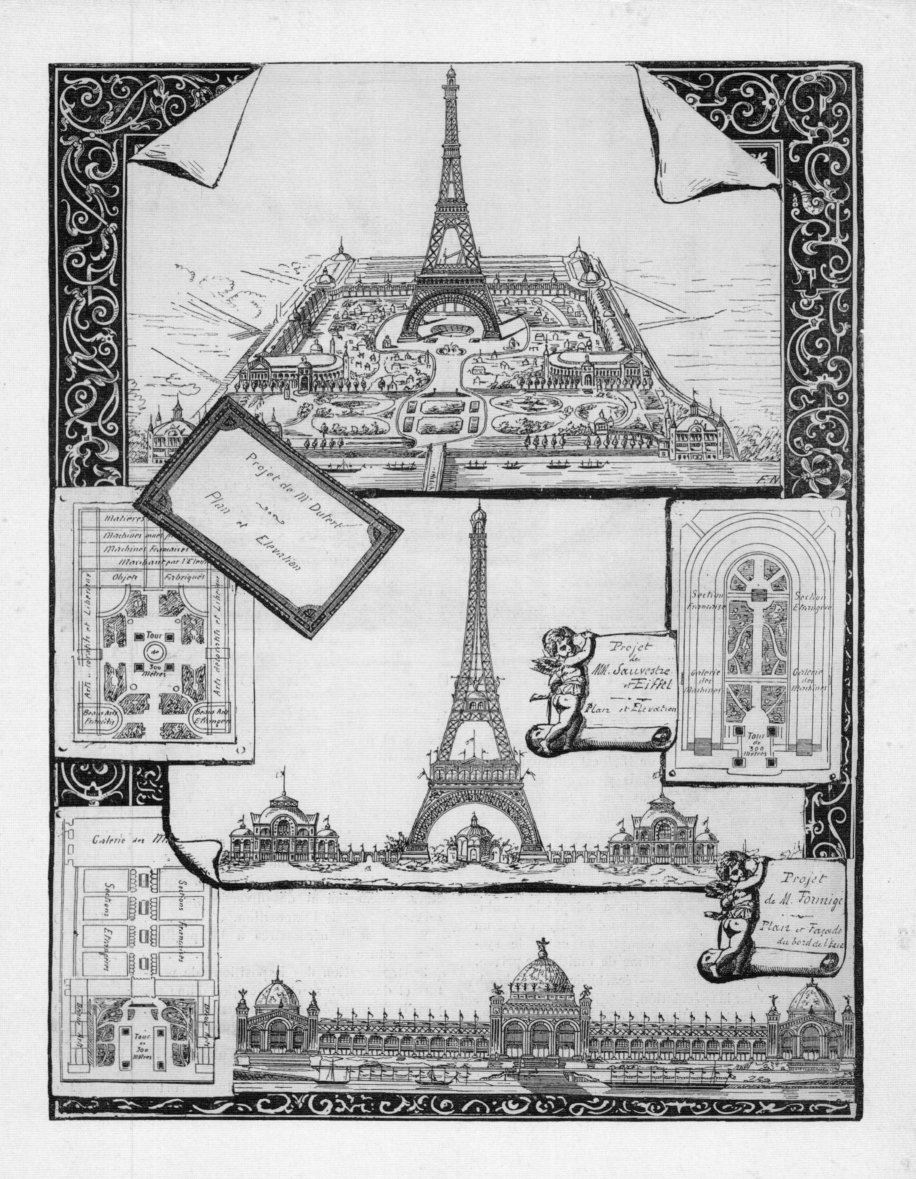

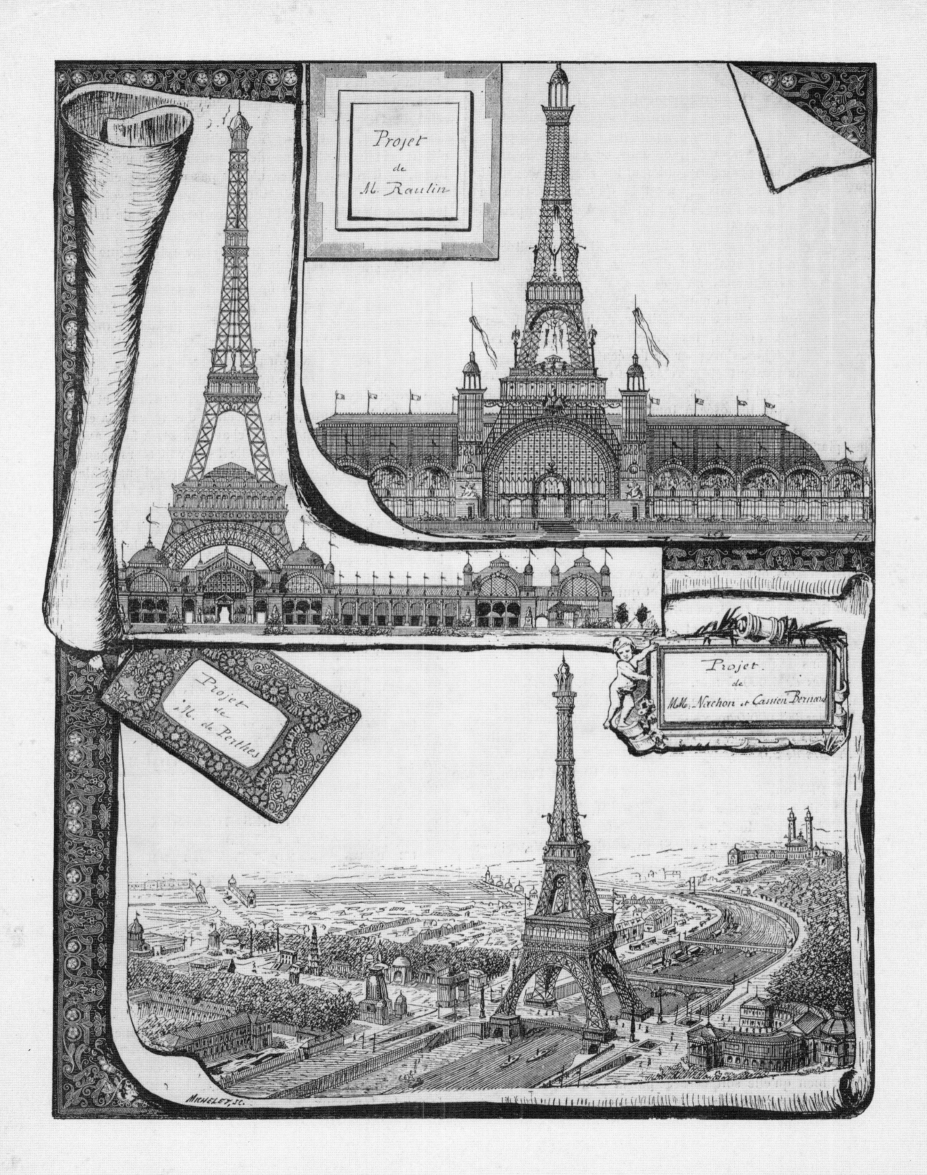

"I wanted to build a triumphal arch in celebration of modern science
and in honour of French industry,
an arch as striking as those dedicated by previous generations to the great conquerors."

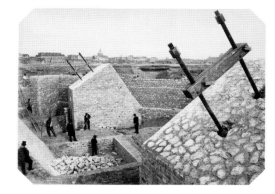
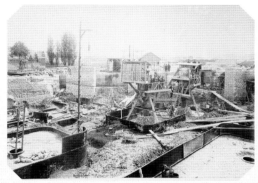
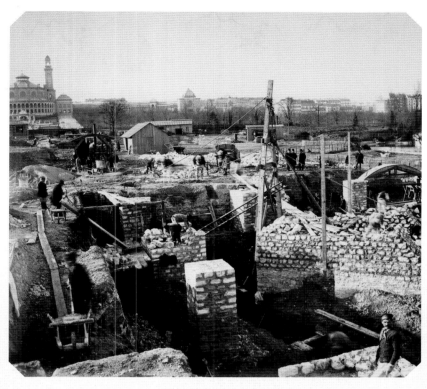
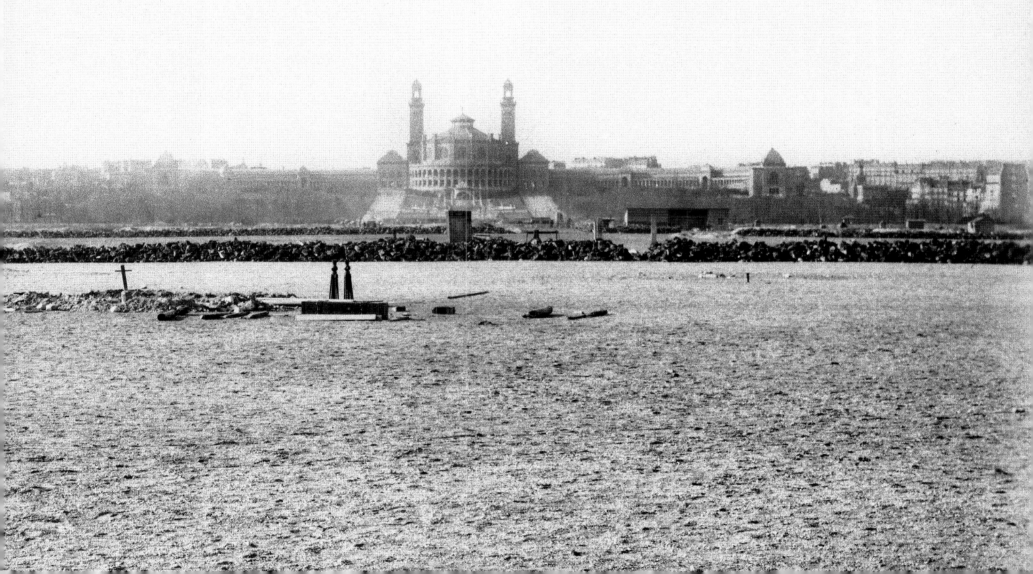

Below:
The Champ de Mars photographed by Pierre Petit in 1887, before work started on the Eiffel Tower.

Opposite page and left:
Construction of the Tower's foundations and stone pedestals.

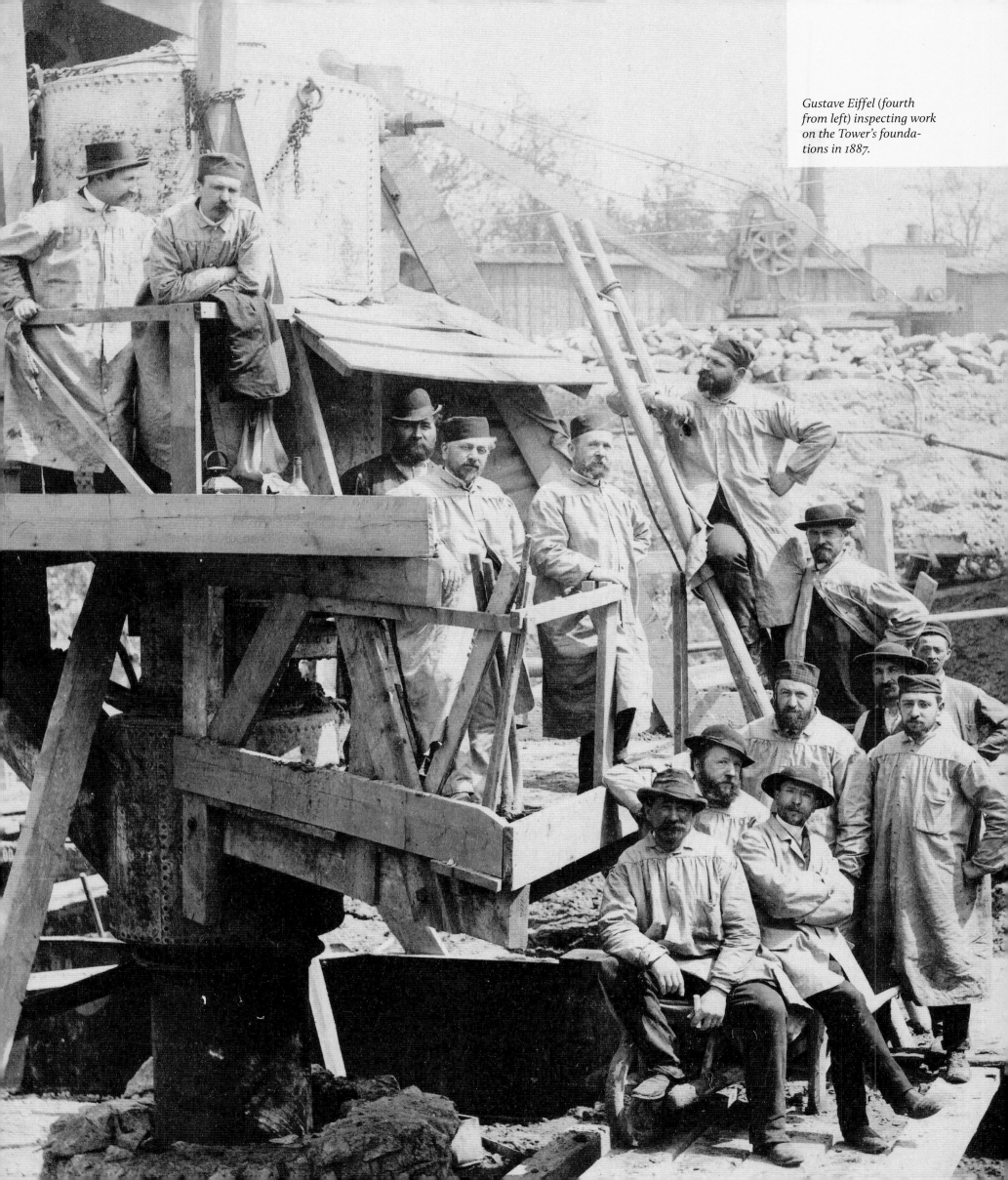

Gustave Eiffel (fourth from left) inspecting work on the Tower's foundations in 1887.

A 300-metre tower

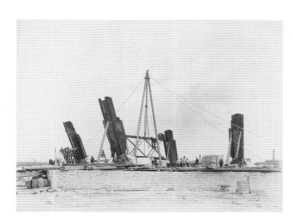
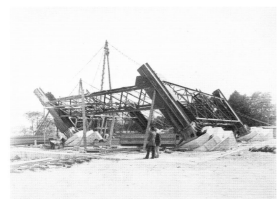
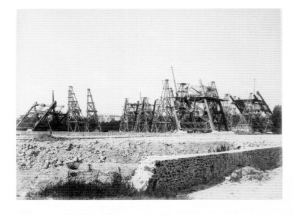
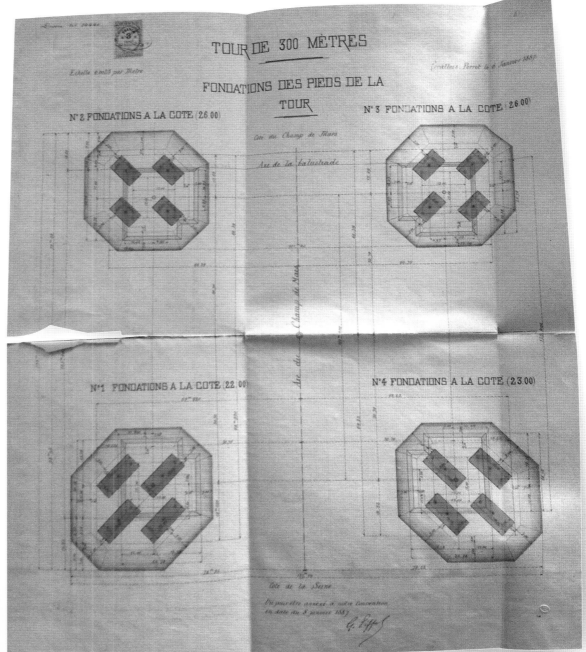
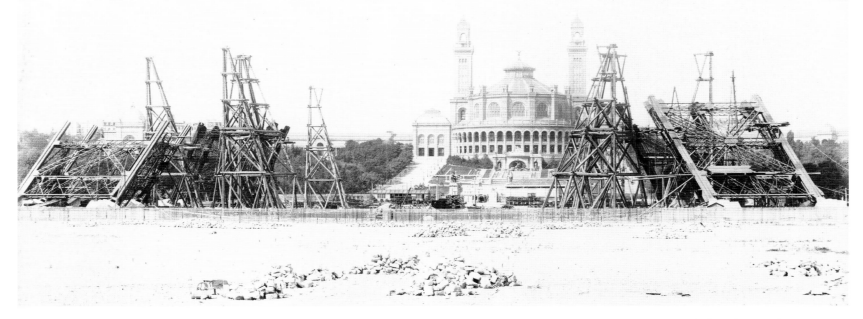

Above and top left: *Stages in the construction of the Tower's feet. The building in the background is the Trocadero Palace.*

Top right: *The plan of the layout of the Tower's foundations that was annexed to the contract.*

Work on the Tower began immediately, but before long Eiffel found himself having to face its critics, who always appear when ambitious plans designed to arouse excitement are on the point of being brought to fruition.

Thus it was that, quite apart from those sceptics who doubted that such a novel and grandiose undertaking could possibly be successful, a group of artists raised arms against the project. This insurgency gave rise to a preposterous letter addressed to Mr Lockroy by a number of well-known artists who had yielded to the entreaties of a lesser-known painter to join him in protest, most of whom came to regret having done so. Mr Lockroy's witty response gave him the last laugh. He had won the battle.

At the same time, the newspaper Le Temps published an abridged version of an interview with Eiffel by Mr Bourde in which the commercial value, usefulness and aesthetic merit of the 300-metre Tower were incontrovertibly asserted.

The success of the enterprise was thus assured and indeed turned out even greater than expected. It is hardly necessary to mention the significant part the Tower played in the 1889 exhibition, of which it became one of the principal attractions, and of which it made the most lasting impression on those who attended. If proof were needed, suffice it to say that the number of people who visited it came to a total of 1,968,287, generating a return of 5,919,884 francs.

The busiest day was Whit Monday, when there were 23,202 visitors, and the most profitable 9th September, when receipts amounted to 60,756 francs.

Background:

The original manuscript of the artists' petition against the Eiffel Tower, which was published in Le Temps on 14th February 1887. The signatories included Charles Gounod, Charles Garnier, Alexandre Dumas Jr, Leconte de Lisle, Charles-Marie-Georges Huysmans and Guy de Maupassant.

Pages 88–89:

Visitors to the construction site of the Eiffel Tower in 1888.

"What reasons did the group of artists give for their protest against the Tower? That it was a useless monstrosity! That it was an abomination! [...] I would very much like to know their justification for such judgments. For, may I remind you, Sir, no one has yet seen my tower and, until it is built, no one can tell what it will be like. It is as yet known only as a two-dimensional drawing, of which hundreds of thousands of copies have been printed. Since when has the artistic value of a monument been discernible from a two-dimensional drawing?

And if, when it is built, my tower turns out not to be a monstrosity, but a thing of beauty, will those artists not regret having so hastily and rashly mounted a campaign against the preservation of a monument that has yet to be constructed? Let them wait until they see it!

I shall tell you what I think, what I hope. I myself believe that my tower will be beautiful. Is it because we are engineers that we are thought to have no concern for beauty in our buildings and that in making them solid and durable we make no effort also to make them elegant? Are the visible constituents of strength not dependent on the abstract constituents of harmony? The fundamental principle of architectural aesthetics is that the shape of a building should be determined essentially by its function, with which it should be in complete accord. What factor, may I ask, have I had to consider above all others in the design of my tower? Its resistance to wind. I maintain, therefore, that the lines of the four pillars on which the building will stand will, if my calculations are correct, create a sensation of beauty, for they will make visible the power of my imagination.

Moreover, size has its own attraction, an appeal to which accepted aesthetic theories can hardly be applied. Who will claim that the pyramids have appealed so strongly to the human imagination on account of their artistic value? Are they not, after all, merely artificial mounds? Yet who can remain unmoved before them? Who, having seen them, is not filled with overwhelming admiration? And what is the cause of this admiration if not the colossal effort that they represent and the grandeur it has resulted in? My tower will be the tallest building ever constructed by man. Will it not therefore be equally grandiose? Why should what is admired in Egypt be hideous and ludicrous in Paris? I have asked myself this question and, I confess, have failed to find an answer.

The protestors claim that my tower will obliterate Notre Dame, the Sainte Chapelle, the Tour Saint Jacques, the Louvre, the cupola of the Invalides, the Arc de Triomphe and all our other monuments with its barbaric bulk. Quite an achievement for a simple tower! It is as much as one can do not to laugh. If one wishes to admire Notre Dame, one does so from the square in front of it. In what way could the Tower, on the Champ de Mars, obstruct such an admirer's view so that he could no longer see the cathedral? Besides, there is nothing more fallacious than the idea that a tall building obliterates all those around it. Is the Opera House obliterated by the surrounding houses, or they by it? Or does the Arc de Triomphe make the houses around the Étoile look smaller? On the contrary, the houses look precisely 15 metres tall, and it is hard to believe that the Arc de Triomphe reaches 45 metres.

Therefore, as far as the aesthetic consequences of the Tower's presence are concerned, no one can judge these in advance, not even I, who am astonished at the size of the foundations that have begun to emerge from the ground. As for its supposed detrimental effect on the capital's other monuments, this is pure conjecture."

An extract from Eiffel's response to the artists' petition (1887).

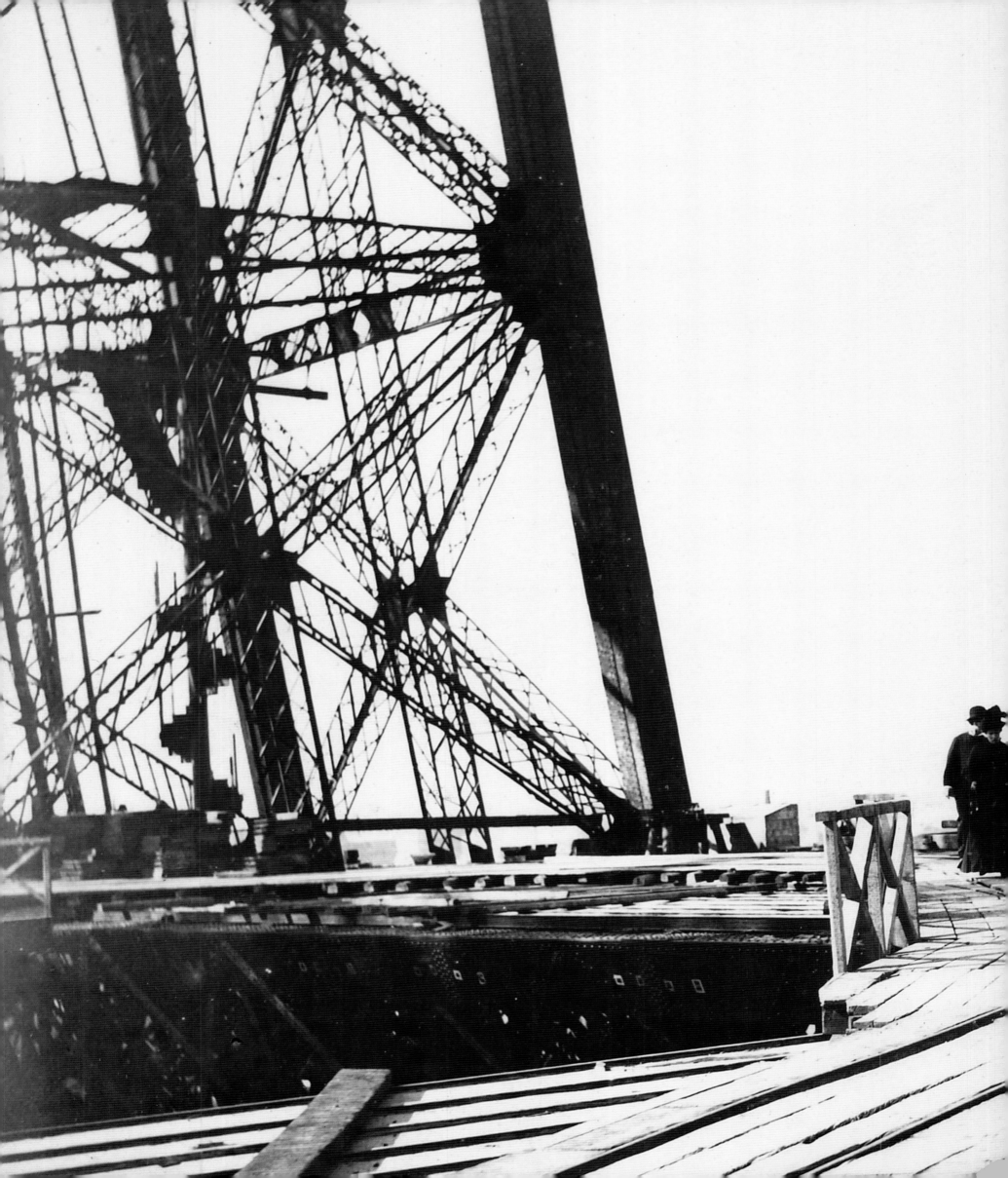

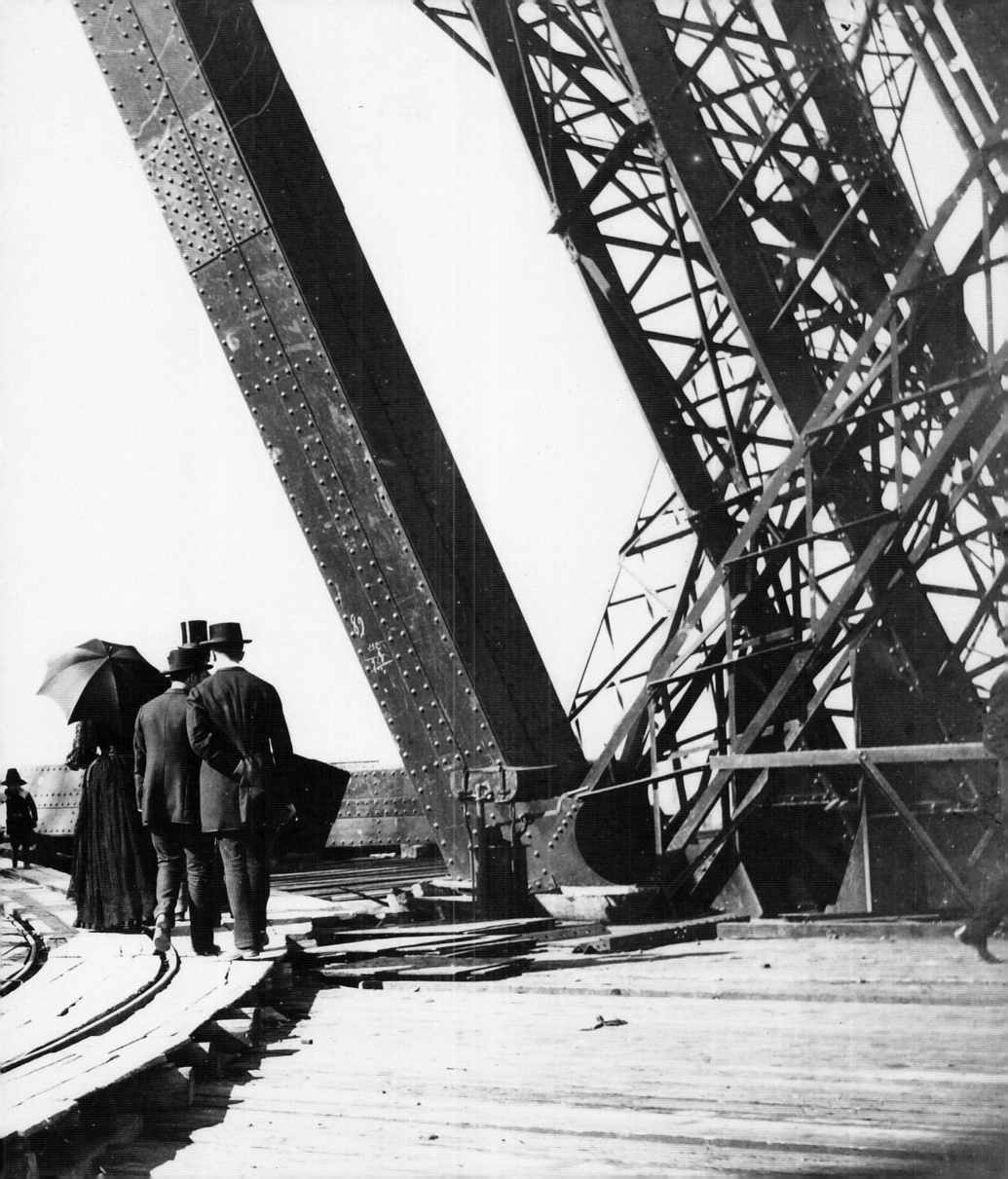

A 300-metre tower

Orchestrating the extraordinary

With his natural flair for publicity, Eiffel turned the construction site into a show, which both Parisians and foreign visitors came to admire. Even before it was finished, the 300-metre Tower became a spectacle. The workers themselves, who numbered between 150 and 250 at any one time, were so proud to be building the Tower that they worked in almost all weathers and progressed at remarkable speed. But in return for their efforts they demanded higher wages. Eiffel refused to listen, so they went on strike. After just three days, Eiffel backed down and granted them an increase. Site safety was exemplary; only one worker died, and that was after the Tower had been opened to the public—probably as a result of carelessness.

Progress was as steady as it was rapid, which meant that the work was completed on time, two years and two months after it had begun. On 31st March 1889, Eiffel himself planted the French flag at the very top of the enormous building, the traditional signal that the job had been completed. Eiffel turned this moment, too, into a PR exercise, inviting 150 celebrities, politicians, senior civil servants, journalists and friends, who all climbed up with him; the lifts had not yet been installed. Many gave up before they got there, and only about 40 completed the ascent. After climbing down again, Eiffel mounted a podium that had been set up for the occasion and made a speech in which he expressed his gratitude towards all those who had taken part in the project and his pride in their achievement.

From the very next day, 1st April, the Paris Council voted to give every worker a 1,000 franc bonus, and a month later Eiffel was made an Officer of the Legion of Honour by order of the President. He had reason to be proud: the Tower was the largest building ever constructed, weighing 7,000 tonnes (but exerting a pressure of just 2 kg per square metre at its base—merely half the pressure exerted by its architect when he sat in a chair); it consisted of 12,000 pieces and 2.5 million rivets, and had 1,792 steps. Every part of it had been manufactured in the factory at Levallois-Perret and, like a gigantic Meccano set, had been numbered before being brought to the site. To facilitate the operation of the restaurants on the first-stage platform, Eiffel designed a system of waste pipes concealed within the structure, which would subsequently be adopted by a large number of other architects. The height of the Tower could vary by as much as 20 cm according to the temperature, but even the strongest wind would not cause the top to move by more than 6 cm. It had cost some 8 million francs, 1.5 million consisting of a grant and the remaining 6.5 million having been borne by Eiffel et Cie itself. Gustave took advantage of his position by making his creation into his personal pantheon: he had the names of the 72 most notable people of the previous century inscribed in gold letters around the perimeter of the first-stage platform.

Below:
An engraving depicting a group of people including Gustave Eiffel planting the French flag at the top of the Eiffel Tower to signal its completion on 31st March 1889. "The French flag is the only one to have a 300-metre staff," Eiffel would boast.

Bottom of page:
Drawing of the first-stage platform showing the side facing the École Militaire, with 18 of the 72 names of notable people chosen by Eiffel to decorate the balcony.

Opposite:
Above, painting the Eiffel Tower: a high-risk job.

Below, politicians, journalists and friends whom Eiffel invited to the opening of the Tower on its first-stage platform.

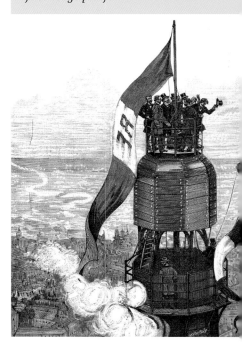

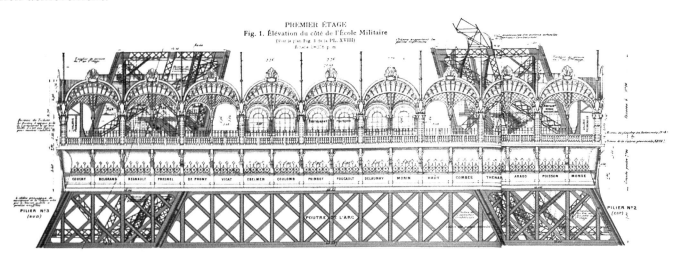

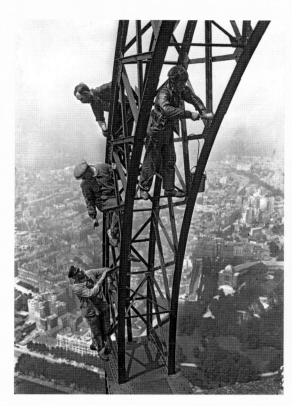
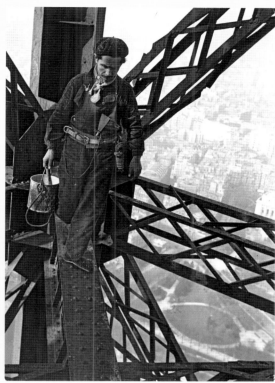
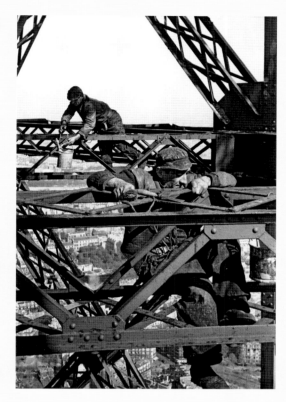

"My concept had two powerful advocates, which are still sympathetic to it: the patronage of men known for their great wisdom and the irresistible force of public opinion."

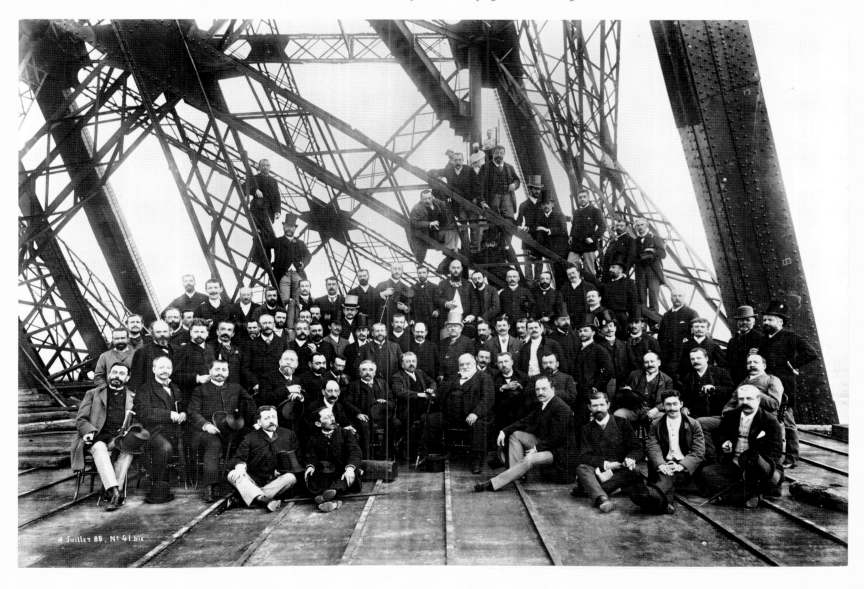

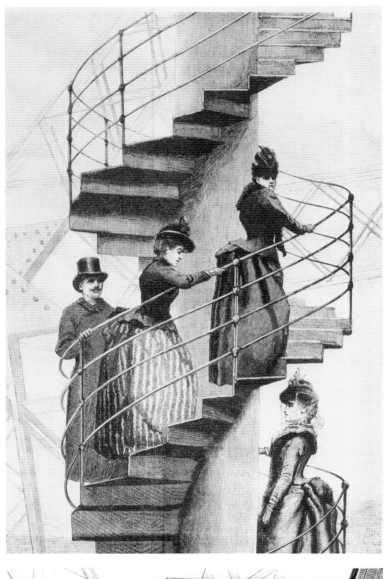

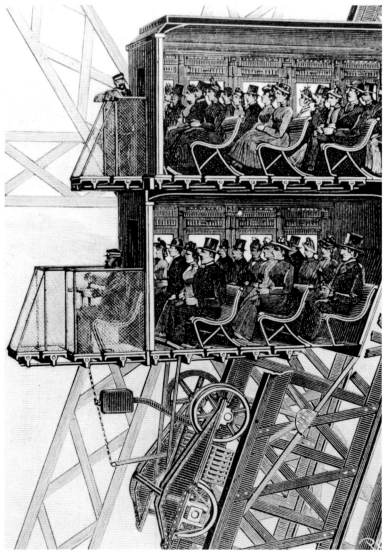

Above: A Flemish restaurant, between the north and west pillars, was turned into a theatre after the 1889 exhibition, then into a "Dutch" restaurant in 1900. It later became a theatre again and was demolished in 1937, to make way for... a restaurant.

Left: Above, an engraving showing intrepid visitors climbing the staircases before lifts were installed.

The Exposition Universelle began on 6th May but it was not until 15th May that the Tower was opened to visitors, as the interior had yet to be finished and the lifts had not been installed. These came into service one by one: the first stage on 27th May, the third on 13th June. This did not deter early visitors, who scaled the Tower on foot. In the first week alone, almost 30,000 of them braved the stairs and muscled their way to the top. By the end of the exhibition, on 30th November, some 2 million people had visited the Eiffel Tower, which no one dreamed of calling "the 300-metre Tower" any longer. The receipts for the year 1889 alone were sufficient to cover the capital invested in the Tower's construction.

Below: An engraving by Louis Poyet showing a cross section of the lift to the top platform in 1889. Each tier measured 14 m² and could hold up to 65 people, seated on benches and swivelling seats.

Below: A graph showing how the number of visitors to the Tower varied between 1889 and 1973 according to events such as the development of radio and television.

Right: Above, the second-stage staircase (357 steps).
Below: The second-stage lift, built by Fives-Lille.

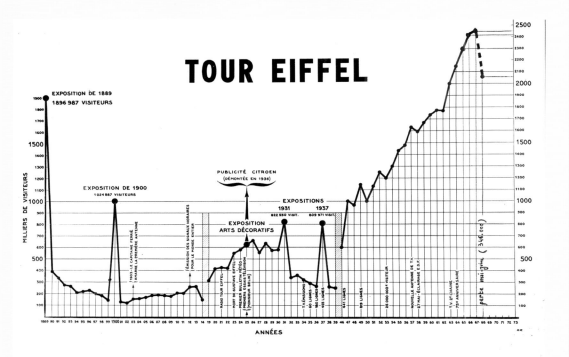

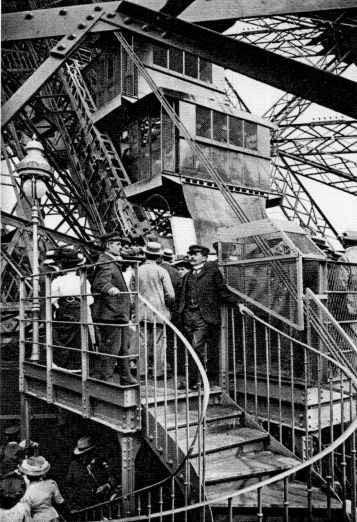

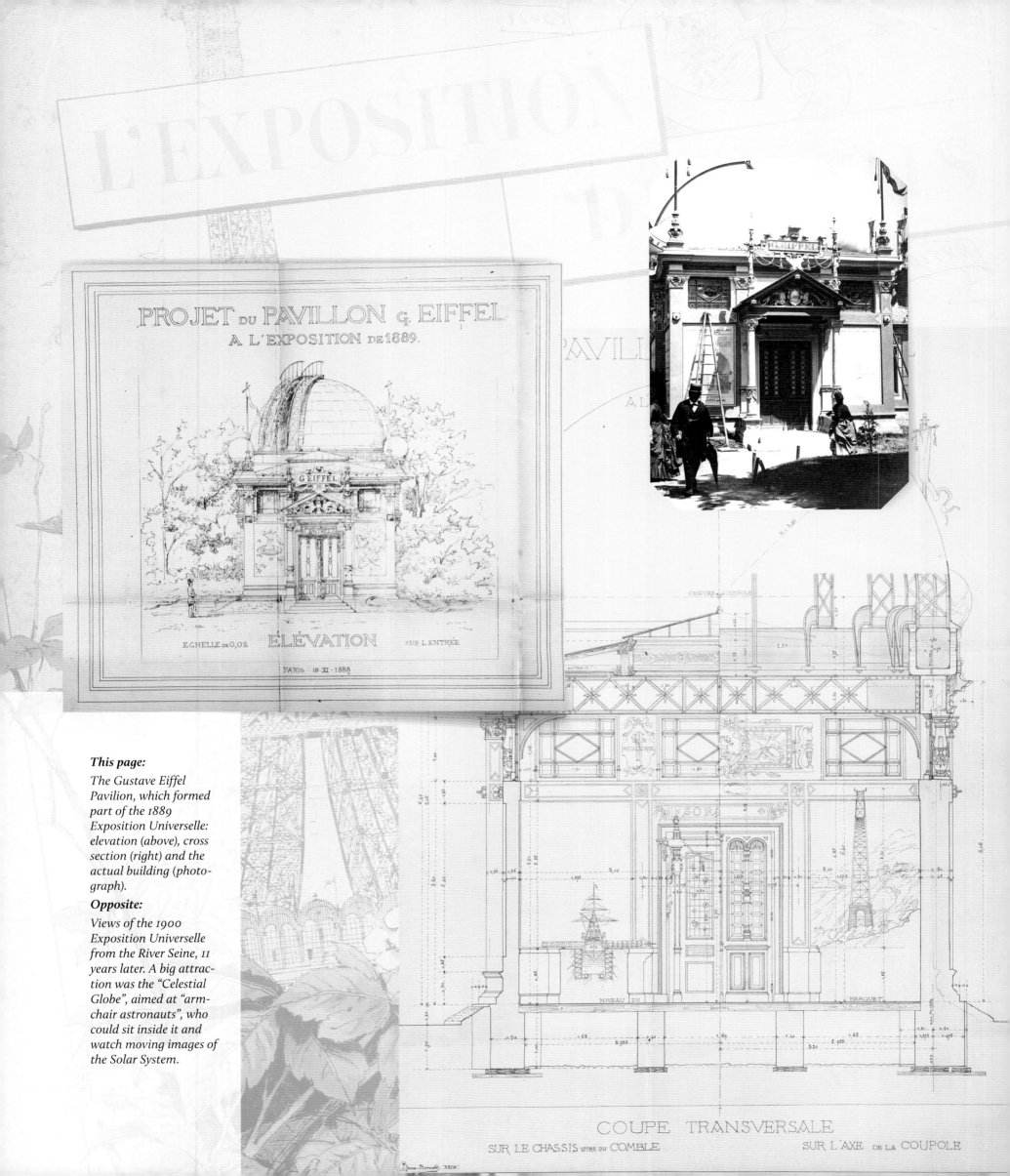

This page:
The Gustave Eiffel Pavilion, which formed part of the 1889 Exposition Universelle: elevation (above), cross section (right) and the actual building (photograph).

Opposite:
Views of the 1900 Exposition Universelle from the River Seine, 11 years later. A big attraction was the "Celestial Globe", aimed at "armchair astronauts", who could sit inside it and watch moving images of the Solar System.

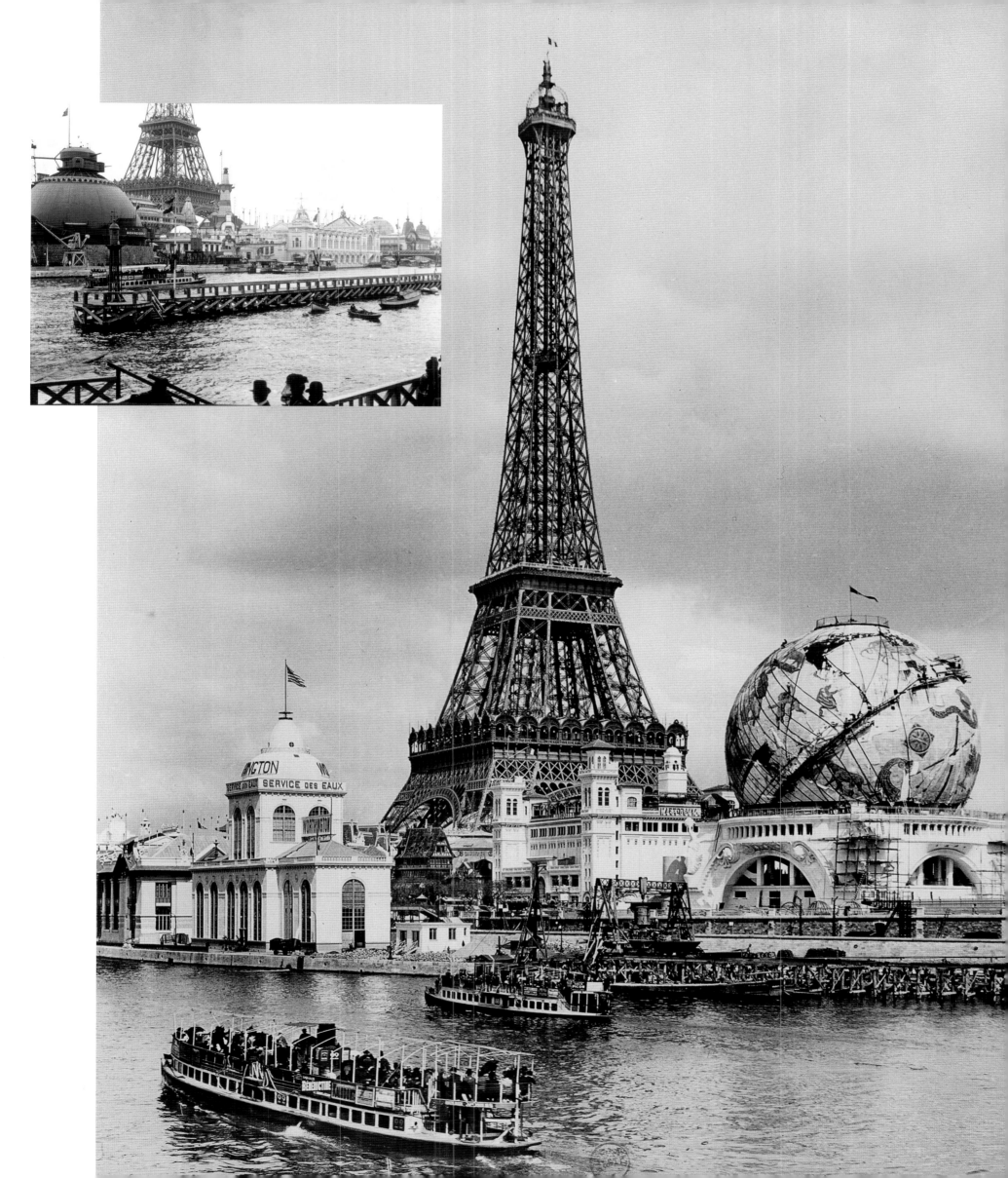

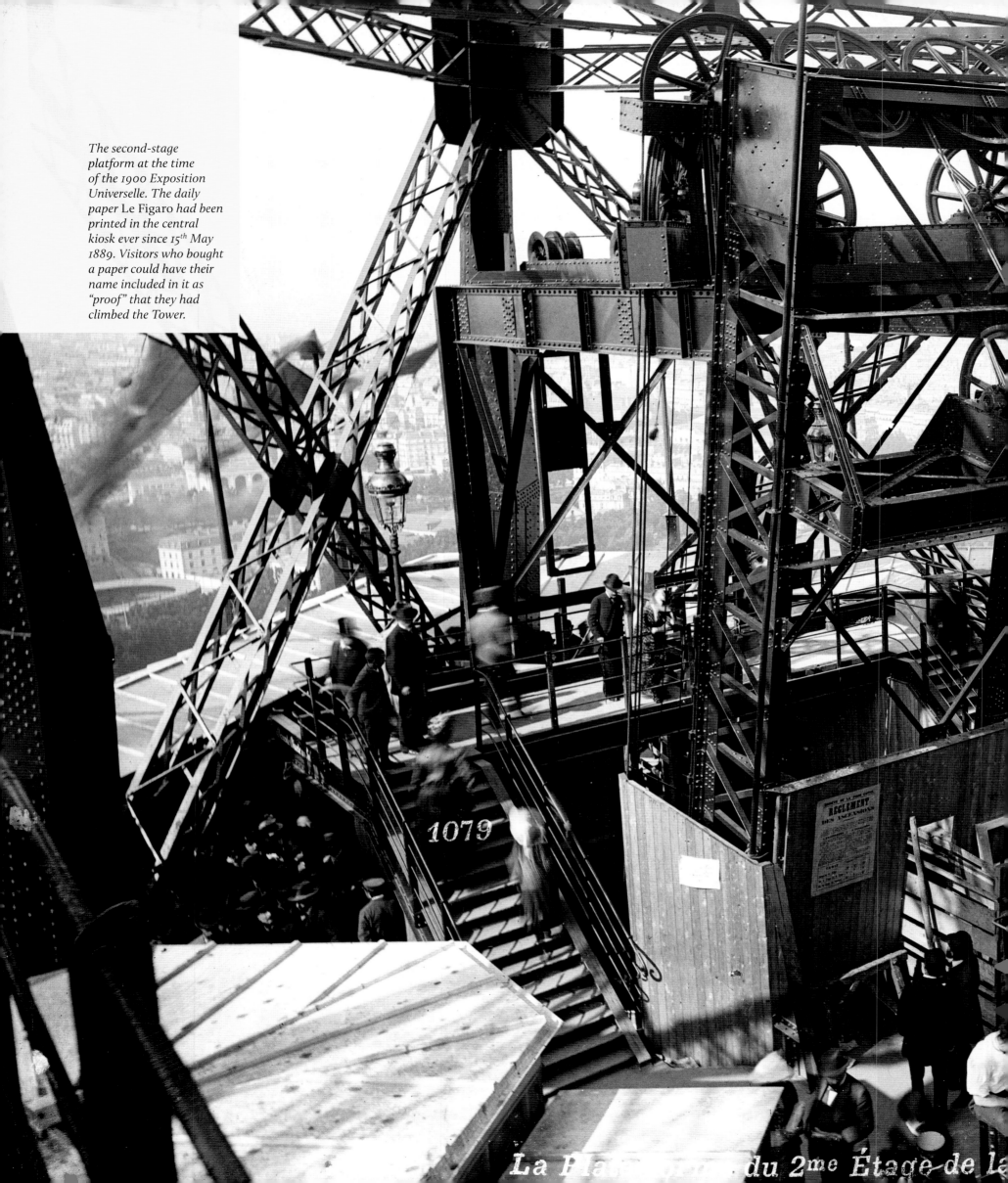

The second-stage platform at the time of the 1900 Exposition Universelle. The daily paper Le Figaro *had been printed in the central kiosk ever since 15th May 1889. Visitors who bought a paper could have their name included in it as "proof" that they had climbed the Tower.*

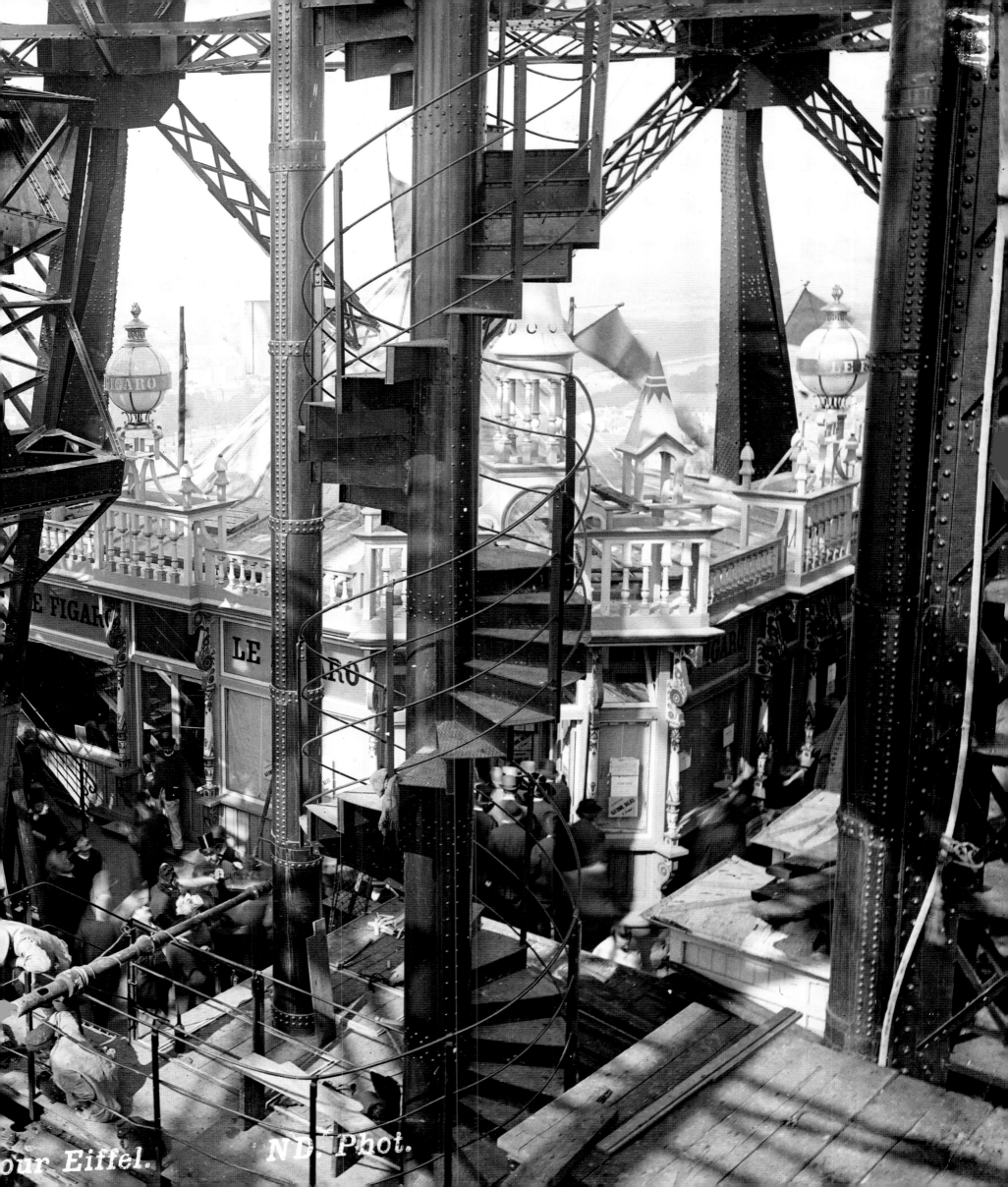

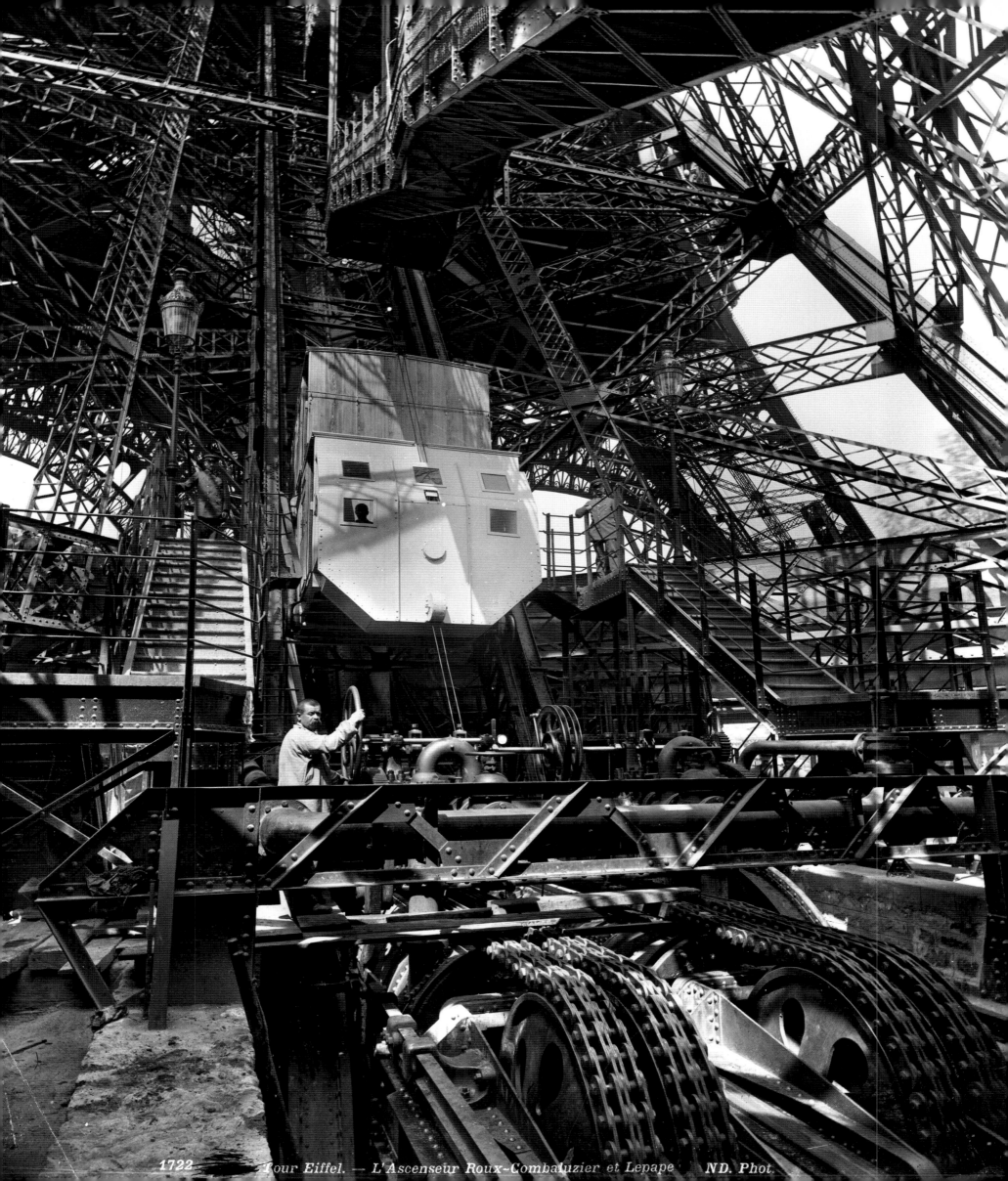
1722. Tour Eiffel. — L'Ascenseur Roux-Combaluzier et Lepape ND. Phot.

A 300-metre tower

Opposite:
One of the lifts built by Roux-Combaluzier et Lepape installed in the east and west pillars, which took visitors to the first-stage platform, photographed in 1900.

Below:
On the very day the Tower opened, Valentine Eiffel asked its most distinguished visitors to sign her fan, which she gave to her father as a souvenir.

Eiffel hardly left the Champ de Mars for the next month, as he wanted to personally greet the Tower's many distinguished visitors: Bartholdi, Buffalo Bill, the Prince of Wales, King George I of Greece... But, for Eiffel, by far the most important was the American inventor Thomas Edison, in whose honour Eiffel organized a "concert" on an Edison phonograph in his private apartment on the top platform. A few days later, Edison returned for the Society of Civil Engineers' lunch in the Restaurant Brébant. The composer Charles Gounod, at another table, was asked if he would honour his eminent host with an improvised recital, which also took place in Eiffel's handy apartment. And the visit by Prince Baudouin, nephew and heir to the throne of King Leopold II of Belgium, was the occasion for a technological first: a telephone connection with a foreign city, from the top of the Tower.

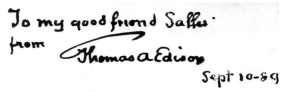

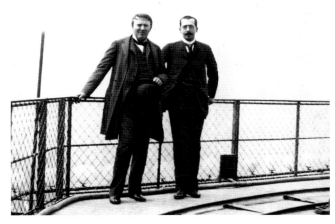

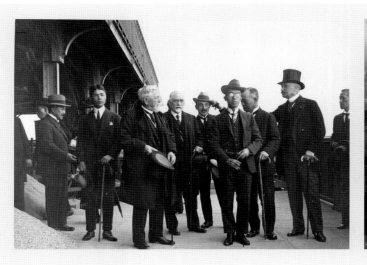

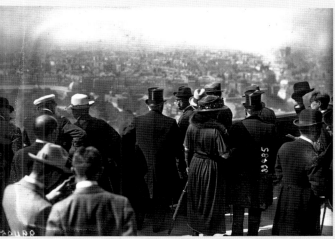

Above:
Thomas Edison visited the Eiffel Tower on 10th September 1889 and is seen here with the engineer Adolphe Salles, Gustave Eiffel's son-in-law (right), to whom he presented one of his famous Class M phonographs.

Left:
Gustave Eiffel giving Prince Hirohito a private guided tour of the Tower in June 1921.

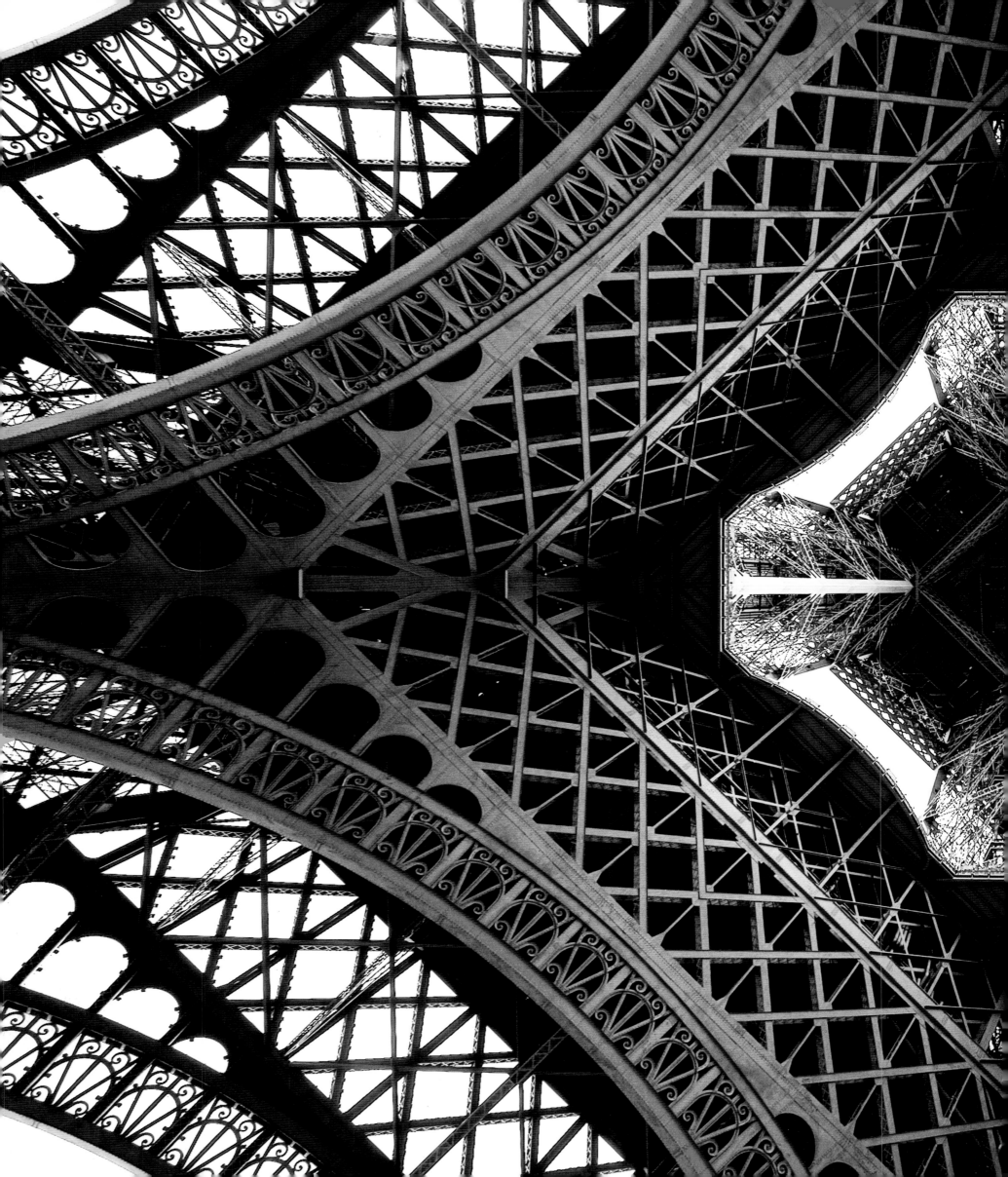

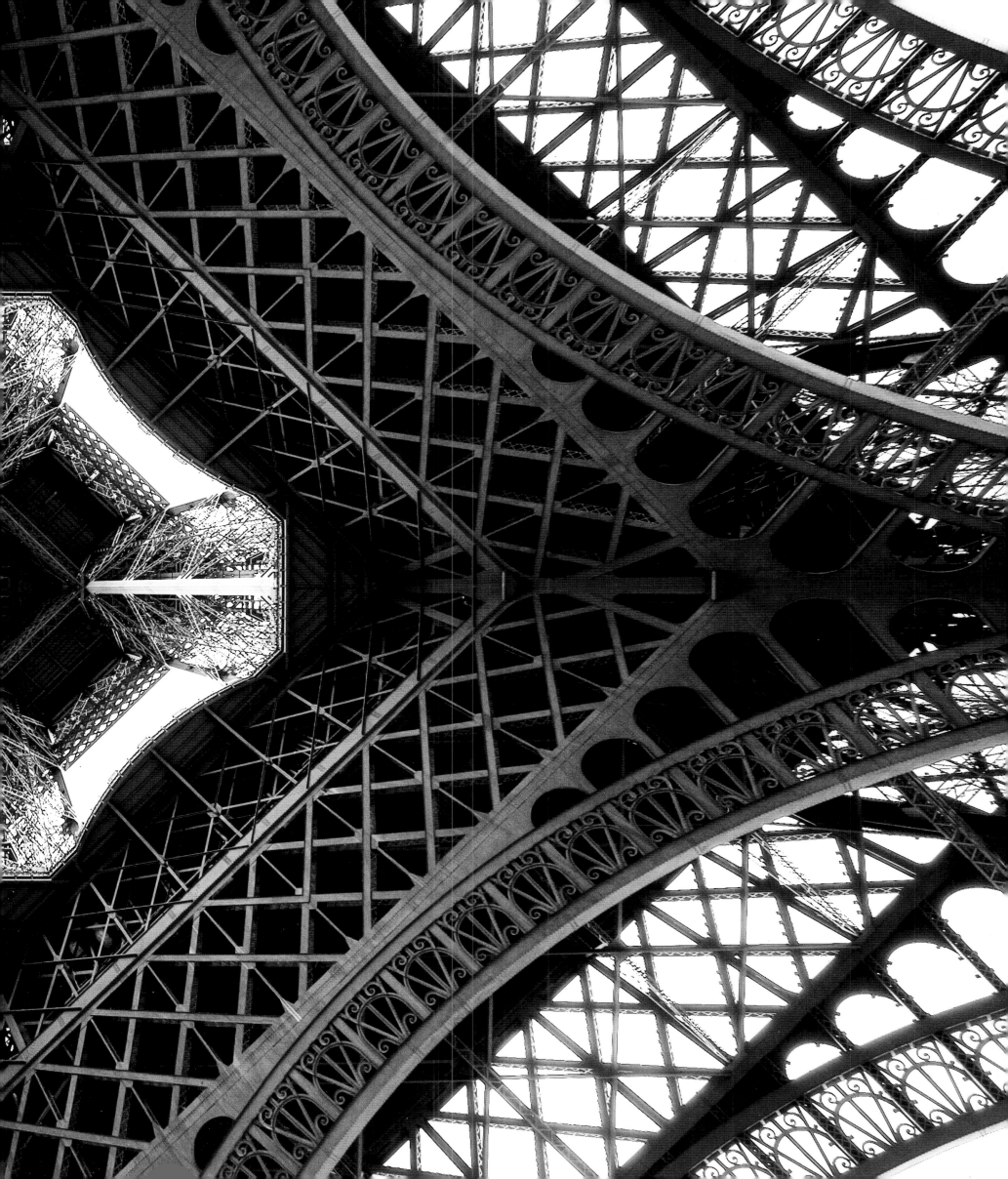

Eiffel
A 300-metre tower

Boosted by the triumph of his 300-metre Tower, Eiffel put forward two other ambitious proposals in the year 1890. But neither was to enjoy the same success—in fact, far from it. His draft proposal for an underground railway in Paris was rejected because the suggested network would cover only the city centre. His second scheme was for a transport link beneath the Channel, an idea that had first been mooted in 1802. But Eiffel's concept was not in fact a tunnel; instead, he envisaged laying two tubes on the sea bed between France and England, through which trains would run. As we know, it would be fully a century before the dream of linking the British Isles to the Continent became a reality. Then, in 1891, Eiffel began building an observatory on Mont Blanc, only to have to halt work after just six days; the weather conditions were too dangerous for the workers and the ice was too hard to cut through. These few setbacks amid a welter of successes were not enough to deter Eiffel, who was confident in his abilities and encouraged by the financial rewards and professional recognition, both at home and abroad, that his work had brought him.

Below:
Eiffel's design for an underwater bridge across the Channel (1890): elevation (above) and cross-section of the tubes that were to sit on the sea bed (below).

Opposite:
Above, design for a Paris underground: cross section showing the railway running beneath a street.

Below, draft design for an elevated station on the central line of the proposed Paris underground by the Compagnie des établissements Eiffel (1890).

GARE AÉRIENNE

Left:
Gustave Eiffel (seated) in Chamonix looking at Mont Blanc in 1891. With him is the astronomer Jules Janssen (1824–1907) (left), who, the previous year, at the age of 66, had made his first ascent of the mountain—at the same time as Eiffel was embarking on his observatory construction project, which had to be abandoned when it proved impossible to drill through the layer of ice covering the summit.

Below:
Design for an observatory-cum-refuge on the summit of Mont Blanc by Albert Beaudoin (1909), from the Gustave Eiffel archive.

Opposite:
Eiffel (centre) and his son-in-law Adolphe Salles (left) in around 1900.

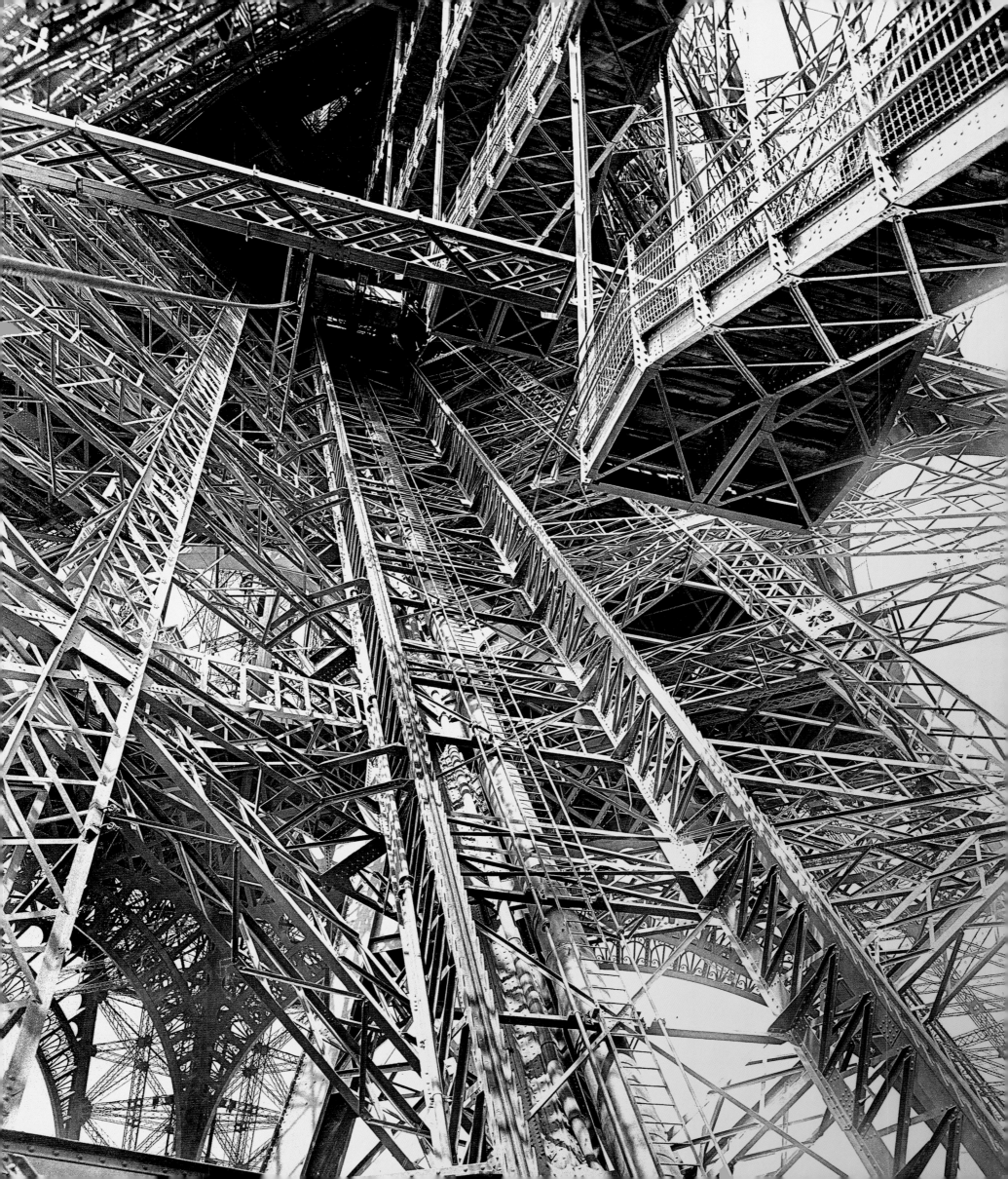

CHAPTER IV

PANAMA AND AFTER...

Unjustly implicated in a scandal that indelibly tarnishes his reputation, Eiffel reinvents himself... and becomes the father of modern meteorology and aerodynamics.

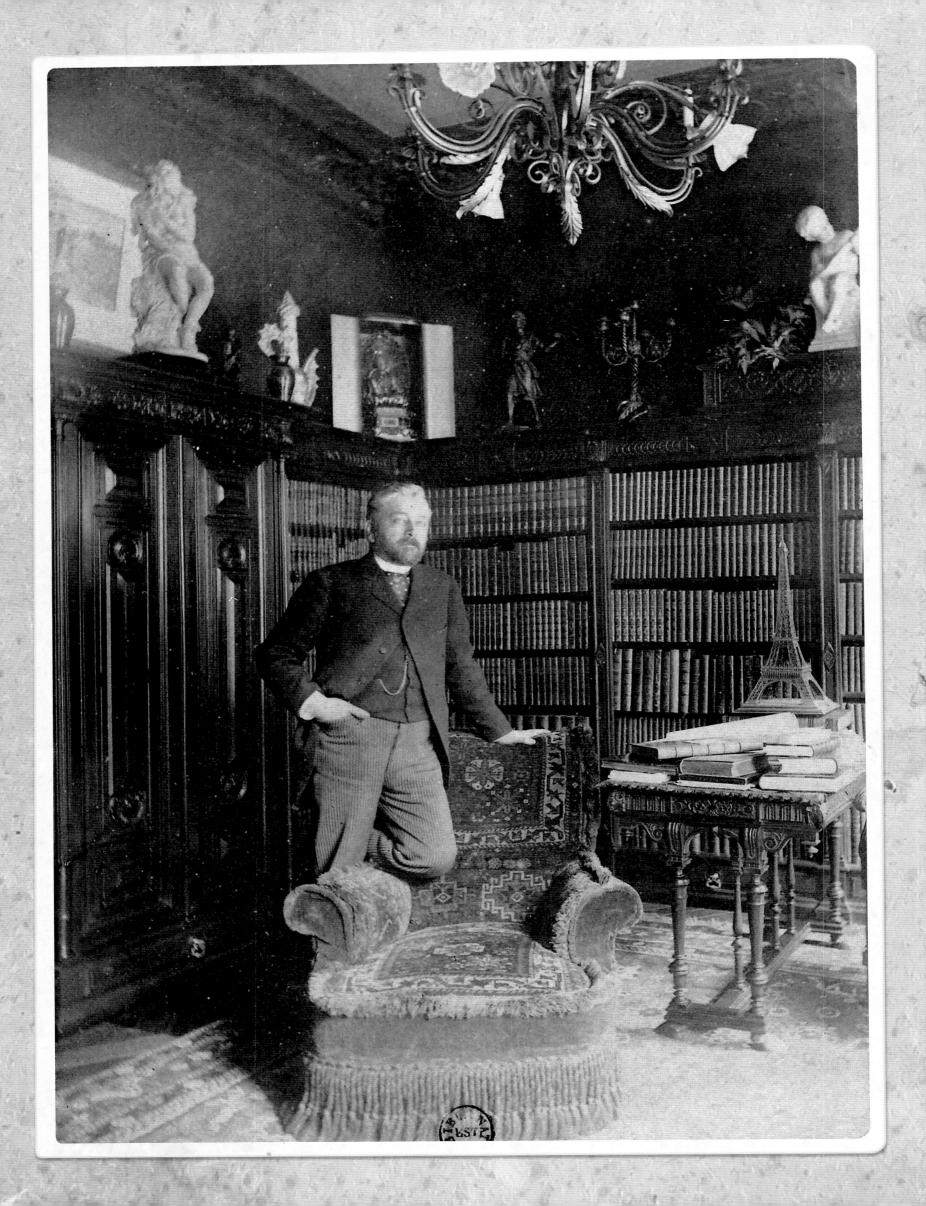

Panama and after...

A captain of industry weathers the storm

Opposite:
Eiffel in his office in 1890. The photograph, by Dornac, is one of a collection entitled Our Contemporaries at Home.

Below:
The bronze medal issued to commemorate the opening of the Suez Canal to shipping on 17th November 1869. A year earlier, Eiffel had failed to win the contract for the construction of its lighthouses, which went to Ferdinand de Lesseps. As it happened, the two long-standing rivals were destined to meet again on the site of the Panama Canal.

Bottom right:
Letters of credit issued by the Compagnie universelle du canal de Panamá in 1888 in favour of Gustave Eiffel.

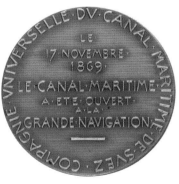

Eiffel's glorious and well-deserved reputation was to be severely tarnished by the infamous scandal over the building of the Panama Canal.

In May 1879, Eiffel had attended a meeting at the International Congress on the Research into an Inter-oceanic Canal through Panama as a representative of the Society of Civil Engineers. Two proposals were under discussion: a single-level canal, as proposed by Ferdinand de Lesseps, and a canal with locks, supported by Gustave Eiffel, who was one of only a small number of delegates (8 out of 98) who voted in favour of the latter solution. His explanation of why it would be impossible to construct a canal on one level was met with booing from the public gallery, which the sensitive Eiffel took to heart.

Seven years later, when the project ran into difficulties, the viability of a single-level canal was seriously called into question. In November 1887, the concept of a canal with locks, which Eiffel had supported, was officially accepted and Eiffel himself chosen to put it into practice. The contract was without exclusion clauses, which meant that he must undertake the work at his own risk and guarantee its completion by the specified date; any delay would incur him a penalty of 100,000 francs per month. Nor was there any allowance for force majeure; if there was an earthquake or a hurricane, it was too bad for Eiffel.

From the moment the project had started to founder, well before the November 1887 decision, Eiffel had secretly put out feelers among his network of contacts, without alerting Lesseps or his associates, in order to secure financial backing for his own project. The above-mentioned contract, which was signed on 10th December 1887, stipulated that Eiffel was to construct ten gigantic locks, transport them to Panama, install them and put them into operation—all within 30 months. The budget was as colossal as the locks themselves: 125 million francs—15 times the cost of the Eiffel Tower. If all went according to plan—which was anything but certain—Eiffel should be left with 20 million: a considerable profit.

By the time it came to signing this huge contract, however, the cost of the Panama Canal had already reached astronomical proportions. A billion francs, raised by selling shares to small investors, had been spent before Eiffel came to its rescue. A major part of that billion had been eaten up by unbelievably high interest rates and the commission fees charged by a multitude of middlemen. Even if the work could be completed on time, the shareholders would have precious little chance of earning any dividends for at least ten years—an unthinkable timescale for private investors. This, of course, was a fact that was carefully concealed from them...

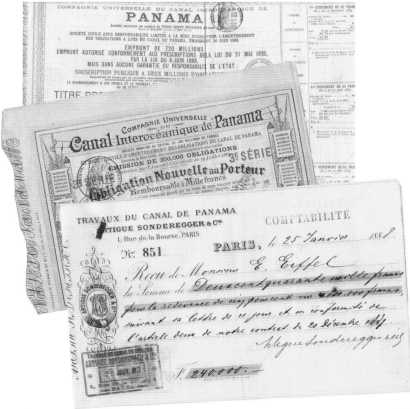

Panama and after...

To enable it to complete the project, the Panama Canal Company launched another appeal to investors, for 720 million francs, in June 1888, but on 26th June the erroneous report of Lesseps' death caused the appeal to flop. Yet another share issue was proposed in December, but this too had to be abandoned because barely half the required number of shares were bought. The Panama Canal Company was finished, and on 15th December it was forced to declare bankruptcy. A liquidator was appointed and he persuaded its suppliers to renounce their contracts. On 11th July 1889, less than two months after the opening of his 300-metre Tower to the public, Eiffel signed an agreement to cancel his contract with the Company in view of its bankruptcy. He handed over the locks that had been constructed or were under construction, along with all his on-site equipment, waived his right to indemnity, to which he should under normal circumstances have been entitled, and even reimbursed the sum of 3 million francs. The agreement was ratified by the courts and Eiffel could consider himself out of the wood.

Nothing could have been further from the truth. The Canal Company's bankruptcy pushed a number of small shareholders over the edge and some committed suicide. Others took legal action. Eiffel found himself caught in the storm that had swept away Ferdinand de Lesseps, his son Charles, the secretaries of the Canal Company and the banks that had been funding it. He was accused, among other things, of having made money out of the situation, lots of money, while the shareholders had lost everything. At first, the politicians tried to prevent news leaking out that many of them had misappropriated the Company's funds. But, despite the intervention of the French president, Sadi Carnot, who defended the good name of Lesseps, and against the advice of the Attorney General, the Minister for Justice assigned legal responsibility for the debacle to five people: Ferdinand de Lesseps, his son Charles, the two secretaries of the Canal Company, Henri Cottu and Marius Fontane, and Gustave Eiffel. The banker Jacques de Reinach escaped justice only by taking his own life. There were rumours that 126 members of parliament had received cheques—which is why they soon became known as the "chequers"—in exchange for voting in favour of the 1888 share issue. As the scandal spread, the press launched attacks of unprecedented savagery, especially, on account of his notoriety, on Eiffel.

Before the ensuing trial began, in October 1892, Eiffel announced that he was resigning his post as president of the Compagnie des Établissements Eiffel, as well as his duties as company secretary. In February 1893, his board of directors accepted his resignation, acknowledging his magnanimity in so doing, and the firm became the Société de constructions de Levallois-Perret (SCLP). Eiffel also relinquished 2,000 of his 3,571 shares in the company, which had been allocated to him in proportion to his capital investment. He thus attempted to shelter the company he had founded from the threats that were hanging over him personally. He was only partially successful. Admittedly, orders continued to come in, but the SCLP did not enjoy the continued expansion that its many achievements would normally have ensured.

Nevertheless, from a purely legal point of view, Eiffel's case was unassailable: he had been a contractor to the Panama Canal Company, not a representative of it. As such, he could not be asked to refund any sums paid to him in accordance with the agreed schedule, even if they had not been spent. Nor could he be reproached for having made a profit, since in agreeing to a contract without exclusion clauses he had risked losing a fortune. Besides, the agreement he had signed with the liquidator absolved him of all responsibility for the general operation of the Company, as well as confirming his repayment of 3 million francs. But someone had to take the blame...

Below:
"The French have dug deep in their pockets... How about digging the canal?" A cartoon by Emmanuel Barcet satirizing the Panama debacle, which was published in L'Assiette au beurre *on 11th October 1902.*

Opposite:
Above, from left to right, the first page of Eiffel's contract with the Compagnie universelle du canal interocéanique de Panamá for the construction of locks, signed 10th December 1887; the first page of the cancellation of that contract; the first page of the "Reply to Questions" put to Eiffel during the legal proceedings following the Canal crisis, from which it is clear that Eiffel was in fact acting in his own defence.

Below, the Culebra Cut at Bas Obispo in October 1913, when the Canal was finally connected.

*"From the moment I began, by dint of my own efforts and hard work,
to make a name for myself, I never ceased, at any time in my arduous career,
to be the object of veritable persecution and of obsessive and hateful jealousy.
I have never been forgiven for being successful."*

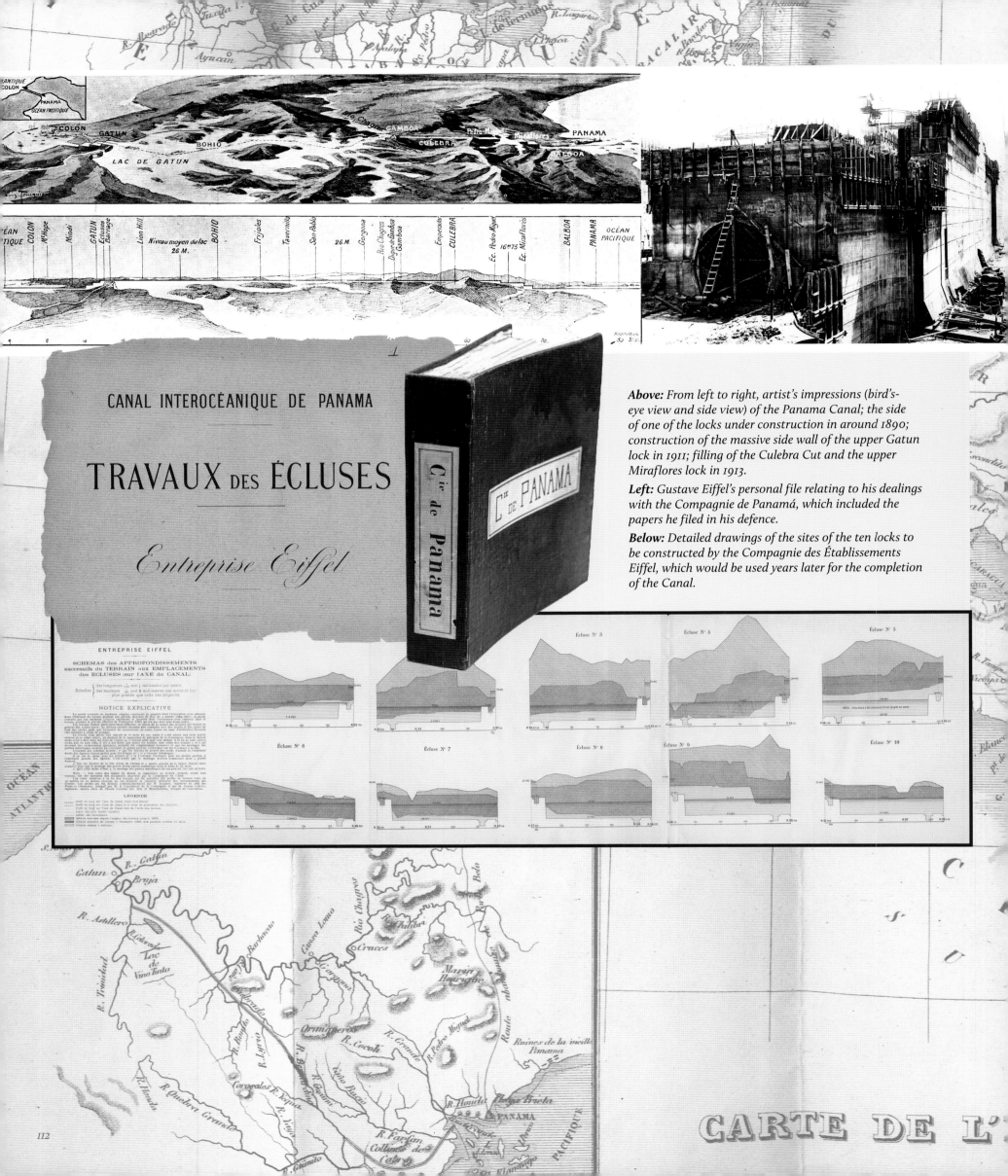

Above: From left to right, artist's impressions (bird's-eye view and side view) of the Panama Canal; the side of one of the locks under construction in around 1890; construction of the massive side wall of the upper Gatun lock in 1911; filling of the Culebra Cut and the upper Miraflores lock in 1913.

Left: Gustave Eiffel's personal file relating to his dealings with the Compagnie de Panamá, which included the papers he filed in his defence.

Below: Detailed drawings of the sites of the ten locks to be constructed by the Compagnie des Établissements Eiffel, which would be used years later for the completion of the Canal.

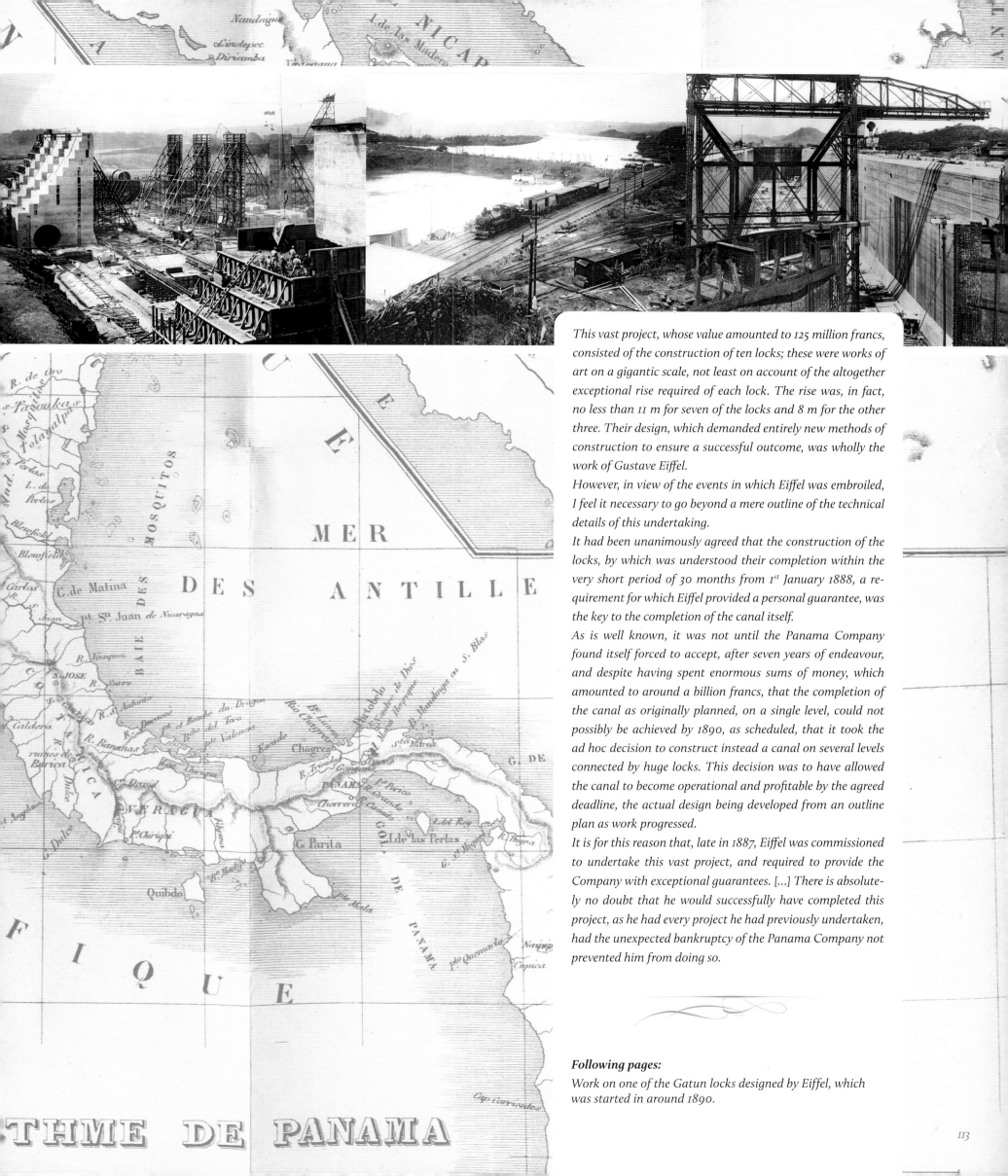

This vast project, whose value amounted to 125 million francs, consisted of the construction of ten locks; these were works of art on a gigantic scale, not least on account of the altogether exceptional rise required of each lock. The rise was, in fact, no less than 11 m for seven of the locks and 8 m for the other three. Their design, which demanded entirely new methods of construction to ensure a successful outcome, was wholly the work of Gustave Eiffel.

However, in view of the events in which Eiffel was embroiled, I feel it necessary to go beyond a mere outline of the technical details of this undertaking.

It had been unanimously agreed that the construction of the locks, by which was understood their completion within the very short period of 30 months from 1st January 1888, a requirement for which Eiffel provided a personal guarantee, was the key to the completion of the canal itself.

As is well known, it was not until the Panama Company found itself forced to accept, after seven years of endeavour, and despite having spent enormous sums of money, which amounted to around a billion francs, that the completion of the canal as originally planned, on a single level, could not possibly be achieved by 1890, as scheduled, that it took the ad hoc decision to construct instead a canal on several levels connected by huge locks. This decision was to have allowed the canal to become operational and profitable by the agreed deadline, the actual design being developed from an outline plan as work progressed.

It is for this reason that, late in 1887, Eiffel was commissioned to undertake this vast project, and required to provide the Company with exceptional guarantees. [...] There is absolutely no doubt that he would successfully have completed this project, as he had every project he had previously undertaken, had the unexpected bankruptcy of the Panama Company not prevented him from doing so.

Following pages:
Work on one of the Gatun locks designed by Eiffel, which was started in around 1890.

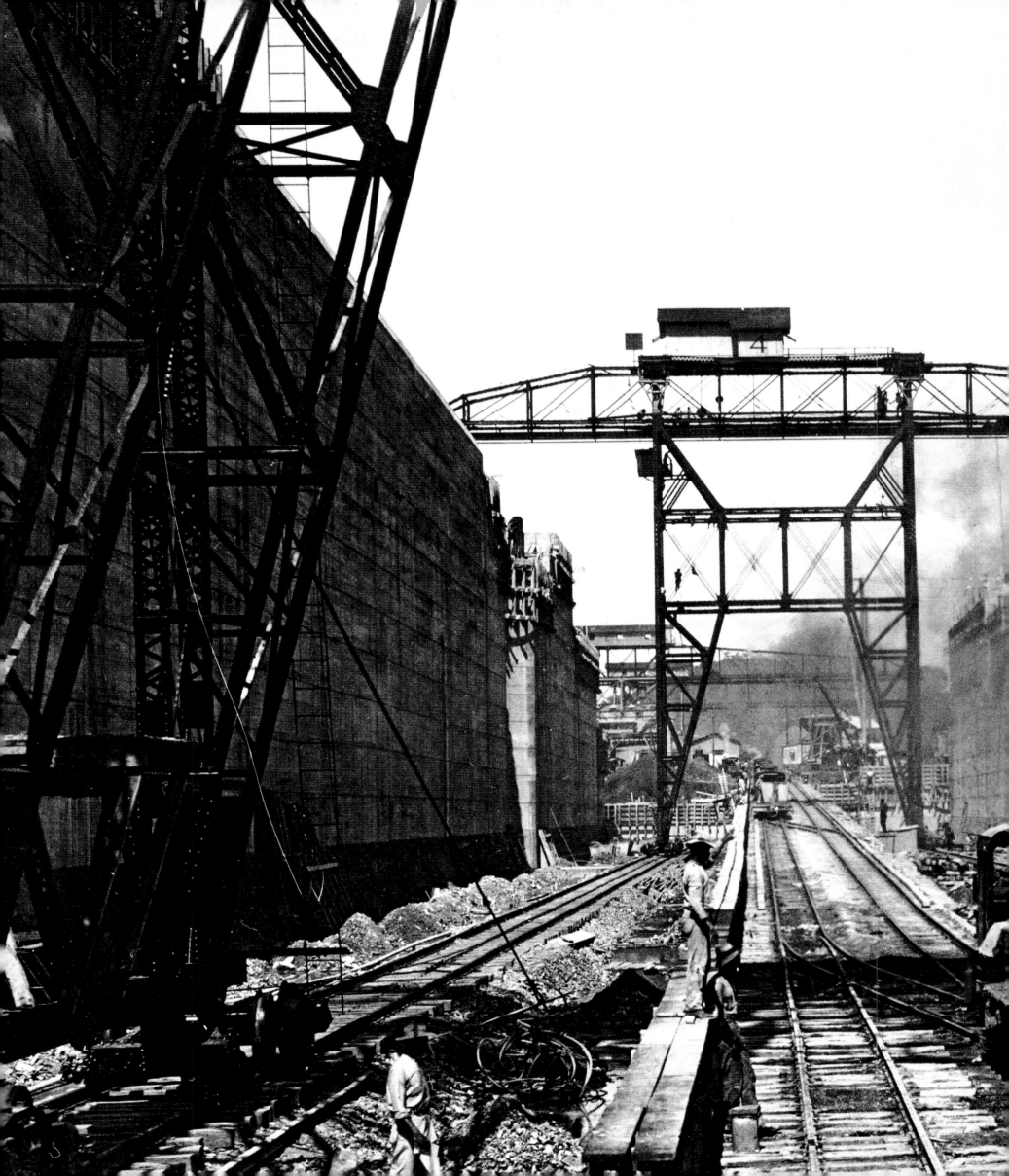

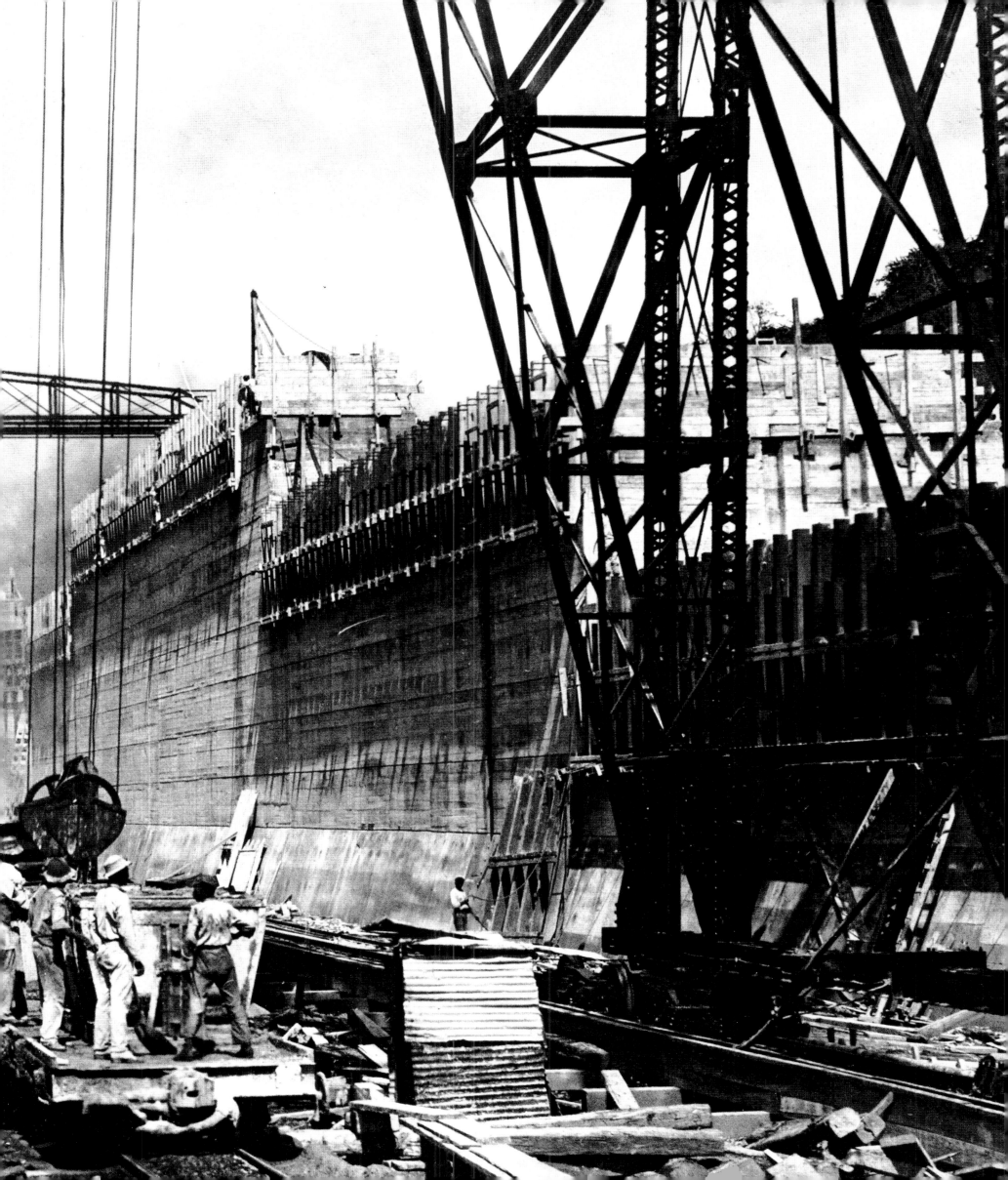

Panama and after...

At the trial, the prosecution resorted to a specious argument, based on an ambiguous detail in Eiffel's contract, to shore up its indictment and, on 9th February 1893, the court imposed the minimum penalty. This was denounced by both the national and international press, which inferred that the court had made a national celebrity the scapegoat for the real guilty party: the politicians. The other defendants were given prison sentences of up to five years, as well as various fines. Needless to say, they all appealed.

The Appeal Court's decision did not put an end to the Eiffel's indignities. Concentrating on the first line of defence of Eiffel's lawyers, that Eiffel had acted as a contractor, the Court invoked the statute of limitations and therefore made no judgment on the other points of the case. Eiffel was acquitted but not absolved. The decision had not erased the wounds that had been inflicted on his honour. He therefore set about rehabilitating his reputation by printing a leaflet summarizing the facts of the case and sending it to all the leading figures in Paris. A few loyal friends excepted, this attempt to justify his actions earned him little but rebuffs.

The bond holders, or rather the small investors who had been ruined, were still not satisfied, however, and demanded that Eiffel refund their investments to the tune of 18 million francs. He refused, referring to the agreement he had made with the liquidator and the fact that he had continued manufacturing for more than ten months after the Canal Company had stopped paying him, which had cost him 7.5 million francs—a sum he had little chance of ever recovering. Nevertheless, pursuing his vision of May 1879 and eager to see the Canal completed with the type of locks he had proposed, he shrugged off all his trials and tribulations and, in that very same year, 1893, offered to buy 10 million francs' worth of shares in the new company that had taken on the Panama Canal project. After some negotiation, his offer was accepted.

His enemies still refused to lay down their arms and loudly demanded that he renounce his membership of the Legion of Honour. The council of the Ordre national de la Légion d'honneur rejected their demands, affirming that Eiffel had always acted honourably. The anti-Eiffel brigade counter-attacked by submitting a request to the Chamber of Deputies that the Ordre's statutes be revised. The council responded by resigning en masse.

To add insult to injury, two trumped-up charges were brought against Eiffel, but the judges ruled them out of court.

In June 1894, a new Panama Canal Company was formed in an attempt to retain the concession. It undertook a certain amount of work, but with disastrously limited resources. The concession had to be renewed and a few locks were completed, but ten years later, the concession was sold to the Americans for 200 million francs. After protracted negotiations, an agreement was reached on 22nd April 1902. Eiffel, who, it will be remembered, had decided to purchase 10 million francs' worth of shares in the new company, once again made a tidy profit. Should this be held against him? As he emphasized in his autobiography, his decision to invest in the new canal company helped to make it financially viable. Besides, despite all the accusations that had unjustly and illegally been made against him—and I make no apology for repeating this assertion—Eiffel's priority was always to do what he could to see the project through to completion.

The Americans resumed work on the Canal in 1904 and it was finally opened to shipping in 1914, fully 35 years after its inception. On the commemorative plaque at the entrance to the Canal, the Americans inscribed Eiffel's name alongside that of Lesseps—a belated recognition that Gustave Eiffel probably never considered sufficient compensation for the wrongs he had suffered.

In 1894, at the age of 62, Eiffel had ended his career as a building designer and taken his life in a new direction.

Background:
Aerial view of the Gatun locks.

Opposite:
Above, the first vessel, the tug Gatun, *passes through the upper Gatun lock, on 26th September 1913, and the Panama Canal is officially opened on 15th August 1914.*

Below, one of the Canal's upper lock gates on 31st October 1912, before water was let in.

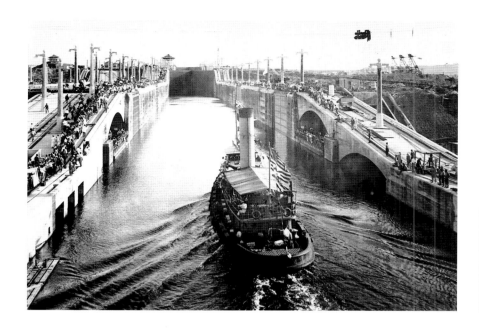

"I thought it wise to remain silent and to distance myself from all discussion on the subject until such time as the legal process should produce a definitive judgment, which would give me the opportunity to respond with the help of irrefutable facts and documents."

Panama and after...

Patron of the sciences

Opposite:
The top of the Eiffel Tower photographed from the air by Robert Durandaud.

Below:
The various scientific instruments installed at the top of the Tower in 1949.

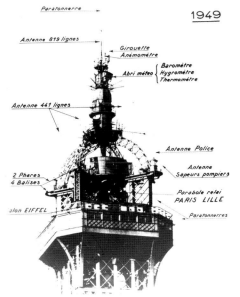

Eiffel decided to dedicate the rest of his life and donate his considerable wealth to a noble but demanding cause: science. It was a field in which he would achieve outstanding success and lay the foundations of two new disciplines: meteorology and aerodynamics. If today we can predict the weather several days in advance, fly in aeroplanes that resist gravity, travel in high-performance cars and live or work in high-rise buildings, it is partly thanks to Eiffel's genius. This long period of his life, which was to last almost 30 years, is not the least interesting part of his long career, despite the fact that it has been eclipsed by his star achievement, the Eiffel Tower. Though little known, it is far from being less illustrious.

No sooner had the Tower been completed than its summit was adorned with a meteorological station, which transmitted the data it captured to the nearby Central Meteorological Office. Over the next few years, similar stations were installed in the grounds of all the properties belonging to the Eiffel family: first in Sèvres near Paris, then in Beaulieu-sur-Mer on the Côte d'Azur and Vacquey near Bordeaux and finally in Ploumanach in Brittany, where the property itself was called "Ker Awell", meaning "House of the Wind". With each installation, Eiffel improved and developed the design, which came to be known as a "Sèvres station".

At the time, predicting the weather, even one day ahead, was about as reliable as reading tea leaves, and meteorology was largely a matter of collecting data, without putting them to any practical use. Nevertheless, Eiffel was convinced that reliable weather forecasts were not a pipe dream and that in developing them he could provide an important service, especially in the fields of agriculture, shipping and aviation. He knew, though, that meteorology as a science was in its infancy, lacking in both instruments and knowledge—deficiencies that Eiffel sought to rectify by devising a protocol for the collection of data and developing new commercial uses for meteorological information. He began by comparing the results that were obtained using different types of instrument for measuring humidity, rainfall, insulation, temperature and the speed and direction of the wind. He also patented designs for an anemometer and a heliograph. Once the reliability of the data he was obtaining met his exacting standards, Eiffel turned his attention to their commercial potential, and his methodological innovations resulted in meteorology becoming a distinct scientific discipline.

The reason Eiffel was fascinated by this field was, of course, that it brought him back into contact with his old adversary, the wind. The top of the Tower, whose shape had been designed to resist its onslaught, provided a unique opportunity to study its behaviour—and to discover a number of unexpected phenomena. For example, he found that, at 300 m above the ground, the wind blows in gusts, the weakest being between 9 and 10 o'clock in the morning and the strongest at 11 o'clock at night; that the air temperature is higher than at ground level at night, whereas it is lower in the day; and that the air is layered.

Information is worthless unless it is published, and so, drawing on the data collected from the 25 weather stations he had set up in all parts of France, Eiffel set to work to produce a *Meteorological Atlas*, which was published annually from 1906 to 1912. This undertaking led to his appointment as president of the French Meteorological Society in 1910. Such publications require a great deal of work, however, and Eiffel put aside the *Atlas* in order to apply his skills and knowledge to two other rapidly evolving fields, namely aeronautics and aerodynamics.

"If I may be forgiven for saying so, my labours have not been in vain, since many of the ideas I have developed have gradually been adopted and are now part of common practice. In due course, they will help to disseminate knowledge that was formerly restricted to far too small a number of scientific bodies and to generate increasing quantities of data, from which gifted minds—in specified fields, at least—will eventually make useful deductions, particularly with regard to agriculture and to meteorological predictions of a more or less long-term nature.

This must surely be the true goal of the science of meteorology, which has too often been limited to meticulous but sterile observations, serving only, in fact, to establish weather- or climate-related averages that are far too generalized to be of great use—still less because they eliminate every trace of specific phenomena, which have the greatest value in terms of paving the way for future knowledge.

[...] It would perhaps be best to completely abandon the current methods of making predictions, which seem unlikely to produce certain or even probable outcomes to justify the observations that have been taken.

[...] Natural phenomena are never, in fact, the result of pure chance, which is merely the name we give to all phenomena that occur as a result of laws we are as yet ignorant of, laws that combine—to a greater or lesser but always limited extent—all kinds of elements and whose application must lead to the same consequences; which is to say, in short, that the same causes will produce the same effects.

This conclusion accounts for the extensive interest in the study of the pattern of trade winds and in the search for the best routes for sailing ships, as well as for aeroplanes and balloons, which has already been pursued with considerable enthusiasm. The same applies to the great ocean currents. Why should it not also apply to the currents in the upper atmosphere?

It is true that the layers of air above us are far less stable than those of the oceans below us and therefore that an understanding of the causes of atmospheric phenomena requires far more thorough research, but there is no doubt that we shall eventually succeed in comprehending them. It is therefore on this field that I believe meteorological science should focus its attention."

Left:

Photographs of scientific instruments from the Gustave Eiffel archive: in the centre, Eiffel's photographic heliograph, patented on 16th May 1907 (no. 373,495); at the bottom, the equipment housed at the Central Meteorological Office in the Rue de l'Université, near the foot of the Eiffel Tower, that recorded the data captured by the instruments at the top.

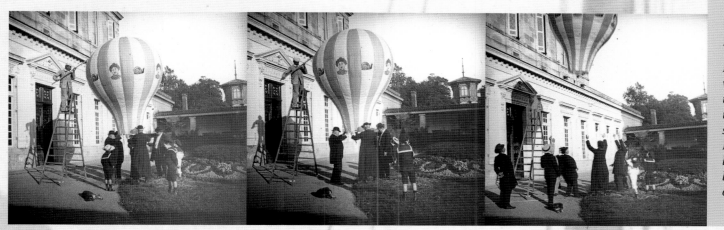

This page:
Eiffel challenging his favourite sparring partner, the wind, at the helm of the Aïda at Beaulieu-sur-Mer (with his son Édouard behind him) and launching a hot-air balloon (to the great delight of his grandchildren).

Panama and after...

The Exposition Universelle of 1900 boosted attendance at the Eiffel Tower, which had gradually dwindled since its triumphant appearance in 1889. Nevertheless, the question arose as to whether the Tower should be left in place once Eiffel's 20-year concession ended in 1909. The French Association for the Advancement of Science was in favour of preserving the structure on the basis that, as it proudly asserted, the Tower "has already rendered invaluable service to science in enabling physical, meteorological and mechanical experiments to be conducted that would otherwise have been impossible; indicating that it will unquestionably be called upon to render yet more such services in the future." The Association's argument convinced the council for the Seine district to vote for the preservation of the Tower—but by the narrowest of margins: a majority of one. In fact, the decision, which was not taken until 1906, was merely to extend the life of the Tower by five years. There were to be several more extensions, until, in 1908, the Tower was granted a reprieve until 1926. This reassured Eiffel somewhat as to the longevity of his creation, in which he had invested both intellectually and financially by installing equipment for conducting scientific experiments.

One such experiment, which Eiffel announced in 1903, was dubbed the "Eiffel Tower Aerodrome". The idea was to stretch a cable between the second stage of the Tower and a pylon erected 500 m away at the far end of the Champ de Mars and run along it aircraft parts or even complete aeroplanes. But while Eiffel was happy to finance and supervise the installation, he did not want to be responsible for its use. He therefore invited the Aéro-Club de France to take charge of this innovative apparatus—in effect, a forerunner of the flight simulator—but it wasn't interested, so Eiffel abandoned the idea and turned his attention to another type of experiment relating to air resistance.

On the second-stage platform of the Tower, he installed a laboratory that would study falling objects. In order to achieve meaningful results, he used an accelerometer that he himself had designed in 1903, his 70th year. This contraption enabled him to study the behaviour of bodies dropped from a height of over 100 m and therefore reaching speeds previously unimaginable. The experiments caused not a little consternation, not to say terror, among passers-by, who would see objects sometimes resembling cannon shells falling from the sky and coming to rest just a few metres from the ground. However, the results challenged contemporary wisdom. It has to be said that, although a number of scientists had addressed the subject of air resistance, they had come to differing conclusions. Eiffel's single-minded research enabled him to establish once and for all the fundamental laws of air resistance, and in 1907 he published the results of the experiments he had conducted from the Tower in a seminal work, which was recognized by the Academy of Sciences the following year. Eiffel nevertheless thought he could do even better and designed a much more sophisticated piece of equipment that would have the advantage of allowing experiments to be conducted in isolation from the effects of the wind. This was a wind tunnel, housed in a large hangar, which would be located at the foot of the Tower so that it could be powered by electricity, a source of energy that was then available only in a few parts of the city.

The principle behind the wind tunnel was utterly revolutionary: to make air move around an object. Until then, the object under study had been propelled through the air by being spun on a sort of roundabout; not only could this not achieve great speeds, but the results were compromised by the centrifugal forces that were brought into effect. In inventing the wind tunnel, Eiffel founded modern aerodynamics. He began by comparing the results from the new wind tunnel with those obtained by dropping objects from the second platform of the Tower. This comparison enabled him to establish two extremely important principles: first, that artificial flight tests (i.e. those conducted on stationary objects inside a wind tunnel) produced identical results to real flight tests; and second, that the results obtained from tests on scale models could be extrapolated to the full-size objects. Not surprisingly, his experiments, which turned contemporary knowledge on its head, aroused considerable controversy among other experts—and those who called themselves experts. Eiffel, who was confident of the reliability of his experiments and the accuracy of the results, immediately approached the most eminent scientists of the day and asked them to decide who was right. It was the famous mathematician Henri Poincaré, a member of the Institut Français, who overcame the arguments of the Duc de Guiche and declared Eiffel to be correct.

Below:
Eiffel in Auteuil in 1904 looking at the accelerometer he had devised to measure air resistance.

Opposite:
Eiffel (centre) under the Tower in the same year after the accelerometer had reached the end of its fall.

Appareil de chûte pour mesurer la résistance de l'air

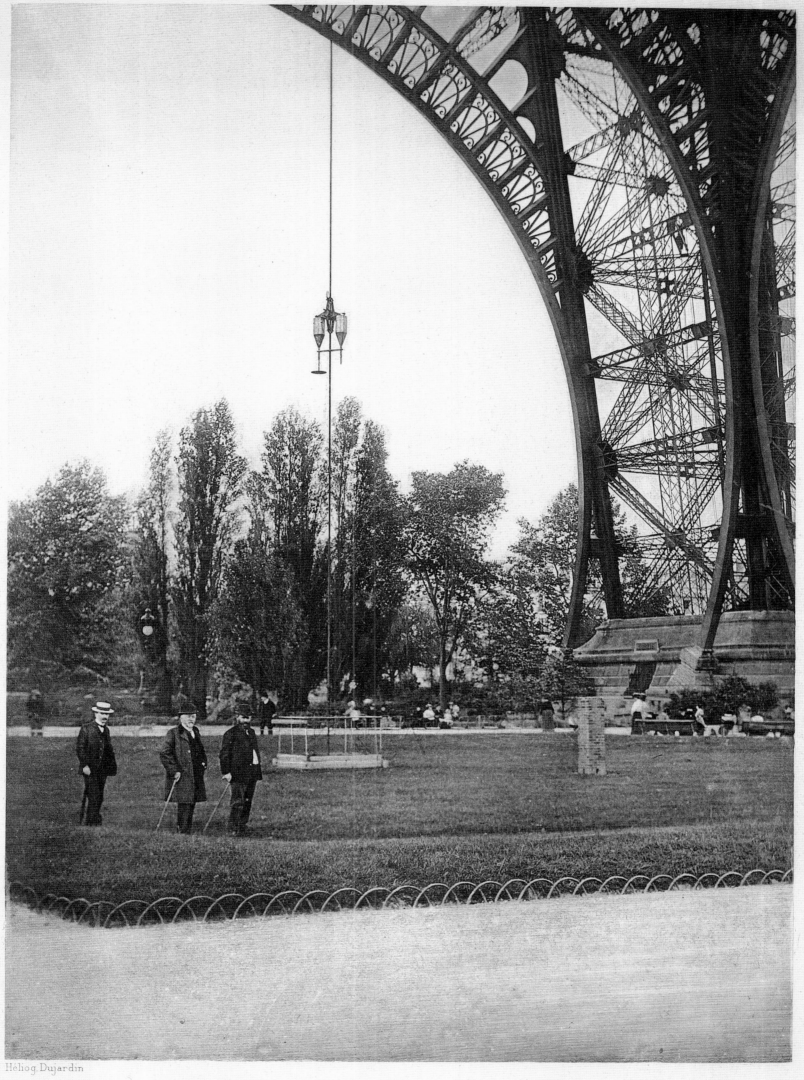

L'appareil après la chûte est engagé sur le cône d'arrêt

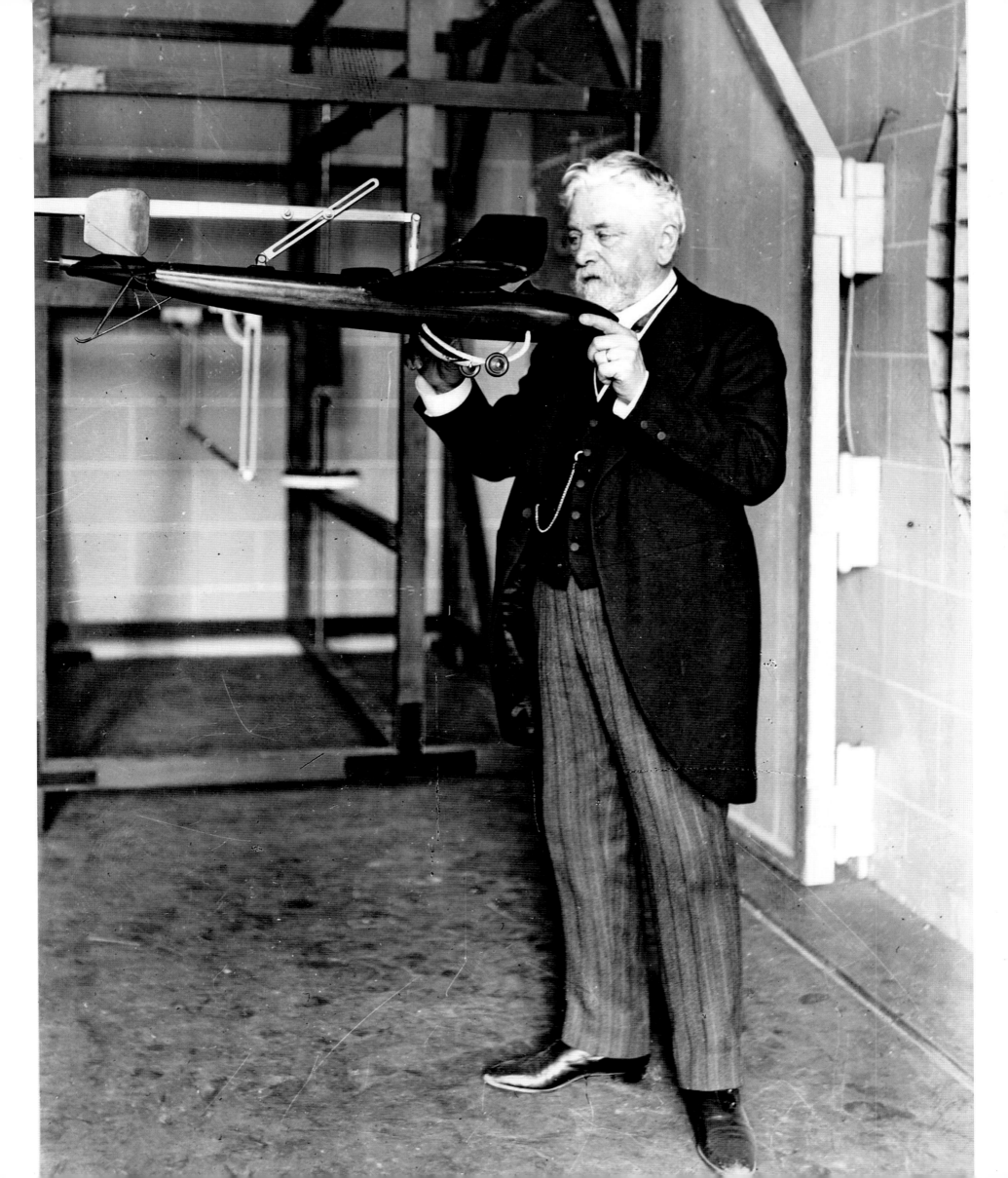

Panama and after...

Opposite:
Gustave Eiffel in his laboratory, studying a model of an aircraft known as the "Air Torpedo", designed by Victor Tatin.

Below:
The Eiffel Laboratory of Aerodynamics, seen from the Rue Boileau, in 1912.

Bottom of page:
Cross section of the wind tunnel in the Laboratory of Aerodynamics in Auteuil, which was patented on 28th November 1911 (patent no. 436,934).

When, in 1909, aircraft manufacturers began asking to use Eiffel's wind tunnel, he gladly opened its doors to them. Typically, he asked only one thing in return: the right to publish the results of their tests. By inventing the wind tunnel Eiffel did more than create a new science: he also saved lives—namely those of the pilots who, until then, had acted as guinea pigs by testing aircraft whose behaviour in the air it was impossible to predict, and who more often than not were killed. As Eiffel wrote in his autobiography: "The tests enabled the art of the engineer to be substituted, in the design of aeroplanes, for the imagination of the draughtsman." In other words, thanks to Eiffel, aeronautics ceased to be a matter of experimentation and became a science.

Among the many discoveries the wind tunnel tests led to, the most significant for the future of aviation was perhaps the discovery of the force known as lift. This explained why the lightweight material used to cover aircraft wings would be ripped off the top of the wings, sending the planes crashing to the ground and killing their pilots. It was not the delicacy of the material itself that caused this phenomenon, since in that case it would also have been ripped off the underside of the wings. Tests showed that the upward pressure on a wing was twice the downward pressure, which also explained why, in a storm, the roofs of buildings tend to be torn off. Eiffel was not the only scientist working in this field; the physicist Ludwig Prandtl was simultaneously carrying out research in Germany. In 1911, Eiffel sent him his report on air resistance, which was based on the results of experiments carried out in the Champ de Mars wind tunnel, and Prandtl acknowledged its importance. The scientific world has no borders and the two men continued to exchange information until their respective countries became enemies. In 1913, just a year before the outbreak of the First World War, Eiffel invited the German scientist to visit his wind tunnel in Auteuil.

It was in 1910 that Eiffel had been obliged to relocate the wind tunnel because the City of Paris wanted to convert the part of the Champ de Mars on which it stood into a park. Having no choice but to move it, Eiffel found a plot in Auteuil, which at the time was in the countryside surrounding Paris, and constructed a building that was to house a new wind tunnel, more powerful than the previous one. The Auteuil laboratory was opened on 19th March 1912 and its design, to which Eiffel had made a number of improvements, was patented. Eiffel agreed, however, that it could be copied in other countries without any royalty payments, on condition that each building bore a plaque with the words: "Aerodynamic Apparatus designed by Eiffel, Paris".

Aircraft designs were tested using models made of polished wood, some of which have been preserved and can still be seen at Auteuil. A number of full-size aircraft components were also tested, such as propellers, wing profiles, radiators and undercarriages. The manufacturers received test reports, along with various recommendations, from the Eiffel Laboratory, which they could use to perfect their designs. One development was that wings were lowered in relation to the fuselage, a feature still seen in modern planes; another was that radiators were lightened and streamlined to reduce wind resistance, which generated fuel savings and therefore enabled planes to travel further between fill-ups—a significant benefit for early aircraft, which could only carry a small amount of fuel.

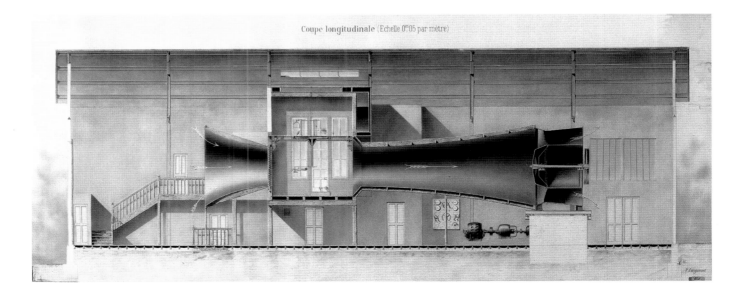

1912

Drzewiecki

Tatin

1913

Nieuport

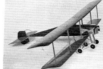
Bréguet

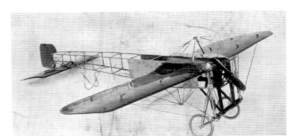
Blériot

1915

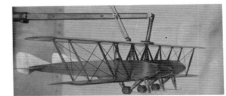
Astra

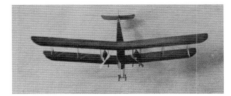
Clément-Bayard

1916

Bossi

Bréguet

1917

Paris II

1918

Janoir

Borel

1919

Besson

Nieuport

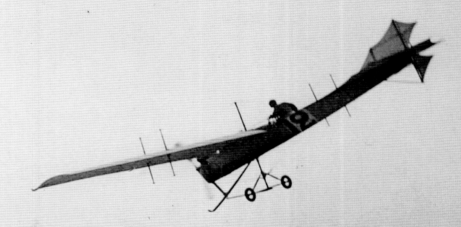

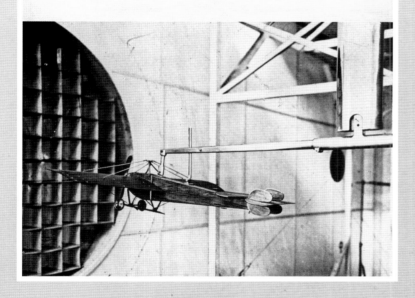

"Being obliged to quit the site my laboratory had occupied on the Champ de Mars, I was forced to demolish it, in the summer of 1911. I decided, however, that I should continue my research, with which I had every reason to be satisfied, by constructing a new and larger laboratory.

The Champ de Mars wind tunnel measured 1.5 m in diameter and the maximum speed of the air flow was 18 m/sec. My aim in the new installation was to increase the tunnel diameter to 2 m and the wind speed to 30 m/sec, which is a little more than 100 km/h.

Had it been necessary to replicate the Champ de Mars installation, this would have meant fitting a fan with a rating of 400 horsepower, which would have represented not only a considerable capital expenditure but also significant operating costs.

By inserting a long converging-diverging nozzle between the test chamber and the fan, I was able to resolve this problem and reduce the power required by the installation I had decided upon to 50 horsepower.

It was in this way that I arrived at the definitive design of what came to be known as the "G. Eiffel Wind Tunnel", which has since been reproduced elsewhere in France (at Saint-Cyr and Issy-les-Moulineaux), Holland, Japan, the United States, etc. [...] The Auteuil laboratory was officially opened on 19th March 1912, in the presence of a large number of French dignitaries."

Opposite: Aircraft models tested at the Auteuil laboratory between 1912 and 1919.

Above left: Above, letter from Eiffel to a Mr Albessard, dated 17th May 1918, in which he advises him of the poor results of the tests on his "Triavion" design.

Below, model of the "Monoplan" being tested in the wind tunnel.

Background: A photograph of an air show that took place in April 1910 in Nice, which Eiffel kept in an envelope, together with a list of the participants, their nationality and the type of plane they flew.

Eiffel's work was closely followed abroad, especially in the United States, where powered flight had been pioneered by Orville and Wilbur Wright, and in 1913 the Smithsonian Institution awarded Eiffel the Langley Medal. It was only the second time that the medal, intended to recognize men who had been of outstanding service to aeronautics, had been awarded. The first recipients, three years earlier, had been none other than the Wright brothers themselves. On account of his advanced age, Eiffel was unable to travel to Washington, and it was the French Ambassador who received the medal on his behalf from Alexander Graham Bell. An amusing footnote to Eiffel's achievements in the field of aviation is that he never flew.

It was not only aeroplanes that were tested in Eiffel's wind tunnel but also balloons and even the hangars that were to house all kinds of flying machines. Later, long after Eiffel's death, the skyscrapers of La Défense, west of Paris, would be tested for wind resistance at the Auteuil laboratory.

Tests were also carried out on early cars. Peugeot's first racing car was tested at Auteuil, as were many others, including Renault's "Shooting Star", which broke the world land speed record in 1956 at Bonneville Salt Flats in the United States.

Background:
A photograph of Gustave Eiffel in his new laboratory used for publicity purposes by the Meurisse agency in 1912.

Opposite:
The Langley Medal awarded to Gustave Eiffel, which was received on his behalf by the French Ambassador to the United States on 6th May 1913 and presented to Eiffel six days later.

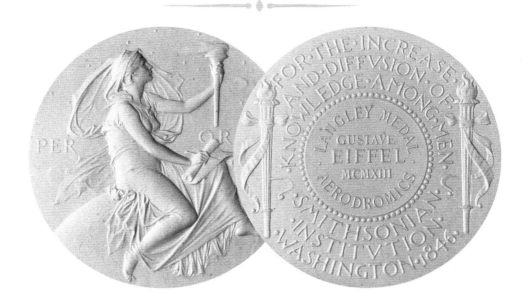

Extract from the speech delivered by Dr Alexander Graham Bell in Washington on 6th May 1913.

Since the Wright brothers won the Langley Medal three years ago, the field of aviation, particularly in France, has been a hive of activity. Ministries of Defence in every country have worked ceaselessly to develop better aircraft; but progress has been almost imperceptible. As far as the public is aware, the principal developments to date have been limited to details of construction and improvements to engines. Progress has been far more noticeable in the Arts than in the science of aviation. There has nevertheless been considerable progress in this science, and this has been achieved principally by Mr Gustave Eiffel, Director of the Eiffel Laboratory of Aerodynamics in Paris, who has pursued the work of our late lamented Secretary, Samuel Langley. Although now 80 years of age, the distinguished designer of the Eiffel Tower has continued his research in his chosen field with youthful enthusiasm, and his writings on air resistance have already become the standard reference works.

The results of his research into the effects of air resistance on aircraft, which were published in 1907 and 1911, are especially significant and of major value in providing engineers with the data necessary for the study and design of flying machines in accordance with solid, scientific principles.

Given that Mr Eiffel's experiments have been so closely related to the research undertaken by the late Samuel Langley, it is particularly fitting that he should receive the Langley Medal. We would truly have liked to be able to present the medal to Mr Eiffel in person here today, but we are happy to welcome His Excellency the French Ambassador, who has undertaken to receive it on his behalf and to convey it to Mr Eiffel in Paris. This award serves not only as a mark of the high regard we have for Mr Eiffel's important research, but also as a token of our appreciation of the wonderful progress France has made in the field of aviation technology and of the great debt we owe to that country.

Your Excellency, it is with honour that I present to you, in the name of the Smithsonian Institution, the Langley Medal awarded to Mr Gustave Eiffel in recognition of the progress in the science of aviation that has been made possible by his research into the effects of air resistance on aircraft.

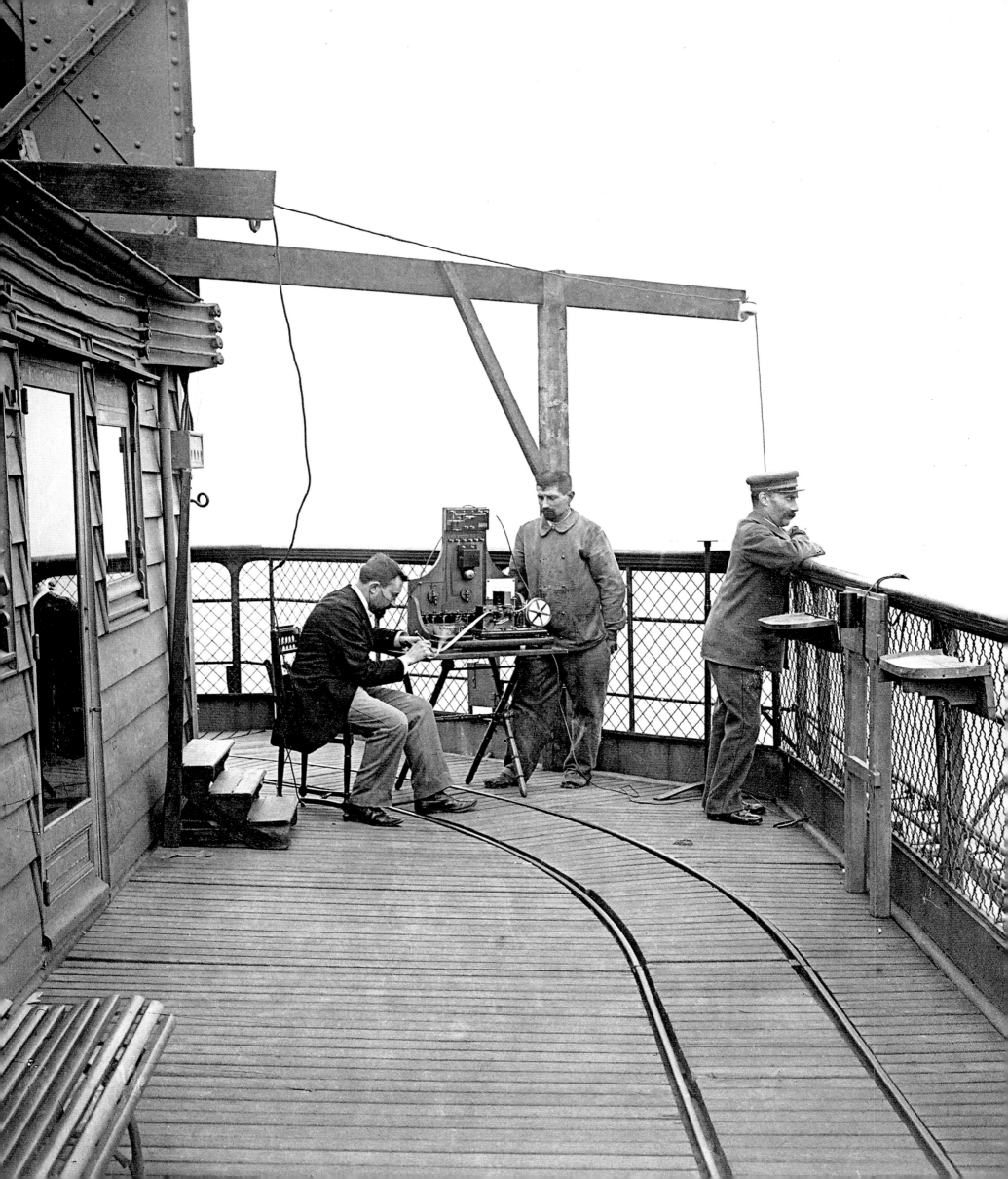

Panama and after...

The patriot

The Eiffel family was half German; one of Gustave's ancestors, Jean-René Bönickhausen, had left his native North Rhine-Westphalia in 1700 to make a home for himself in Paris, where he married the daughter of one of the Duc de Grammont's guards. The name Bönickhausen even appeared, beside Eiffel, on Gustave's birth certificate, although the family had been known as Eiffel for generations. When France was defeated by Prussia in 1871, Gustave worried that the connection would bring him trouble, given the fervent anti-German feelings aroused by France's defeat. A designer he had dismissed spread malicious rumours that he was spying for Count Bismarck. Although Eiffel managed to sue him through the courts, he decided that it would be prudent to erase all trace of his German ancestry from his children's identity papers. He therefore asked his father to send him documents proving the family's long-standing presence in France and the established use of the name Eiffel, and he submitted a request to the relevant authorities that he and his family should henceforth be known only by that name. It was to be several years before his request was granted.

The installation, at Eiffel's own expense, of a wireless telegraph station at the top of the Tower in 1904 was undoubtedly a factor in the decision not to demolish it. Six years earlier, France's first airborne transmission had been made by Eugène Ducretet from the Tower to the Panthéon. Although it had proved less than entirely successful, Eiffel sensed that the alleged explanation for its partial failure—that the airwaves had been disturbed by the great mass of metal that was the Tower—was based on erroneous reasoning, since such signals could be received even by armoured vehicles. He was to be proved right, in spectacular fashion.

The benefits of modern telecommunications for national defence had not escaped a certain army captain by the name of Gustave Auguste Ferrié. He nevertheless failed to convince the Ministry of Defence of their importance, and it continued to rely on homing pigeons (tens of thousands of which were to be used to transmit messages during the First World War) and the optical telegraph system. The latter consisted of the transmission of visual signals via a network of lighthouse-like towers, which had been spread across the whole of France from the 1840s. Captain Ferrié had therefore approached Eiffel, who immediately grasped the strategic significance of wireless telegraphy. Indeed, he was so convinced of its importance that he offered to set up a telegraph station at his own expense and to make it available to Ferrié. By 1906, the Eiffel Tower station was able to transmit messages to fortresses in eastern France, and in 1908 signals reached warships 3,000 km away, and coastal stations in Algeria, Ireland and even North America. From 1912, the Tower's transmissions could be received all around the world. It had become a location of great strategic importance.

The telegraph station at the top of the Eiffel Tower continued to prove its usefulness in a number of areas. In 1912, it was chosen as the base station for the worldwide transmission of time signals, which meant that, from then on, every clock on the planet was set to the time relayed from the Champ de Mars.

Opposite:
The first wireless communication in France, between Ernest Roger, seen here at the top of the Eiffel Tower, and Eugène Ducretet, stationed at the Panthéon, on 29th July 1898.

Below:
The Eiffel Tower acting as a radio mast in around 1914. Six antennae were connected to the ground by cables stretched from the top of the Tower and anchored to concrete piers before running through a square hole into the underground wireless station. The latter was destroyed by floods in 1910 and subsequently rebuilt.

Bottom right:
A soldier standing beside the cable anchorages in around 1914.

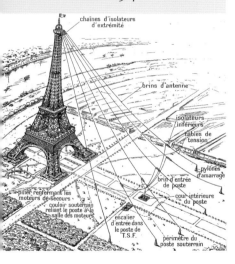

Panama and after...

The Tower even played a crucial role during the Great War. Having been requisitioned by the military at the start of the conflict, in July 1914, it succeeded in capturing enemy messages only a few weeks later. As a result, the French army, which had set up a communications centre beneath the Champ de Mars, knew that enemy troops were preparing to march on the capital. Twelve hundred Paris taxis were immediately requisitioned, to transport 6,000 troops to the eastern front, where they halted the German advance at the famous Battle of the Marne. There would be no further calls to pull down the Tower; its services to the nation had made it indispensable. In January 1917, another coded message was intercepted by the communications centre beneath the Tower, which led to the arrest of Mata Hari.

Other nations, no doubt impressed by the global impact of Eiffel's great monument, invited him to construct something similar in their country. Eiffel declined all such invitations: there could be only one Eiffel Tower—in France. Meanwhile, like so many other businesses, the Auteuil laboratory was forced to close at the outbreak of war. In 1915, the Ministry of Defence contacted Eiffel, who was approaching 83 but still in good health, and asked him if he would again put himself at the service of his country. Eiffel's patriotism was never in doubt, and he duly made the Auteuil laboratory available to the military aviation authorities (it was the only such facility to be in use throughout the war), took part himself in the work undertaken there and wrote off the costs of the entire operation. His advice was also sought by France's allies, Italy and Japan, the latter awarding him the Imperial Order of the Rising Sun—yet another decoration to pin to his sagging lapel.

Bottom left:
"Marne taxis" on the Rue de Rivoli by the Tuileries Gardens in 1916.

Below:
Eiffel's sugar ration card for the year 1917.

Opposite:
A letter to Eiffel from his son-in-law Camille Piccioni (1859–1932), Valentine's husband, whose photograph appears in the background, dated March 1917. Before telling Eiffel his own news, he informs him of "the request of His Royal Highness the King of England" to be sent "a recent document showing [his] signature", adding that "The great service rendered by the Tower in relation to Allied communications is sufficient in itself to justify the King's flattering interest" (see translation on page 169).

Affaires étrangères

Direction des Affaires politiques et commerciales

Sous-Direction des Archives

11 mars 1917.

Mon cher frère,

La lettre ci-jointe de M. Paul Cambon vous mettra au courant du désir de Sa Gracieuse Majesté Britannique. Je pense que vous voudrez bien donner un spécimen récent de votre signature, et je me charge de le transmettre à M. Paul Cambon par notre valise quotidienne. Vous voudrez bien me retourner la lettre de l'Ambassadeur, à moins que vous ne préfériez la conserver. Les grands services rendus par la Tour aux communications inter-alliées suffiraient à eux seuls à justifier la flatteuse curiosité du Monarque.

Marcel est arrivé cette nuit d'Albert. Il a laissé sa division en marche et en tête des forces britanniques ; une nouvelle avance de ces derniers est imminente. La prophétie du Colonel Fyler se réalise : l'ennemi est obligé de retirer son front !...

En attendant, nous avons Marcel en permission pour dix jours. Il est enchanté, malgré les grands froids qu'il a subis, de la discipline et de l'organisation anglaises. "On se sent tout le temps commandé !" Quel rêve ! et comme l'organisation du Quai d'Orsay m'a permis de le réaliser rarement ! Ici on prépare une nouvelle crise ministérielle ; je n'en éprouvais pas le besoin !... Heureusement les nouvelles d'ailleurs (Washington compris) sont bonnes.

Valentine, Marcel et Jacques se joignent à moi pour vous embrasser de tout cœur, en vous priant de ne pas nous oublier auprès du Ministre et de transmettre à Claire et à Ninette nos plus affectueux souvenirs,

Pierre

Panama and after...

While it is true that Eiffel's interest in aeronautics dates from before the First World War, it cannot be said that it was motivated solely by a passion for progress. From the outset, Eiffel sensed that, in the event of war, aviation would play a significant and perhaps even decisive role.

Germany, too, was investing in aviation research, and its military command considered Eiffel's work so important that it commissioned a German translation of his *New Research into Air Resistance and Aviation*, the fruit of his work at the Auteuil laboratory, which was published in France in 1914, just before the outbreak of war. As can be imagined, the Germans did not ask Eiffel's permission to translate his findings and use them against his country.

The tests carried out at the Auteuil laboratory were not restricted to aircraft. The Ministry of Defence, having finally realized the importance of wind tunnel testing, insisted that tests also be carried out on shells and bombs, with the aim of maximizing their destructive power. Aircraft had not yet been fitted with bomb bays, which meant that pilots had to carry the devices in their laps and drop them by guesswork, when they thought they were over the target area. Not only was this method somewhat haphazard, but the fact that pilots had to carry bombs in the cockpit and manhandle them themselves also added to the dangers they faced. Eiffel and his friend Abraham Louis Bréguet were the first to devise a solution to these problems.

Not content with that, Eiffel designed an aircraft that incorporated everything he had learned from his experiments and patented it on 16th May 1917. It was called the "Avion L.E.", which stood for Laboratoire Eiffel. This revolutionary concept was the forerunner of modern aircraft. Its fuselage was shaped like a rocket to enable it to break all speed records. Eiffel calculated that it would fly at over 250 km/h. He naturally specified the metal it should be made from—duralumin, a light alloy of aluminium, copper and magnesium—and Bréguet volunteered to build it. By March 1918, the prototype was ready for its test flight at the Villacoublay air base near Paris. Sadly, Bréguet had chosen a young and inexperienced pilot to put it through its paces. The plane reached a staggering 250 km/h before crashing. The pilot was killed instantly. There were no further test flights, and the project was abandoned.

After the signing of the armistice in November 1918, the Tower was "demobilized" and resumed civilian duties, its life expectancy having been extended to 1945. For the next two years, Eiffel dedicated himself to his wind tunnel experiments, going to the Auteuil laboratory every morning to supervise work and devise new types of test to drive the research programme forward. If he had to leave Paris, he would insist that his staff write to him twice a week to update him on the work they were doing, which he constantly criticized. If they failed to maintain absolutely regular contact, he would fly into a rage. Before he retired, he wanted to achieve one more thing: to become a Commander of the Legion of Honour, a distinction he believed his wartime services to the nation should more than entitle him to. His application was supported by the aircraft manufacturers, but it was not to be; the award was vetoed by the Secretary General of the Ordre national de la Légion d'honneur, who, at the time of the Panama crisis, had worked at the Ministry of Justice and had done his utmost to incriminate the accused, including Eiffel. Gustave gave up hope. The wounds inflicted by the Panama affair would, it seemed, never heal.

Below:
Eiffel and his colleague Antonin Lapresle in the wind tunnel control room at the Auteuil laboratory in 1913.

Opposite:
Front and side elevation and plan of the "Avion L.E.", which Eiffel patented in 1917. It was the first aircraft to have its wings set below the fuselage.

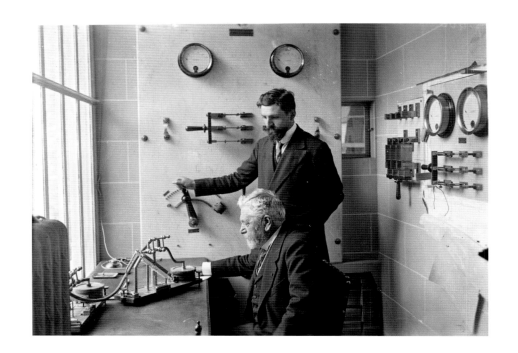

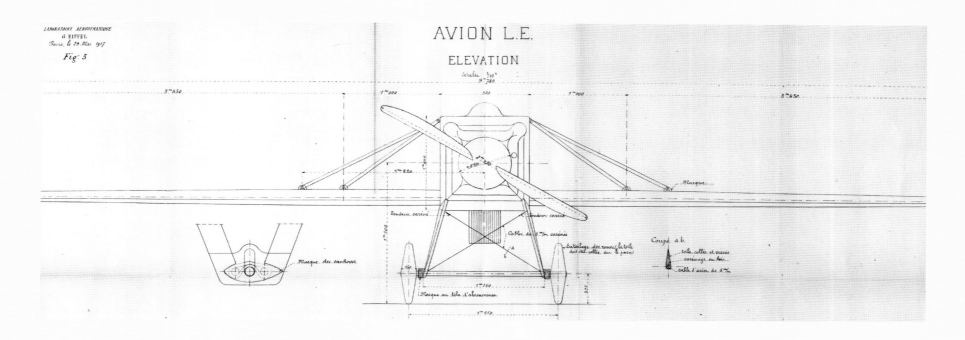
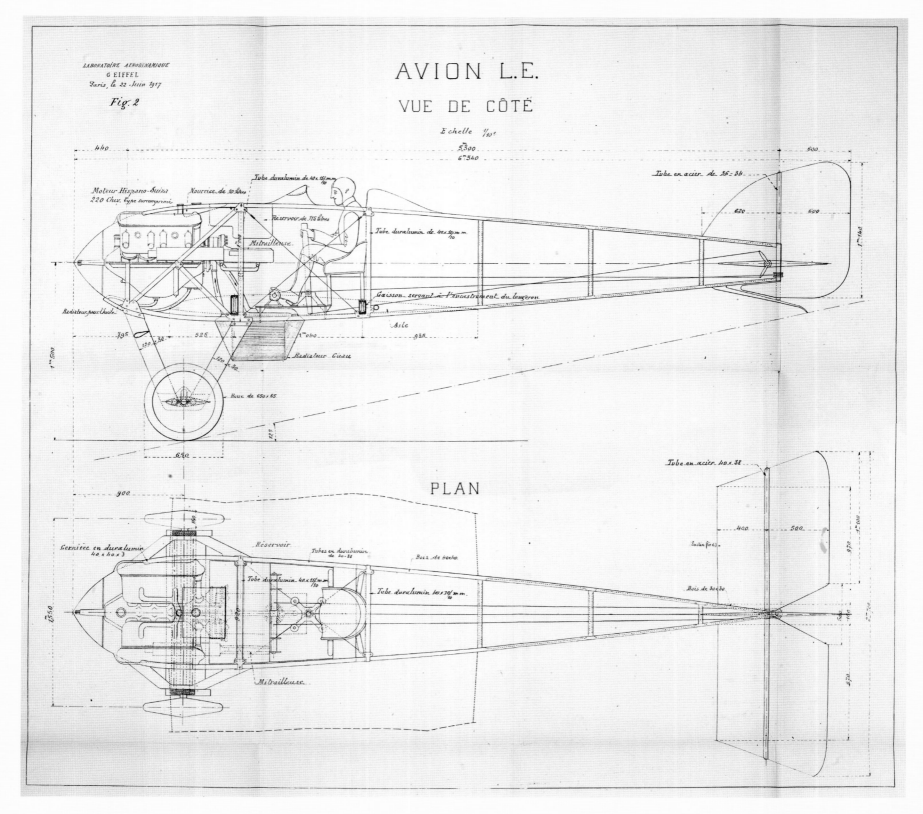

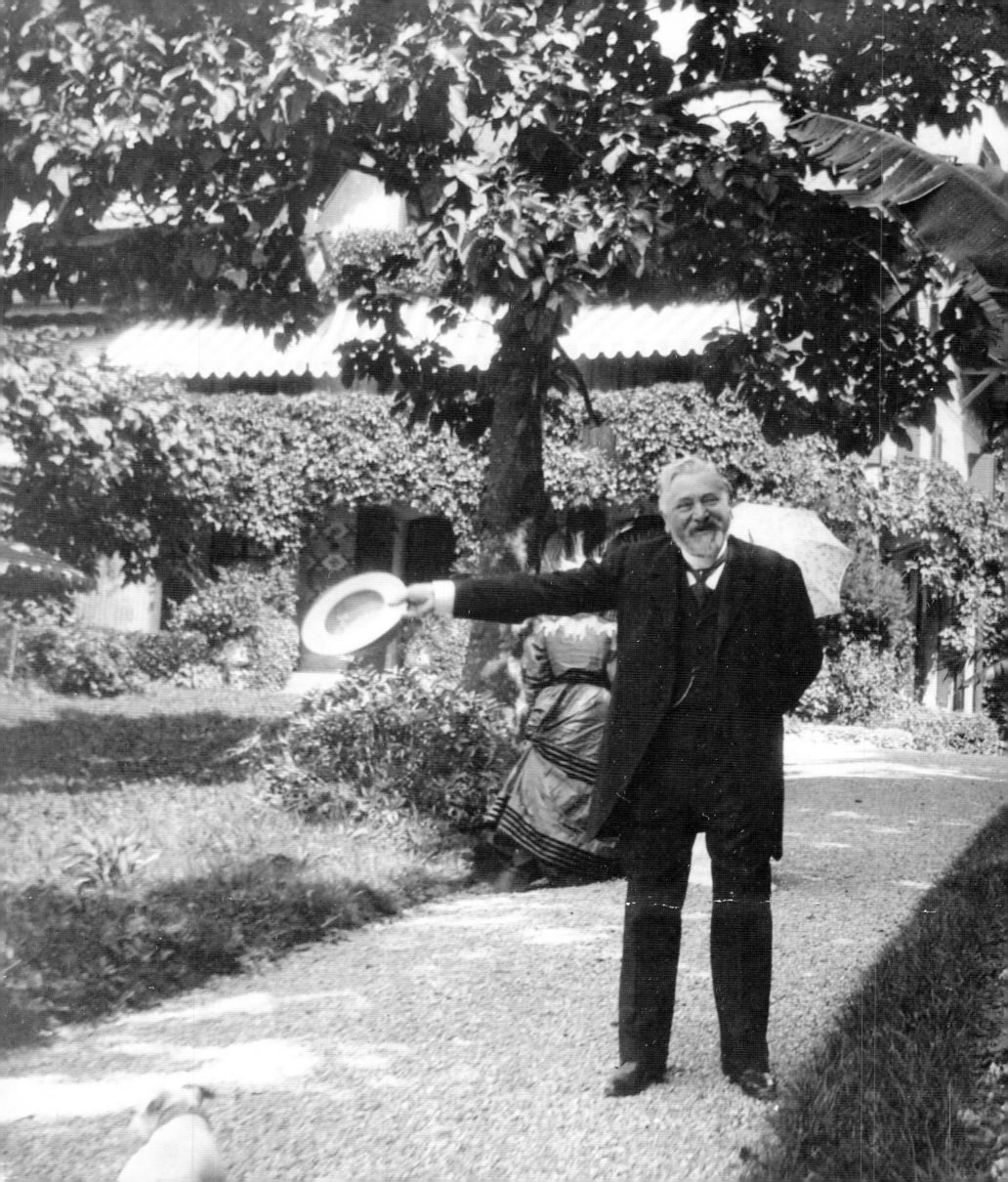

Panama and after...

Opposite:
A joyful Gustave in the garden of the Villa Salles in Beaulieu-sur-Mer (Alpes-Maritimes) in 1919.

This page:
It was in this idyllic setting, the house and gardens overlooking the sea, that Eiffel enjoyed a well-earned "retirement" and wrote his "moral, scientific and industrial testament", dedicated to his children.

Following pages:
A rare and candid snapshot of Gustave Eiffel in the drawing room of one of his other properties, the Villa Claire in Vevey, Switzerland. It is as if we were looking over the balcony...

At the venerable age of 88, after publishing a final work on the study of propellers, Eiffel at last decided to allow himself a well-earned rest. To ensure that his work would continue to serve his country after his death, he signed over both the lease and the management of the Auteuil laboratory to the military aviation authorities. The only things he asked in return were a key and an office, so that he could go and work there whenever he wished. Thereafter, he spent most of his time at Beaulieu-sur-Mer, where the climate was warm, but not so warm as to lull him to sleep, since he had yet to draft his four-volume autobiography and put his affairs in order. He also made use of his time by taking an interest in the new art of the cinema, which had been created in 1895 by the aptly named Lumière [Light] brothers. Convinced that it had a bright future, he purchased shares in the the Gaumont film company. One day, he was asked by the principal of the school adjacent to the Auteuil laboratory to link it to the wind tunnel's electricity supply. It meant that the pupils could watch films.

On 30th December 1921, a few days after Eiffel's 89th birthday, the first French radio broadcast was transmitted from the top of the Tower. There were to be regular broadcasts from 1925, but Eiffel was no longer around to hear them. Nor, sadly, was he able to see the first television programmes, which were broadcast from the Tower in 1935. He would have been proud indeed to be once again at the forefront of progress.

CHAPTER V

THE PATRIARCH

In the twilight of his life, the great man gathers his loved ones around him and passes on his values: the family, goodness, beauty.

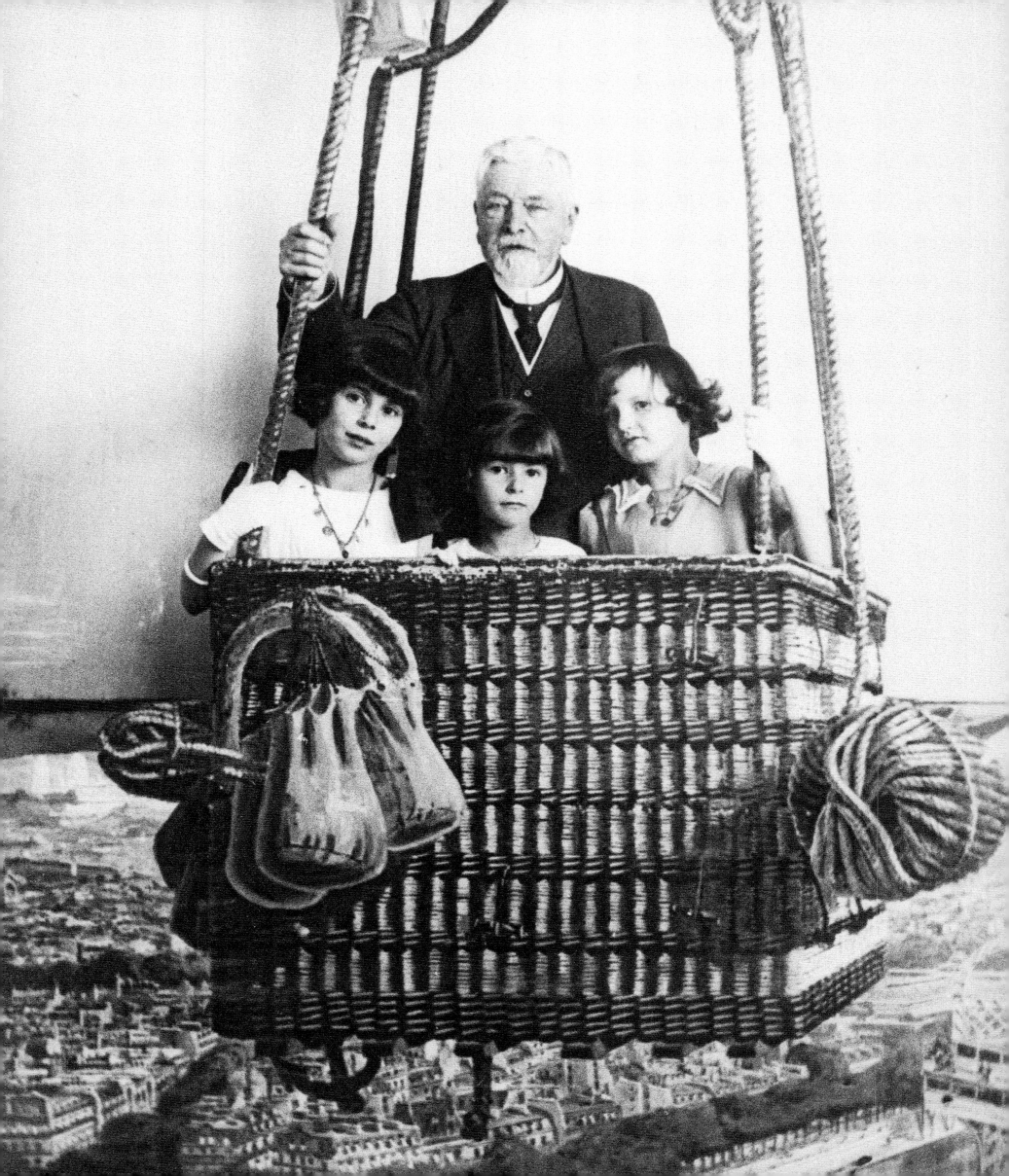

Opposite:
Gustave with three girls, including his great-granddaughter Janine Salles (1913–1999), in the basket of a balloon flying over (a painting of) Paris.

Below:
Gustave and his daughter Claire aboard La Walkyrie, *the steamboat he kept at Vevey.*

The patriarch

Benevolent authority

In 1890, Gustave bought a mansion in the Rue Rabelais, in the 8th arrondissement of Paris, and moved there with his daughter Claire and her husband Adolphe Salles. It was the first of several property purchases. Next came another mansion called "Les Bruyères" in Sèvres, west of Paris, which would be the family's holiday home for many years, and then a large house in Vevey beside Lake Geneva, on what was then known as the Swiss Riviera, which had its own mooring (see photograph on page 8). When they were here, the family would take daily trips aboard *La Walkyrie*, a steamboat Eiffel named in homage to one of his favourite composers, Wagner. Eiffel himself designed an extension to the house: an iron-framed conservatory, which he used as his office. After Valentine's death, the house was sold to a multinational, which decided to locate its headquarters there and knocked it down.

These acquisitions were followed by purchases in Beaulieu-sur-Mer on the Côte d'Azur—along with a yacht called *Aïda*, in Ploumanach on Brittany's "Pink Granite Coast", and in Vacquey near Bordeaux, an area Eiffel had fallen in love with 35 years earlier when he had been sent there to build a railway bridge. The final addition to the property empire Eiffel amassed in these few years was the "Villa des Flots" at Trouville-sur-Mer in Normandy. For Eiffel, it was not simply a matter of investing his wealth in bricks and mortar, but also a question of having room to bring together a family that had grown considerably as a result of marriages and the arrival of children. My generation was the last to benefit from these marvellous places, where Eiffel's memory still hung in the air and where I spent magical and memorable holidays. The only properties that are still in the family are "Ker Awell", the House of the Wind, in Ploumanach, the hunting lodge of the Château Vacquey, to whose roof Eiffel added a guard rail so that he could perform his experiments in safety, and an outbuilding of the house at Beaulieu. There are now so many of us—more than 80—that it is difficult for us all to get together in one place.

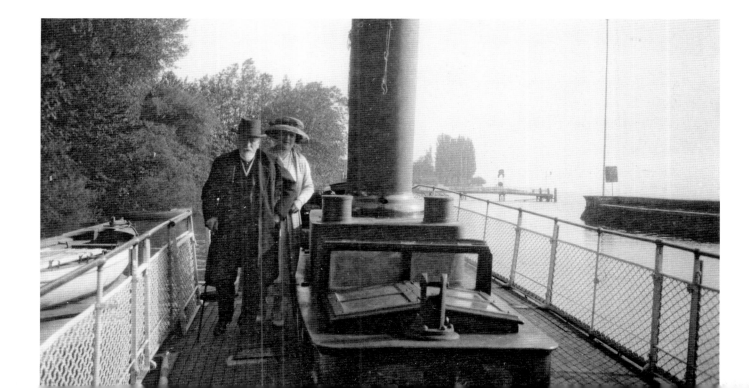

Left:
Gustave on a horse in front of the Château des Bruyères in Sèvres, in around 1897.

Below:
Clockwise from top left: The Villa de Vevey in Switzerland, the Château Piccioni in Corsica, a wine label from the Château Vacquey near Bordeaux, which Eiffel gave to his son Édouard, and the house at Ploumanach in Brittany.

Opposite:
Aerial view of the seafront villas at Trouville-sur-Mer in around 1900. Eiffel's property, "Les Flots", is on the right.

Following pages:
Gustave with his grandsons Robert and Georges Salles and two young women sailing in Beaulieu harbour, in around 1895.

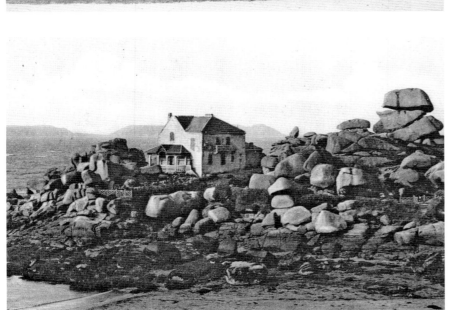

PLOUMANACH. — Villa Eiffel et Chapeau de Napoléon. — LL.

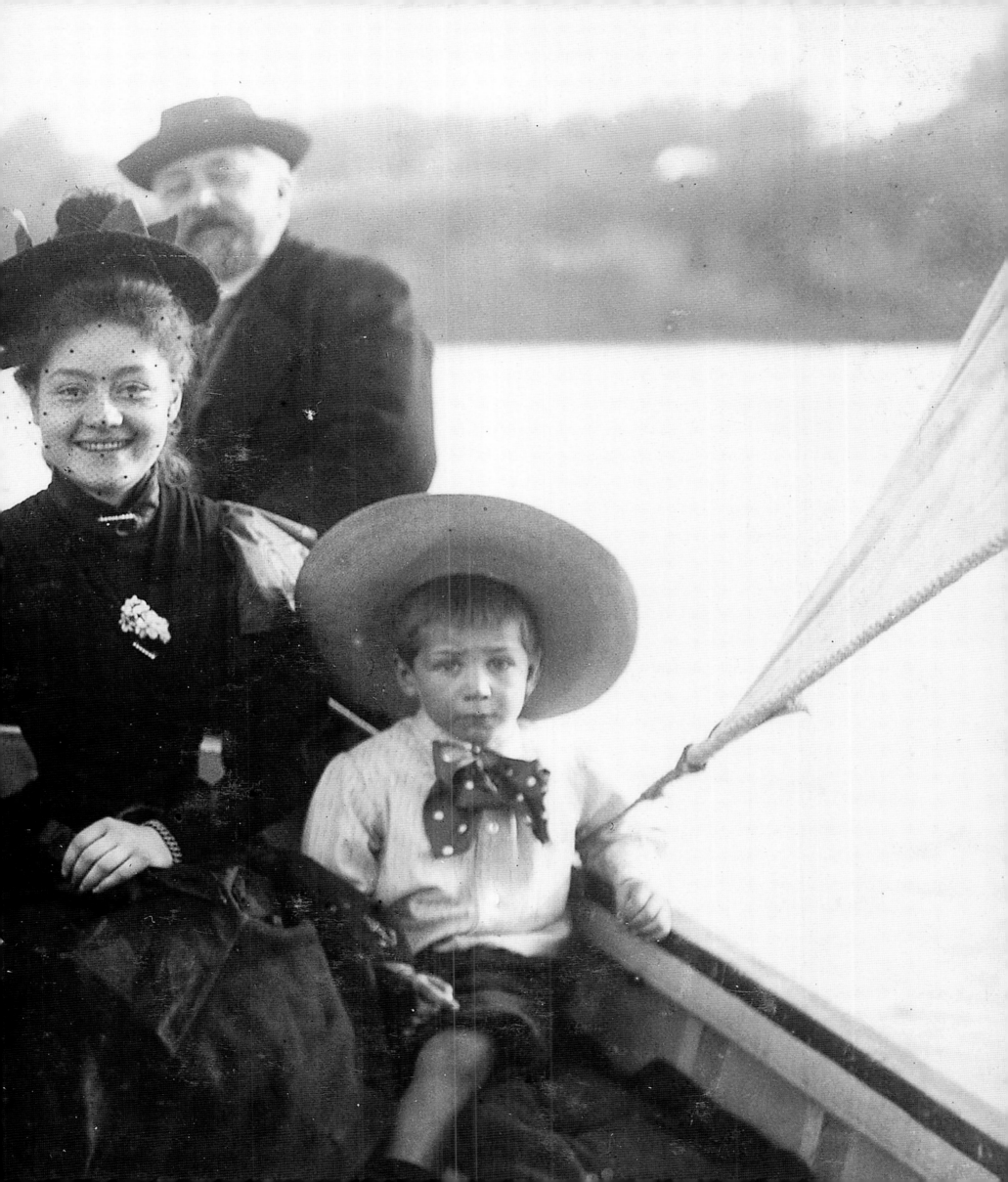

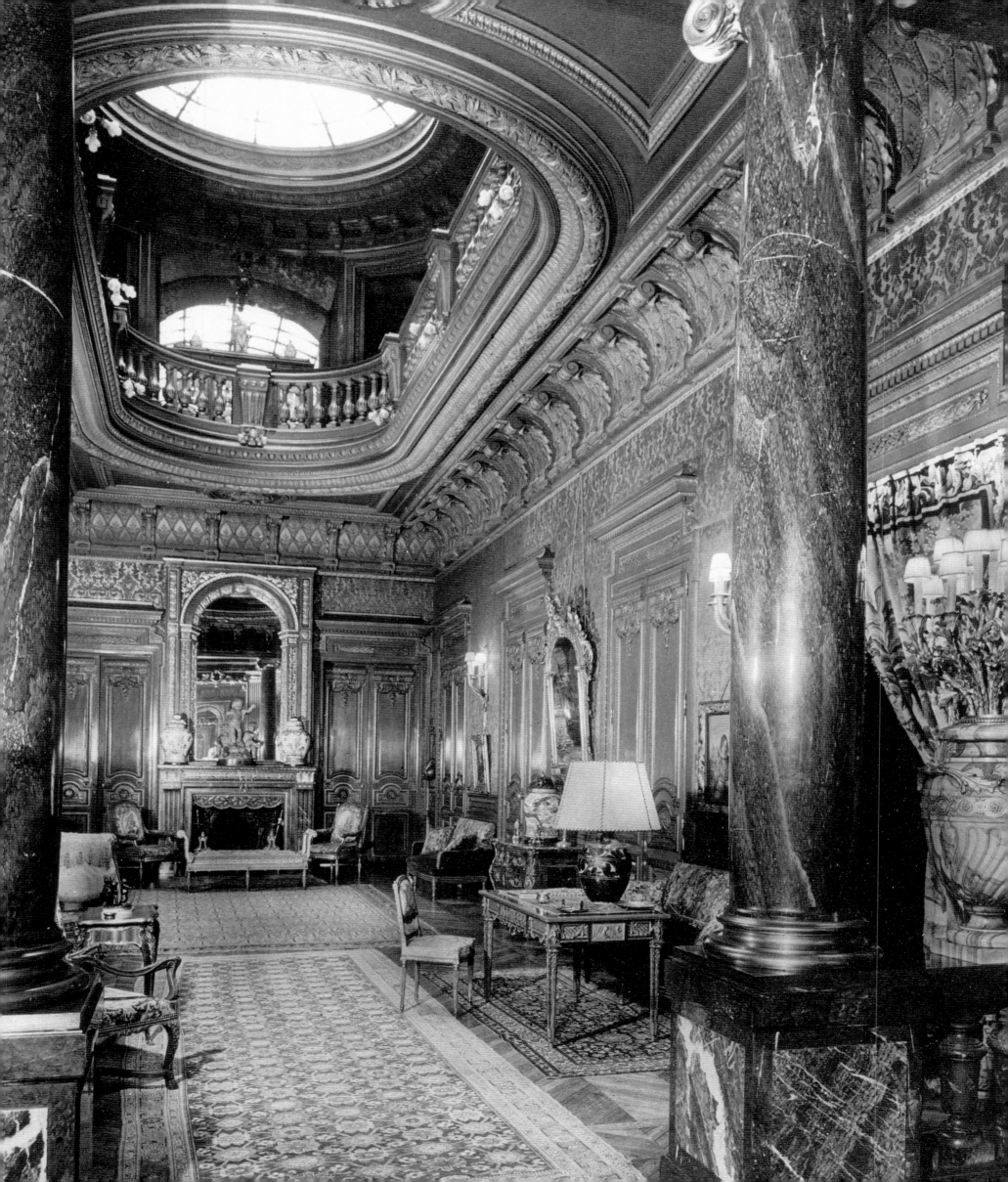

The patriarch

Opposite and right:
The drawing rooms of Eiffel's mansion at 1 Rue Rabelais in Paris, which was designed by Henri Parent. The property no longer exists.

Below and far right:
The interior courtyard of the mansion and Eiffel's business card with the address at the bottom.

Eiffel turned one of the rooms in his Parisian mansion into a theatre. From his time in the capital in his younger days he had retained a love of music and drama, and the whole of Paris flocked to no. 1 Rue Rabelais for extravagant dinner parties. Claire was responsible for getting the house ready, devising the menus, which had to be approved by her father, receiving the visitors and generally ensuring that everything ran smoothly in order to maintain the Eiffels' reputation. Gustave's other children soon came up with a nickname for the house, which was generally known as "The Ministry" on account of the fact that its regular visitors included most of the government ministers of the successive administrations of the Third Republic. And Eiffel himself became a sort of potentate, presiding over his descendants with authoritative benevolence.

Eiffel — The patriarch

Right:
The Eiffel family at the traditional gathering on 15th December, Gustave's birthday. His daughter Claire is far right and Valentine is in the centre, beside her father.

Below:
Printed invitations and handwritten menus with painted decorations were de rigueur. The Eiffels loved to party; the photograph shows them celebrating the grape harvest in 1905.

Every family has its rituals, and Eiffel's observed two in particular. One was the paterfamilias's birthday, on 15th December. This was the occasion for a lavish celebration to which not only members of the family were invited but also distinguished guests, who came to pay their respects to a national treasure. For a time, the Panama affair kept away the opportunists and self-seekers, but they came back as soon as the scandal was over, if not forgotten—drawn by the beanfeasts on offer at The Ministry. These parties sometimes attracted more than a hundred people, who were treated to a show and danced until the early hours. The grandchildren were not left out. They had to recite a poem or perform a short play in front of the guests, and under the watchful gaze of their grandfather—a requirement that terrified more than one of them. There were also speeches by invited dignitaries in homage to their host, who was not one to shun flattery. A native of Burgundy, Gustave always retained his guttural accent, as well as a taste for good wine and fine food. The birthday party menus at Rue Rabelais betray his predilection for foie gras, game and ice-cream. Actors from the Comédie Française performed on the stage of the in-house theatre, musicians played works by contemporary composers such as Debussy, Lalo, Fauré, Offenbach, Tchaikowsky and Rachmaninoff, and singers from the Paris Opera delighted guests with the great arias as well as lieder.

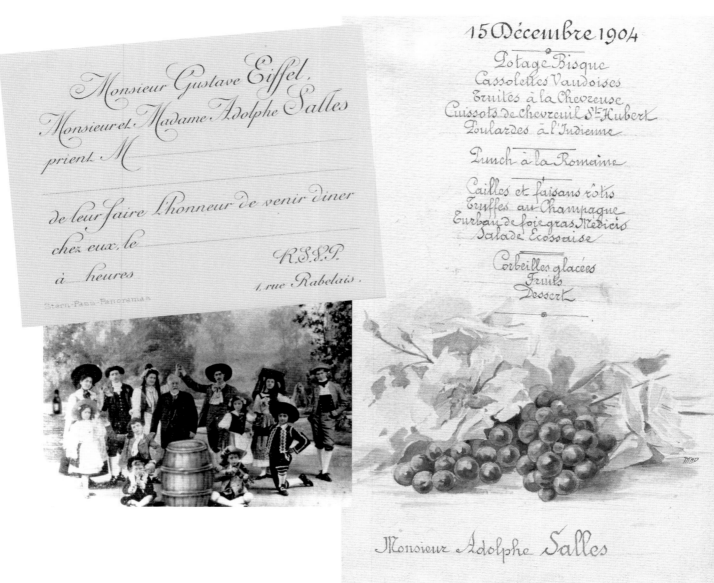

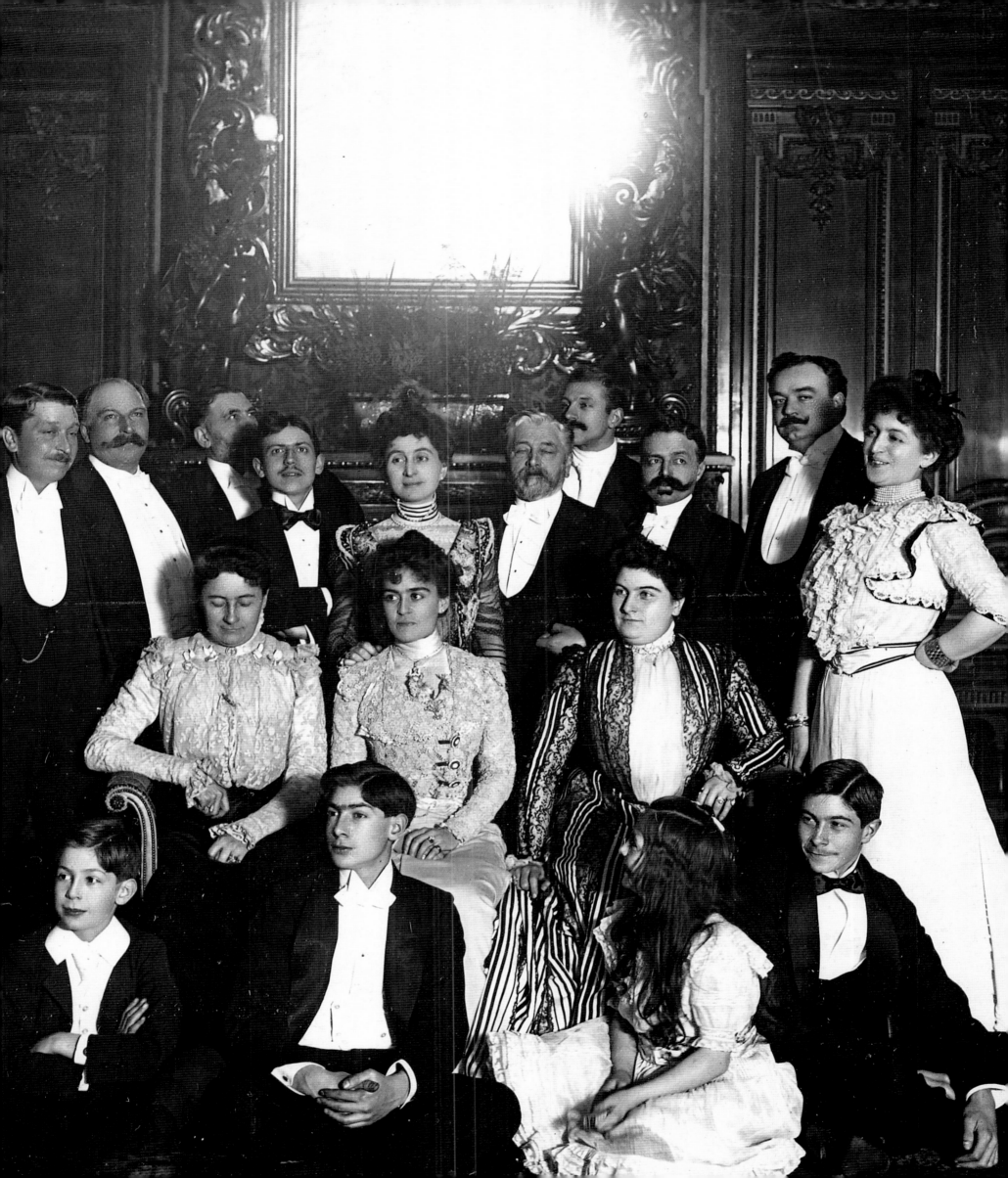

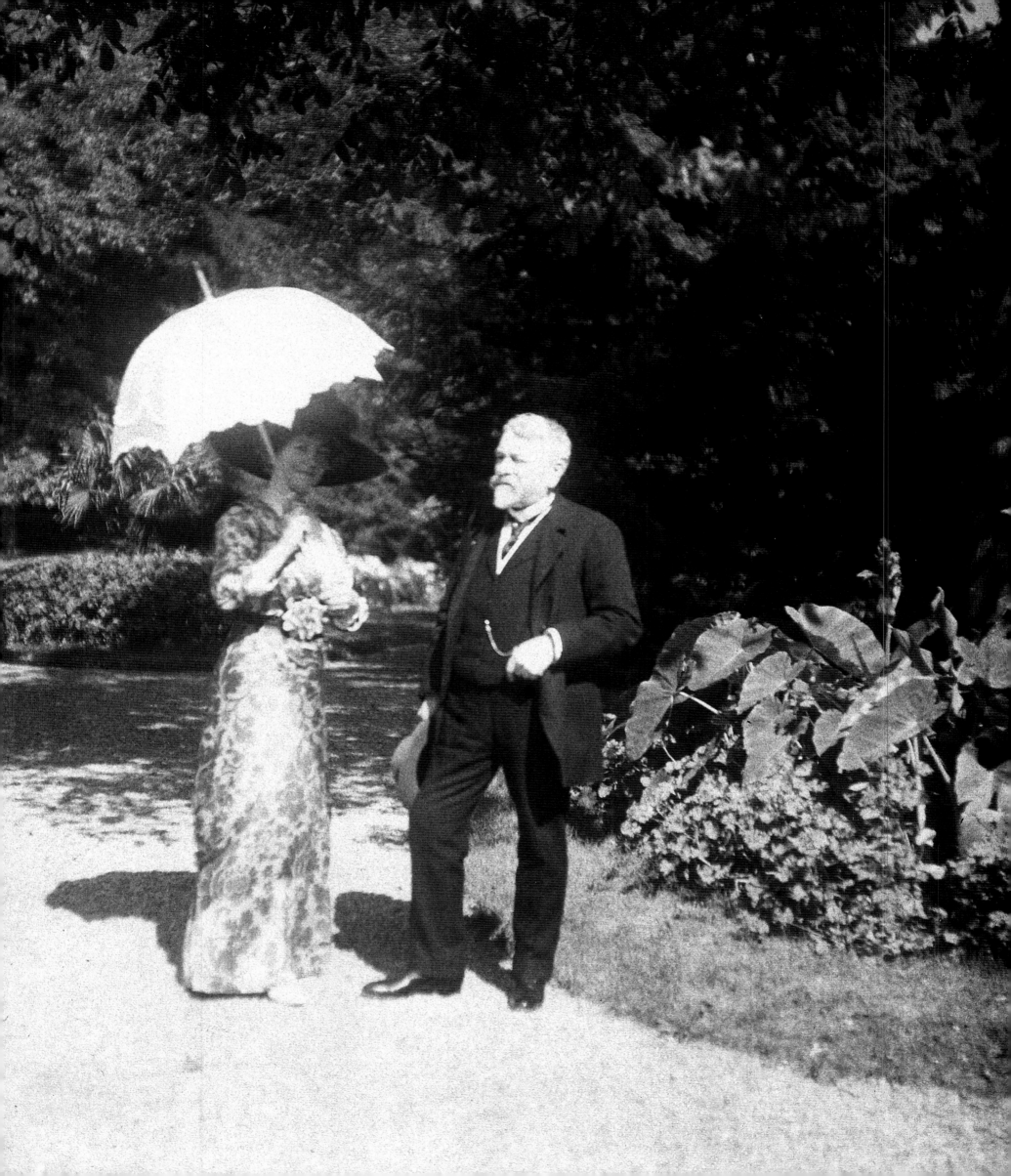

The patriarch

Opposite:
Gustave with his beloved daughter Claire in the gardens of the Villa Salles in Beaulieu-sur-Mer.

Below:
Ordinary documents belonging to an extraordinary man: Eiffel's telephone card, passport and voting card.

The other ritual celebration was usually held at the house in Vevey, because it took place on 12th August every year, Claire's saint's day. Eiffel had chosen the date to show his gratitude and affection for his eldest daughter. A special bond had existed between them since the day Claire had bravely taken over from her mother, who had died prematurely, the role of looking after her father. Gustave would always make a speech extolling his daughter's virtues and expressing his affection for her. He would also present her with a gift, usually jewellery. Eiffel assigned the house in Vacquey to Édouard, who would rather have lived in Paris, where he could have more fun, but his father had decided otherwise. Édouard had little interest in agriculture, from which he was supposed to earn a living, but Gustave, as he did with everyone and everything, supervised and controlled, not to say terrorized, his son. He would send Édouard letters reminding him to put fertilizer on the vines or to take cuttings from the fruit trees. The house at Ploumanach went to Albert, who found the light ideal for painting—a pastime to which he could devote as much time as he wished, since his father paid him an income. Being the son of a great man is not easy. Eiffel did not put the same pressure on his daughters as on his sons. They had only to find a suitable husband and produce children, whereas he expected the boys, if not to live up to his own achievements, at least to make themselves worthy of his succession. Albert and Édouard were both crushed by their father, and neither made a career. In his autobiography, which he wrote at the end of his life, Eiffel devoted several pages to the qualities of his daughters, to their husbands and to the grandchildren who were old enough to fight for their country in the First World War. He afforded considerably less space to his sons, restricting himself to an assessment of their contributions to the war effort. From those few lines it seems that Gustave was less proud of his sons than he was of his sons-in-law. He appointed Adolphe Salles, who married Claire, as his assistant, and of Laure's husband, Maurice Le Grain, a graduate of the École Polytechnique and manager of various industrial firms, he made a point of saying that he had made "a career in engineering and machine-building". Here, without doubt, was a man after his own heart. But the best marriage, in the sense in which a "good marriage" was understood by the upper-middle classes at the time, was unquestionably that between my great-grandmother Valentine and Marquis Camille Piccioni, who came from a noble family in Corsica and, after joining the diplomatic corps, acquired the grandiose title Minister Plenipotentiary First Class. Eiffel would forever be impressed by him, while Piccioni's extreme politeness towards his father-in-law concealed the fact that, in private, he referred to him as a parvenu, which was not exactly a compliment coming from a person of aristocratic lineage. Right up until his death, and even beyond it, Gustave Eiffel continued to exert dominion over his little world. When he came to put his affairs in order, he drew up a will that favoured his daughters—Claire somewhat more than Laure or Valentine. And his heirs were duly warned: if any of them should contest the will after his death, Claire would inherit everything. The warning was well heeded and no one questioned Eiffel's final wishes.

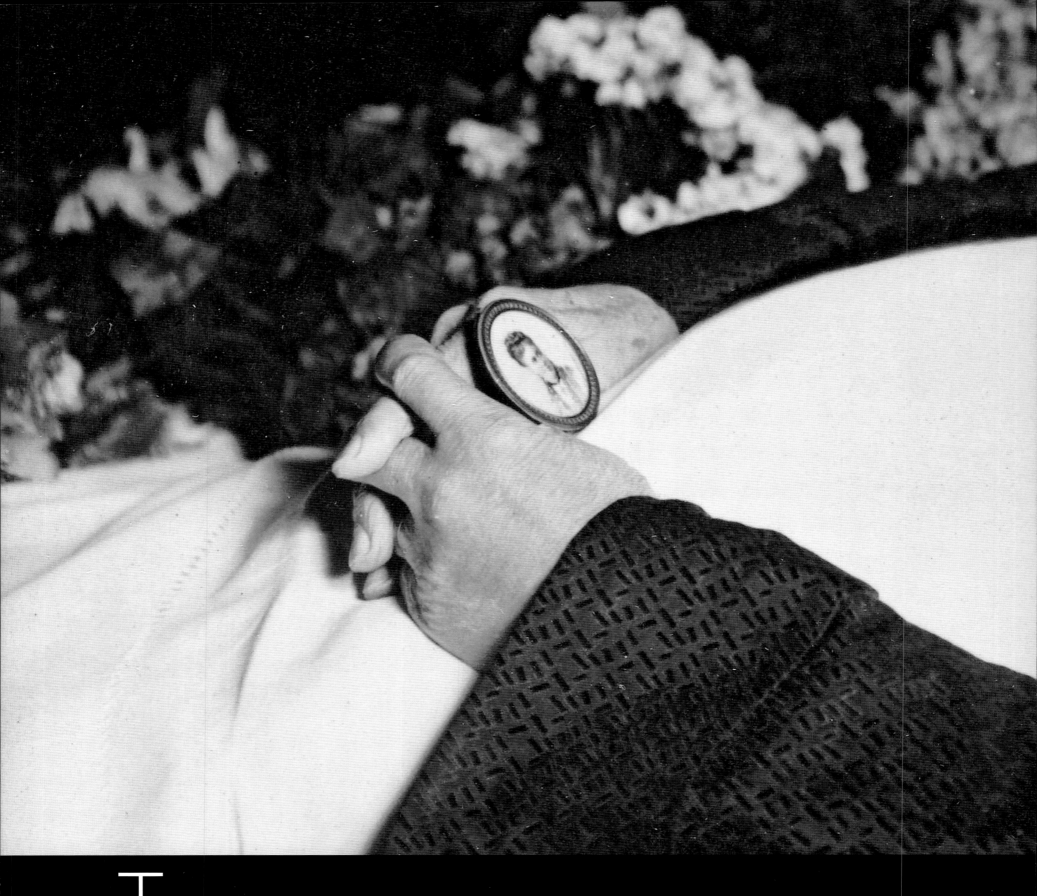

The beginning of the end came in June 1923, when Eiffel suffered a debilitating stroke, which affected his speech and clouded his mind. On his 91st birthday, he nevertheless attended the ritual celebration, organized by Claire, but a few days later, on 27th December, he passed away. Within just two days, his son-in-law Adolphe Salles died suddenly, and so Claire lost both her father, to whom she had been so close, and her husband of 38 years.

At Gustave's funeral, where workers and staff from the Eiffel Tower rubbed shoulders with celebrities who had come to send off the most remarkable man the world of engineering had seen that century, including the First World War hero Marshal Joffre, his friend Abraham Bréguet paid a final tribute to him. Eiffel was buried in the cemetary at Levallois-Perret, where he remains to this day—a few hundred metres from the workshops that saw the start of his meteoric career.

The patriarch

Obsèques de Monsieur Gustave EIFFEL

Cérémonie Religieuse

Entrée : Mort d'Ase (instruments)	Grieg
De Profundis plain chant	
Ego Sum (Instruments & Choeurs)..	Gounod
Kyrie (Choeurs)	Beethoven
Prose (quelques versets) plain chant	
Prière (Instruments)	César Franck
Pie Jesu .. (Ténor)	G. Fauré
Judex (Instruments & Choeurs) ..	Gounod
Libera (Instruments & Choeurs) .	Rousseau
In Paradisum	Fauré
Sortie : Marche Funèbre de Jeanne d'Arc (Deux orgues et Instruments à cordes).	Gounod

Monsieur Gustave Eiffel
Inhumation au Cimetière de Levallois-Perret
où les discours seront prononcés

Above:
Gustave Eiffel on his deathbed. In his hands is a medallion bearing a portrait of his wife.

Right:
The invitation to Eiffel's funeral on 31st December 1923 at Levallois-Perret and the list of music chosen to accompany the ceremony.

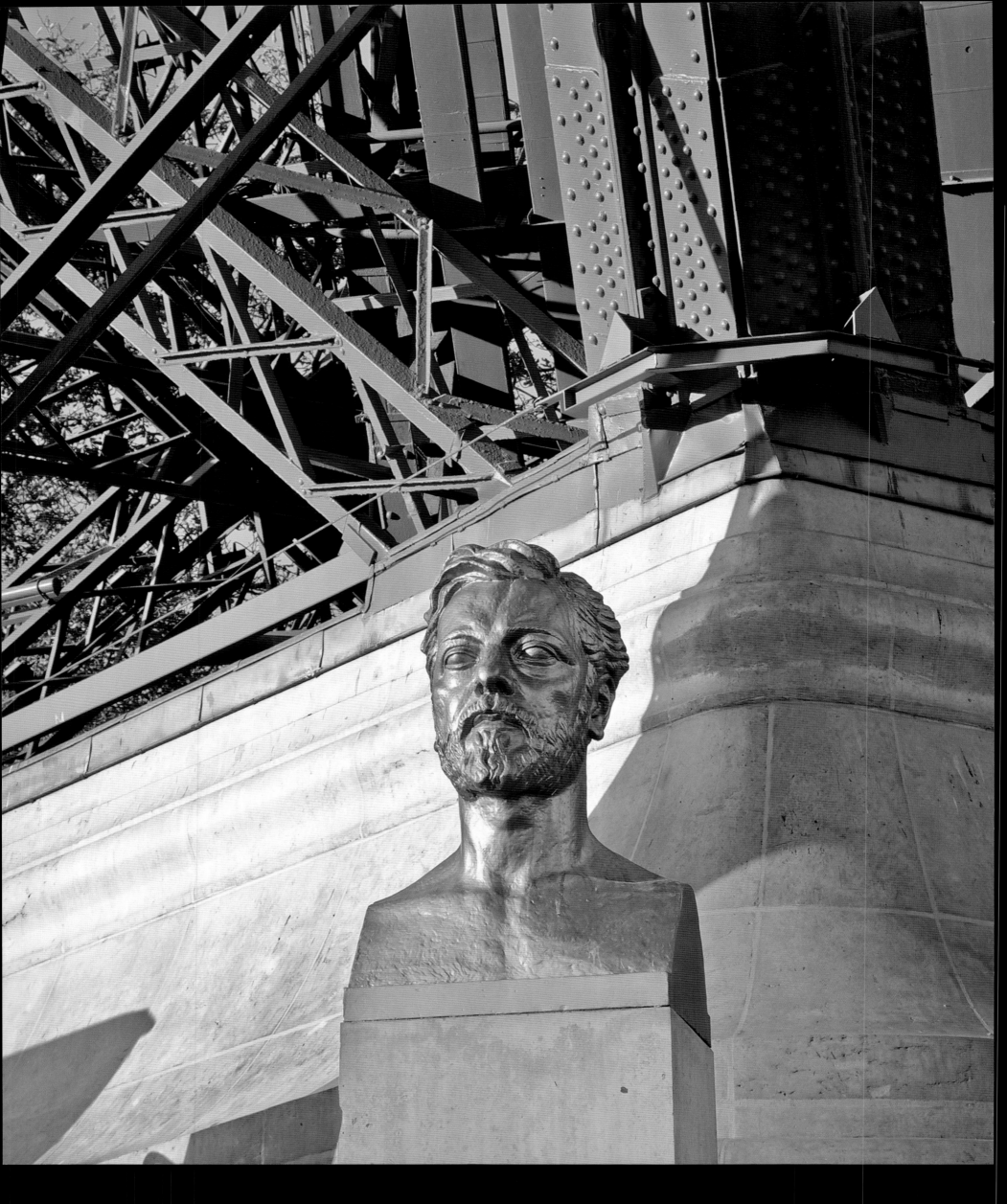

The patriarch

Light and shade

Opposite:
The gilded bronze bust of Gustave Eiffel by Antoine Bourdelle at the foot of the Eiffel Tower's north pillar, where it was placed in 1929.

Below:
Philippe Coupérie-Eiffel at home at the Château Bacon near Bordeaux; behind him is one of the bronze statues of Gustave Eiffel that were given to each of his children.

To be one of Gustave Eiffel's descendants is to live a paradox. My childhood was bathed in a golden light emanating from the 19th century, from a man I never knew; rather like the light we can still see radiating from suns that died millions of years ago. I also live in a shadow: that which the great man has cast over all those who bear his name. It is as if the Tower's fame has made us all inconspicuous. There can be only one outstanding Eiffel: Gustave.

My great-grandmother Valentine took a particular liking to me, possibly because I was the only boy of my generation and because I looked like her son Jean when he was a boy. She lived in the mansion her husband Camille Piccioni had bought, on the corner of the Rue de Bassano and the Avenue d'Iéna in the 16th arrondissment of Paris, where Jean and his wife also lived. Valentine was as accomplished a housewife as her sister Claire, intelligent and assured, and always elegant. One Christmas Eve, she had an argument with her cook, who hung up his apron and walked out. Unperturbed, she rolled up her sleeves and prepared dinner for her 30 guests herself. Her sister Laure, my great-great-aunt, often came to see her. Laure was a delightful old lady, who loved children and was happy to play with them. I was the only one of the great-grandchildren who was allowed in Valentine's bedroom, or at least the only one who was allowed to spend hours there. She would talk about her father with great admiration, hoping that I would follow in his footsteps. Unfortunately, maths was not my strong subject and I had neither the aptitude nor, I must admit, the discipline required to be an engineer. Yet Valentine did all she could to inspire me to make architecture my vocation. For example, she gave me all kinds of model Eiffel Towers to build: cardboard ones, metal ones, wooden ones… I really enjoyed making them—as long as it was just for fun.

With the arrival of the summer holidays we began our annual pilgrimage, which took us from the Château Piccioni on the northern tip of Corsica to Vevey via Beaulieu-sur-Mer, Trouville and Ploumanach. Valentine took half her household with her wherever she went—even her silver dinner service. She still lived the way she had before the War, and no one could have convinced her that times had changed. We lost her in 1966, and not a week passes without my thinking of her. It is her memory that gives me the strength to continue my struggle to keep Eiffel's name alive.

My illustrious ancestor's work lives on—not only on the Champ de Mars and in the Panama Canal, but in some 15 other countries, where his creations are still in use. Panama will soon be celebrating the Canal's centenary, whose capacity will be doubled by major redevelopment. The new locks were built according to Eiffel's designs, drawn up 120 years ago—which goes to show that no one has bettered them since. A monument is to be erected to commemorate the Frenchman's contribution to the Canal: a 120-metre-high lighthouse made of metal, along with a copy of his laboratory of aerodynamics as a testament to Eiffel's achievements in the field of scientific research. This posthumous recognition will at last validate what history has masked: that the construction of the Canal would not have been possible without my great-great-grandfather's input. After all the years I have spent promoting both the man and his work, I shall have the honour of being officially invited to take part in this tribute.

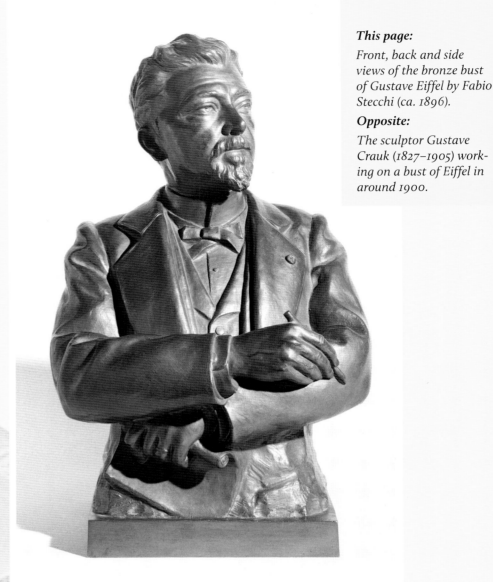

This page:
Front, back and side views of the bronze bust of Gustave Eiffel by Fabio Stecchi (ca. 1896).

Opposite:
The sculptor Gustave Crauk (1827–1905) working on a bust of Eiffel in around 1900.

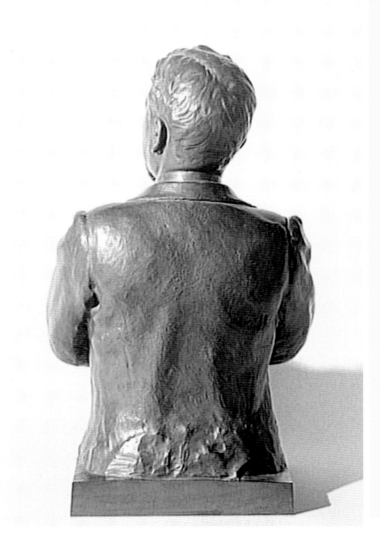

Yes, I am proud and happy to dedicate what remains of my life to a man I never even knew, because his genius, his devotion to his country and the global resplendence he gave it deserve such dedication. "Great men merit their country's recognition" is the inscription on the facade of the Panthéon in Paris. Gustave Eiffel may not have been allowed within those hallowed portals, but should not at the very least a museum have been dedicated to him? For, incredible as it may seem, Paris has not yet deemed it worthwhile to create a Gustave Eiffel Museum. Perhaps it is thought that the tower that bears his name provides sufficient recognition. Yet I continue to hope that such a museum will be opened one day, and that I shall be there to see it. This book should be enough to show that there are many aspects to my ancestor's work other than the Eiffel Tower that are worthy of being exhibited for the interest and edification of the general public. The Auteuil laboratory is now a listed building; it would seem the ideal location…

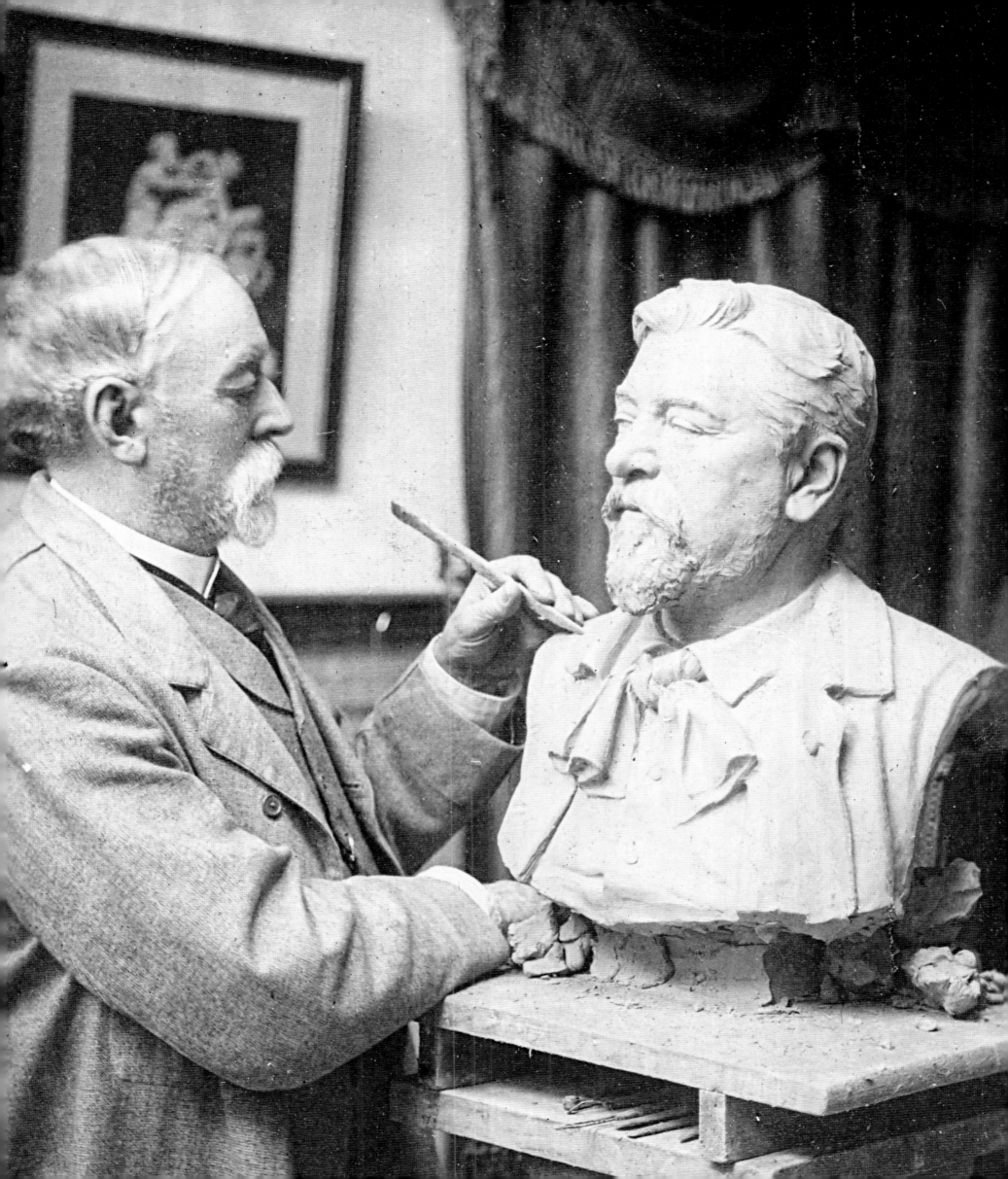

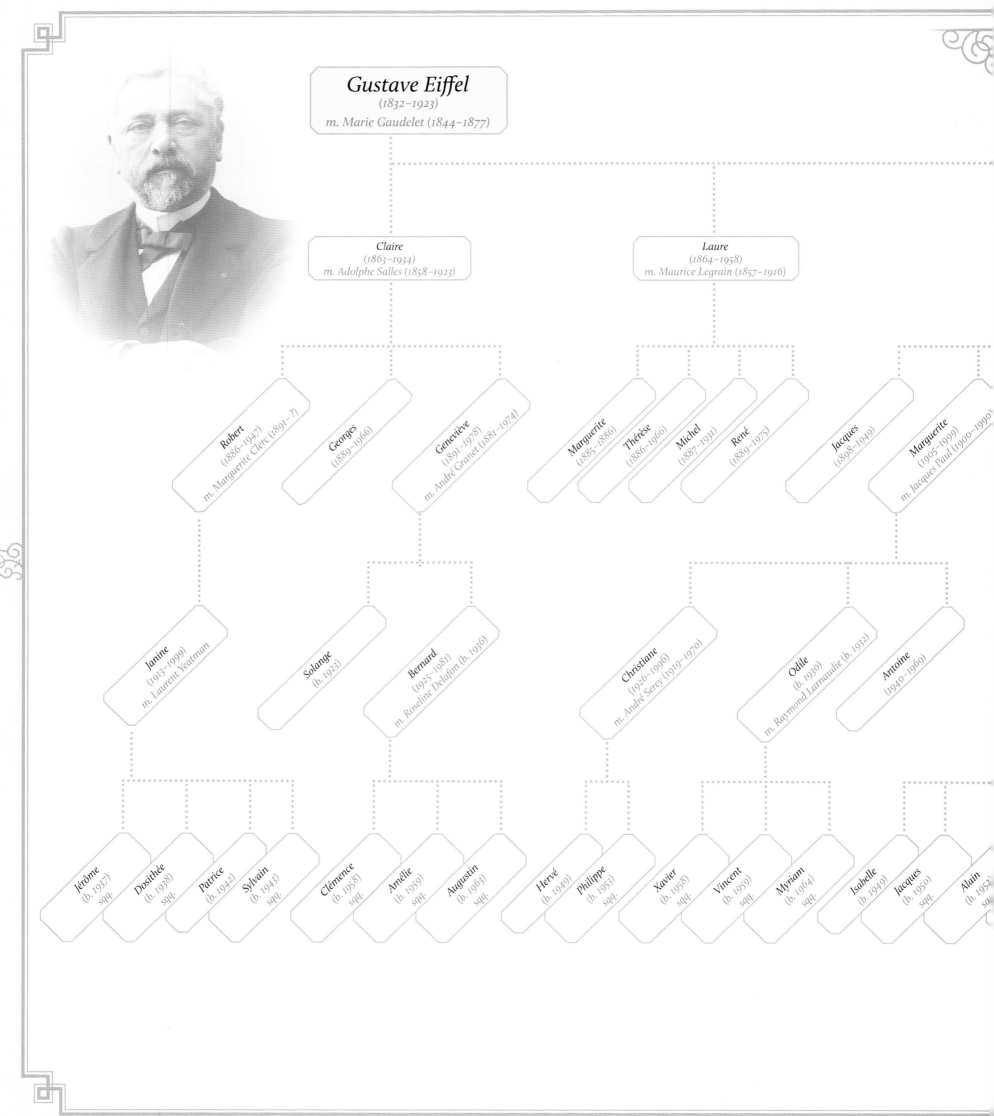

FAMILY TREE

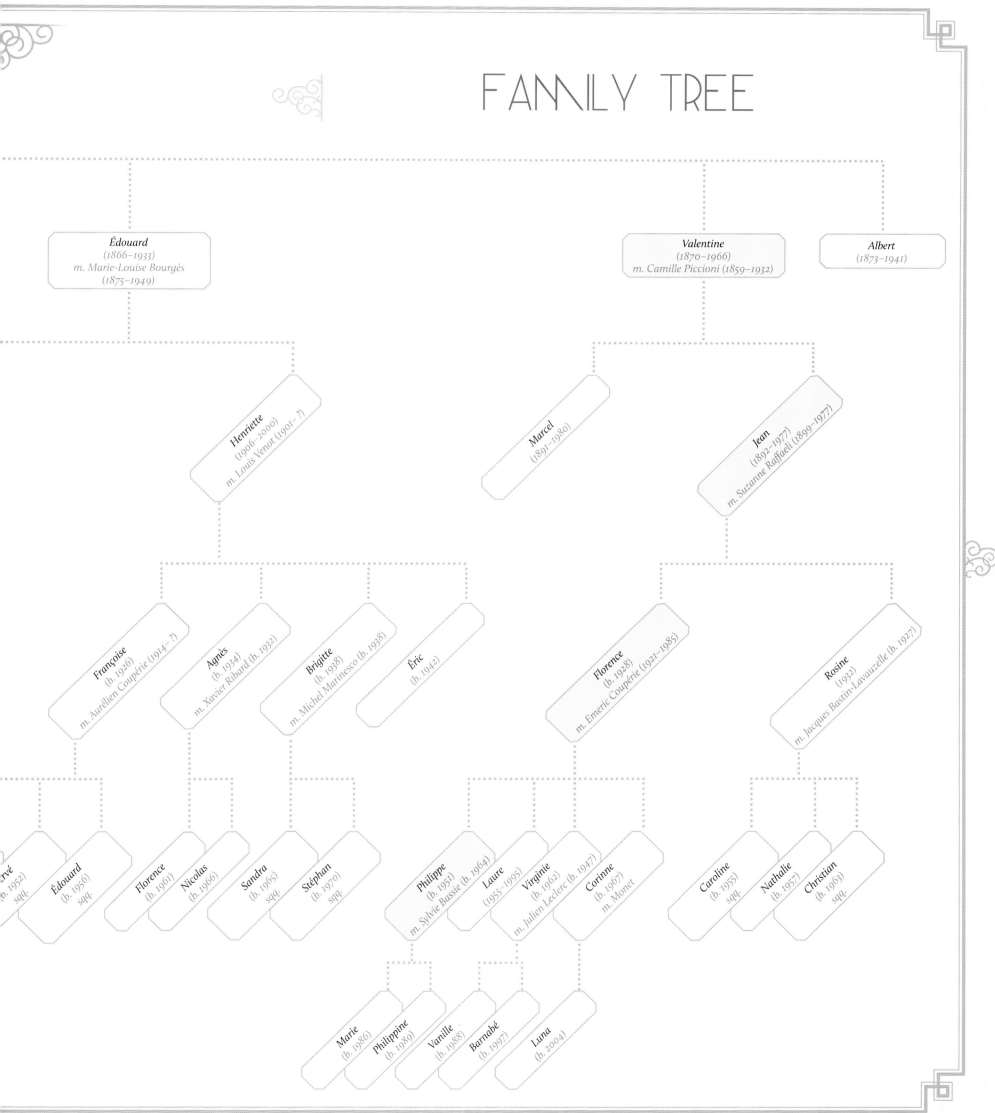

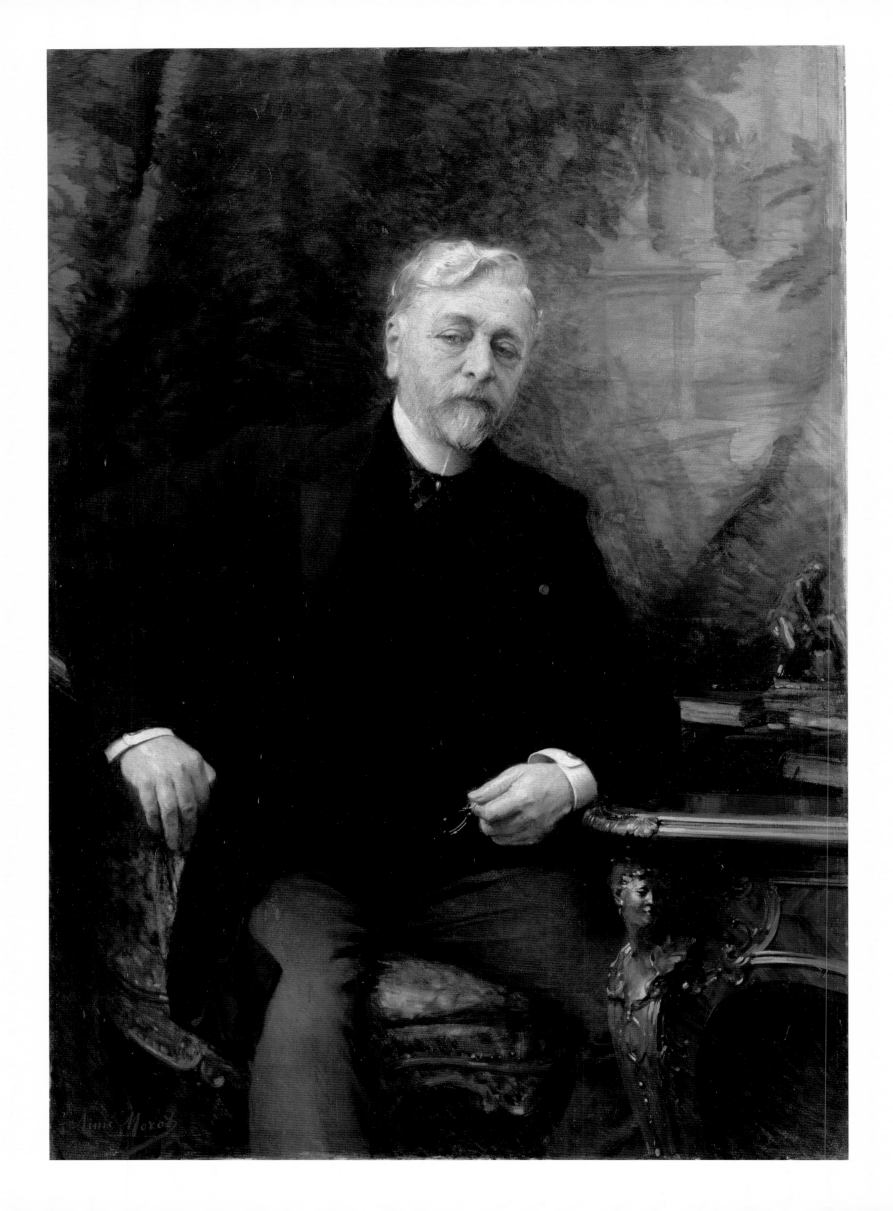

Awards made to Gustave Eiffel

Knight of the Legion of Honour (on the opening of the Exposition Universelle of 1878).

Officer of the Legion of Honour (on the opening of the Eiffel Tower in 1889).

Officer of State Education (for the Exposition Universelle, 1889).

Knight of the Order of François-Joseph (for Pest Station).

Knight of the Order of the Iron Crown of Austria (for the Szeged Bridge).

Commander of the Order of Creators of Portugal (for the Douro Bridge).

Commander of the Order of Isabelle the Catholic of Spaion (for the Tage Bridge).

Commander of the Royal Order of Cambodia (for his work in Cochinchine).

Commander of the Order of the Dragon of Annam (for his work in Cochinchine).

Commander of the Order of the Crown of Italy (for his kit bridges).

Commander of the Order of Saint Anne of Russia (for his kit bridges).

Commander of the Order of the Saviou of Greece (for various work).

Commander of the Order of Saint Sava of Serbia (for various work).

Dignitary Third Class of the Imperial Order of the Rising Sun

(conferred on Eiffel in July 1917 by the Emperor of Japan for his research into air resistance and its application to the science of aviation).

Opposite:

Gustave Eiffel (*oil on canvas, 1905*) *by Aimé Morot, at the Musée national des châteaux de Versailles et de Trianon in Versailles.*

**SOCIÉTÉ
DES
INGÉNIEURS CIVILS
DE FRANCE**
Fondée le 4 Mars 1848

RECONNUE D'UTILITÉ PUBLIQUE
*Par Décret
en date du 22 Décembre 1860*

ADRESSER LES RÉPONSES AU SECRÉTARIAT
**19, Rue Blanche, 19
PARIS (9ᵉ)**

Adresse Télégraphique :
INGÉCIVILS-PARIS

TÉLÉPHONE : TRUDAINE 66-36

Paris, le 13 Janvier 1923

Monsieur G. EIFFEL.
Président d'Honneur de la Société
1 rue Rabelais.
PARIS.

Mon cher Président,

J'ai l'honneur et le plaisir de vous annoncer que, sur la proposition du Comité, vous avez été nommé, dans la séance du 12 courant, Président d'Honneur de notre Société.

Nous avons été heureux de vous donner ce témoignage de haute estime à l'occasion du 75ème anniversaire de la fondation de notre Société qui sera fêté cette année dans le courant de Mai.

Veuillez agréer, mon cher Président, l'assurance de mes sentiments les meilleurs et les plus distingués.

LE PRESIDENT:

Léon Guillet

Titles held by Gustave Eiffel

In France

President of the Society of French Civil Engineers, in 1889.

President of the International Congress on the Construction Programme for the Exposition Universelle of 1889.

President of the Friendly Association of Alumni of the École Centrale, in 1890.

Member of the development council of the École Centrale.

Winner of the Montyon Prize for Mechanics awarded by the Institut Français in 1889.

Winner of the quinquennial Elphège Baude Prize awarded by the Société d'encouragement in 1887.

Winner of the Grand Prix de l'Exposition universelle of 1878.

Winner of the Grand Prix de l'Exposition universelle of 1889.

Winner of the Gold Medal of the Society of French Civil Engineers (triennial François Coignet Prize) in 1913.

Winner of the Fourneyron Prize awarded by the Institut Français in 1914.

Honorary President of the Society of French Civil Engineers in 1923, on the occasion of the 75th anniversary of the Society's foundation (it was only the third time that the Society had bestowed this honour on one of its former presidents).

In other countries

Honorary member of the following institutions:

ENGLAND—Institution of Mechanical Engineers in London.

UNITED STATES—American Society of Mechanical Engineers in New York.

Gold Medal awarded by the Smithsonian Institution in Washington (the Langley Medal, instituted in 1908, "for outstanding research in the science of aerodynamics and its application to aviation", which was awarded for the first time in 1910 to Wilbur and Orville Wright and for the second time in 1913 to Gustave Eiffel).

NETHERLANDS—Royal Institute of Dutch Engineers in The Hague.

RUSSIA—Imperial Polytechnic Society of Russia.

SPAIN—Association of Industrial Engineers in Barcelona.

BELGIUM—Association of Graduates from the Engineering Schools of Gand.

MEXICO—Mexican Geographical and Statistical Society and the Antonio Alzate Scientific Society.

Opposite:
The letter sent to Eiffel by Léon Guillet (1873–1946), President of the Society of French Civil Engineers, on 13th January 1923 informing him of his election as its honorary president.

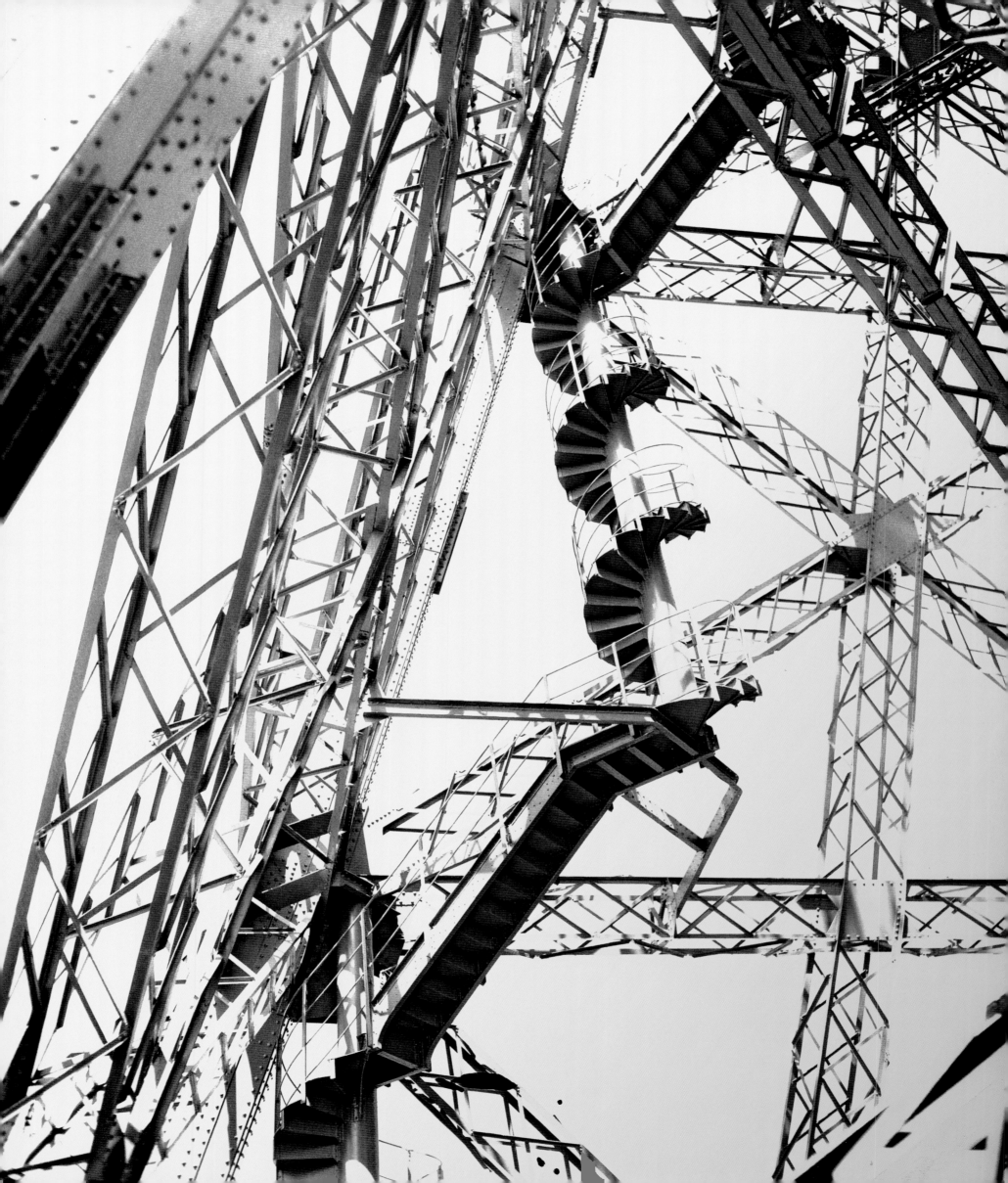

ANNEXES

PAP. IMP. FORTIN PARIS-NEVERS

Translations of handwritten letters

P. 8 30th June 2007
Having inherited from my grandmother Valentine Piccioni-Eiffel the original typescript of the *Biographie industrielle et scientifique* by Gustave Eiffel, which he himself wrote and which includes the Eiffel family tree as well as the autobiography (volume 1: Iron construction; volume 2: Air resistance; volume 3: Meteorology), lists of his honours and titles and of his works, and a handwritten dedication by Eiffel to his daughter Valentine dated 25th September 1923, I hereby leave these documents to my son Philippe Coupérie-Eiffel in memory of his great-grandmother Valentine, with whom he spent so many holidays and who loved him dearly. With love and affection. F. Piccioni-Coupérie

P. 11 In the hope that these pages will remind each of my children of the principal events in the history of our family, as far as I have been able to ascertain them, as well as of my career as a scientist and engineer, I present this copy to my beloved daughter Valentine, as a token of my deepest affection. G. Eiffel

P. 17 Dijon, 31st December 1840
My dear Papa, I beg your pardon for the foollish things I did on sunday, I am very sorry for the hurt I causd you on sunday, I don't know what came into my head, I shall be better behaved next year, I will do everything you want me to do to make you happy, I will work harder next year. I will always remember your goodness my dear father, I will do everything I can to please you, I wish you a Happy New Year even though I have nothing. But what does that matter? Please give Laure a kiss for me. Goodbye father, I love you with all my heart. Your humble servant Gustave Eiffel.

P. 18 Dear Sir, Every morning, or almost every morning, Gustave comes to school with homework that is incomplete. For some considerable time I have been threatening him that whenever such a thing happened he would go without his bath that evening. Finally, today, I had no alternative but to carry out my threat, my forbearance having been exhausted. I therefore put him in detention. I was shocked by Mr Gustave's reaction! His mean, selfish, arrogant manner has lately grown out of all proportion. The slightest criticism annoys him, when he deigns to pay attention to it, and he is as haughty with his peers as he is with his masters. In truth I do not know what these unfortunate children consider their masters to be that they should adopt such an attitude towards them! These matters cause me a great deal of pain. I remain, Sir, your most humble servant. Dubois.
PS Kindly give my regards to your wife and ask her to scold her dear Gustave severely, for his laziness and lack of manners deserve no better.

P. 20 Paris, 7th October 1852
Dear Madam, We have just closed the list of admissions to the École Polytechnique, and I regret to advise you that your son's name does not figure among them. I am extremely sorry to be the bearer of such bad news; indeed I had hoped for a happier outcome, as the young man had made considerable progress during his last year. Yours sincerely. Blanchet.

P. 26 Paris, 31st January 1858
My dear Mama, I was unable to write to you yesterday because I was obliged to spend the whole day in Clichy. I am sending you this note today from Mr Nepveu's, where we have been discussing the Bordeaux bridge project I told you about. From what has been suggested, it seems that I shall be going to Bordeaux, where I shall be based for some 15 months, and that I shall in any case be given a position which will be extremely beneficial to me. It is Mr Pauwels, who is due to return soon, who will make these decisions, but in any event, whatever happens, it will be an excellent experience for me.

P. 32 Bordeaux, 22nd January 1862
My dear Papa, I have not yet replied to your recent letters concerning my matrimonial negotiations, which have all come to nothing, including the latest, which I have yet to tell you about. Whatever the truth may be, you will admit that there are plenty of people in Dijon who dislike us and who would willingly spread all kinds of malicious rumours. I have therefore decided to formally renounce all efforts to find a marriage partner under such circumstances. If I am to find a wife, as you will admit wholeheartedly, without questioning my motives, that it will be nowhere other than Dijon. Besides, to tell the truth, although I shall be happy to marry, the union will no longer be subject to the financial conditions I had originally envisaged; rather, I would be content with a girl who has a modest dowry and a passable figure but on the other hand who is extremely kind and even-tempered…

Bordeaux, 21st February 1862
My dear Mama, I received your letter yesterday and am replying in some haste because, having returned home only two days ago, I am leaving again, first for Toulouse and then for Dax; for the last few months I have truly been living the life of a wandering knight. What you told me about Mr Chaffotte surprises me somewhat, as I have since had occasion to correspond with him and he has always replied in a most friendly manner. However, you are a better judge of such things than I, although unless any special circumstances arise such as some new project, I doubt that his attitude toward me will change much, as I have always been known to take no interest whatever in his affairs. Regarding Marie Gaudelet, she would make a no less disagreeable wife than many others and I am convinced that I shall easily make her into a lovely little wife who will willingly appreciate and show gratitude for any affection shown to her. I should also be grateful for the contribution from my father- and mother-in-law, but the major difficulty lies in the said young woman's paltry dowry…

Levallois, 8th September 1877

My dear parents, My poor beloved Marguerite died last night at 4 o'clock in the morning. She passed away suddenly after a devastating internal haemorrhage. She had been quite well for several days and we were rejoicing in the fact that she felt more comfortable. On Thursday evening, 36 hours before she died, Mr Poterin examined her, accompanied by his assistant Albert Robin, and was most reassuring, suggesting that we might travel to the south in November. Yesterday, Friday, she was well all day, dined with us and ate well, and went to bed at 9.30 in good spirits. But during the night, at around 4 o'clock, she called me and when I reached her room I found her vomiting blood… A few minutes later she passed out and she died without regaining consciousness even for a moment, despite all my efforts to revive her. I am overcome with disbelief and cannot accept that such a terrible misfortune has taken place. What will become of my poor children and of me? With love. G. Eiffel

P. 86 The following petition is currently circulating Paris:
To Monsieur Alphand,
Dear compatriot,
We writers, painters, sculptors, architects, lovers of the capital's beauty, which has hitherto remained untainted, hereby protest in the strongest possible terms, in outright indignation, in the name of good taste and the artistic heritage of France, which have been disregarded and are now under threat, against the erection, in the very heart of our capital, of the useless and monstrous Eiffel Tower, which public opinion, so often marked by good sense and a spirit of justice, has already dubbed the "Tower of Babel".

Without lapsing into chauvinistic hubris, we justly and loudly proclaim that the city of Paris has no rival anywhere in the world. Its streets, its broad boulevards, its elegant riversides and its magnificent pathways are lined with the noblest monuments ever conceived by the human mind. The very soul of France, mother of creative genius, shines from this glorious florescence of stone. Italy, Germany and Flanders are justly proud of their artistic heritage, but none possesses anything to compare to our own, and Paris attracts devotees and admirers from all corners of the globe. Are we then to debase all this? Is the City of Paris henceforth to associate itself with excess, with the mercantile imagination of a machine-builder, to tarnish and dishonour itself irreparably? For let us be in no doubt about it: the Eiffel Tower, which even the materialistic United States wanted nothing to do with, will dishonour Paris. Everyone senses it, everyone says it, everyone is profoundly distressed by it, and we are but a faint echo of that universal opinion, that legitimate alarm. And so, when people come from abroad to visit our Exhibition, they will cry out in amazement: "What? Is this monstrosity the best the French could think of to give us an idea of their much-vaunted taste?" And they will be right to make fun of us, because the Paris of sublime gothic inspiration, the Paris of Jean Goujon and Germain Pilon, of Puget, Rude, Barye and their like will have become the Paris of Monsieur Eiffel.

In order to understand what we are objecting to, imagine for just a moment a ludicrously, vertiginously high tower, looming over Paris, like a gigantic black factory chimney, its barbaric bulk obliterating Notre Dame, the Sainte Chapelle, the Tour Saint Jacques, the Louvre, the cupola of the Invalides and the Arc de Triomphe, imagine all our precious monuments humiliated, all our cherished architecture belittled, everything vanishing in an absurd nightmare. And for the next 20 years we shall see stretching across the entire city, a city still palpitating from so many centuries of inspiration, stretching like a vast ink stain the odious shadow of this odious column of riveted iron.

It is to you, dear compatriot, to you who love Paris so dearly, who have so embellished her, who have so often protected her against administrative devastation and the vandalism of industrial enterprise, to you the duty falls of defending her once again. We entrust you with the honour of pleading Paris's cause, knowing that you will commit to the task all the energy and all the eloquence that a great artist such as you will be inspired to muster by your love of all that is beautiful, all that is great, all that is just. And if our cry of warning is unheeded, if our arguments are ignored, if Paris persists in dishonouring herself, we shall at least, both we and you, have given voice to an honourable protest.

The following have already signed our petition:
Meissonier, Ch. Gounod, Charles Garnier, Robert Fleury, Victorien Sardou, Édouard Pailleron, H. Gérôme, L. Bonnat, W. Bouguereau, Jean Gigoux, G. Boulanger, J.-E. Lenepveu, Eug. Guillaume, A. Wolff, Ch. Questel, A. Dumas, François Coppée, Leconte de Lisle, Daumet, Français, Sully-Prudhomme, Élie Delaunay, E. Vaudremer, E. Bertrand, G.-J. Thomas, François, Henriquel, A. Lenoir, G. Jacquet, Goubie, E. Duez, de Saint-Marceaux, G. Courtois, P.-A.-J. Dagnan-Bouveret, J. Wencker, L. Doucet, Guy de Maupassant, Henri Amic, Ch. Grandmougin, François Bournaud, Ch. Baude, Jules Lefebvre, A. Mercié, Cheviron, Albert Jullien, André Legrand, Limbo, etc., etc.

P.133 22nd March 1917

My dear father-in-law, The attached letter from Mr Paul Cambon will advise you of the request of His Royal Highness the King of England. I imagine that you will wish to send him a recent document showing your signature, and I shall ensure that it is conveyed to Mr Cambon in the daily brief. Kindly return the ambassador's letter, unless you would rather keep it. The great service rendered by the Tower in relation to Allied communications is sufficient in itself to justify the King's flattering interest. Marcel arrived last night with news from Albert. He has left his division marching at the head of the British forces, which are due to make another advance before long. Colonel Feyler's prediction is coming true: the enemy will be forced to withdraw from the front!… In the meantime, we have Marcel with us on ten days' leave. Despite the bitter cold he has had to endure, he is delighted with the discipline and organization of the British. "We always feel that they are in charge!" How wonderful! And how rare for me to achieve a similar sense of order at the Quai d'Orsay! Here we are steeling ourselves for yet another ministerial crisis: it is the last thing I needed!… Fortunately, the news elsewhere (Washington included) is good. Valentine, Marcel and Jacques send you all their love, as I do, and we beg you not to forget us in your dealings with the Minister and to convey our fondest thoughts to Claire and Ninette. C. Piccioni

Selected bibliography

BURES, Charles de, *La Tour de 300 mètres,* André Delcourt, Lausanne, 1988.
CARMONA, Michel, *Eiffel*, Fayard, Paris, 2002.
DE COINTET, Nicolas (ed.), *La Tour Eiffel*, Albin Michel, Paris, 2009.
EIFFEL, Gustave, *Biographie industrielle et scientifique. Généalogie de la famille Eiffel*, 4 vols, 1923.
MATHIEU, Caroline (ed.), *Gustave Eiffel, le magicien du fer*, ESFP, Paris, 2009.
PETER, Martin, and CUISINIER, Jean-Pierre, *Eiffel, la bataille du vent*, CSTB, Paris, 2007.
Sur les traces de Gustave Eiffel (DVD), a film written by Charles Berling and Virginie Coupérie-Eiffel,
HB Productions/RMN/France Télévisions Distribution, 2009.

Picture credits

A study for *Monde Eiffel* by Fifax (www.fifax.com) appears on the inside covers.

Private collection of the author
pp. 8, 10, 11 (dedication), 18 (top and bottom right), 19, 20 (bottom), 21, 24, 93 (bottom left), 99 (top left), 109 (bottom), 111 (top), 112 (centre), 124, 125 (bottom), 134, 144 (centre right and bottom right), 150 (bottom left), 164.

Musée d'Orsay/Réunion des musées nationaux—Grand Palais
Eiffel Archive, donated by Miss Solange Granet, Mrs Bernard Granet and her children, 1981.
Patrice Schmidt: pp. 4–5, 17 (top), 26 (top right), 32 (letters), 42 (left), 56, 57, 62 (bottom), 80–81 (insert), 83 (top), 85 (top left and right), 86–87 (background), 92–93 (top), 93 (right), 99 (top right), 129, 132 (right), 133 (letter), 137, 138–139, 140, 149 (bottom), 150 (top left), 152, 153, 155, 175; Alexis Brandt: pp. 11, 16, 20 (top left and right), 28, 29, 30, 33 (background), 34, 35, 41 (top), 42 (right), 51 (top right), 58, 59, 60, 68–69, 76, 78 (bottom), 82 (top), 85 (left 3), 87, 88–89, 99 (bottom left), 103 (top), 104 (top), 105, 118, 120 (top and bottom), 121, 123, 125 (left), 127 (background), 133 (medallion), 135, 136, 143, 144 (top and centre left), 146–147, 151, 154, 159; Gérard Blot: pp. 12, 36, 74, 162; Hervé Lewandowski: pp. 17 (bottom), 26–27 (bottom), 50 (top), 61 (bottom), 78 (top 1, 3 and 4), 84, 85 (left 2 and bottom), 95 (vignette), 102, 104 (bottom), 127 (centre), 148, 149 (top right), 150 (bottom right); Stéphane Maréchalle: pp. 31, 39, 77 (left), 109 (left); Madeleine Coursaget: pp. 72–73, 142; Centre Pompidou, MNAM-CCI, dist. RMN-Grand Palais/Georges Meguerditchian and Philippe Migeat: p. 91 (top centre and right); pp. 27 (top), 82–83 (bottom), 91 (bottom), 103 (bottom), 122, 158.

Roger-Viollet
pp. 18 (bottom left), 22–23, 79 (Musée Carnavalet), 25 (François Kollar/Bibliothèque Forney), 40 (CAP), 44–45, 46 (left), 46–47 (bottom), 47 (right), 55, 94 (background: Musée Carnavalet/G. Fraipont), 96–97, 98, 106, 145 (Neurdein), 110, 112 (top left), 113 (top right: US National Archives), 130 (Ernest Roger), 132 (bottom: Maurice-Louis Branger), 166 (René-Jacques/BHVP); Jacques Boyer: 113 (top left and centre), 116 (background), 117 (top left), 120 (centre); Albert Harlingue: 112 (top right), 117 (top right and bottom), 114–115.

Gamma-Rapho
pp. 48–49 (Nathalie Cuvelier), 52 (Véronique Durruty), 61 (top: Jose-Fuste Raga/Explorer), 70–71 (Sylvain Grandadam/Hoa-Qui), 92 (top left: GA1029/Gamma; bottom left: coll. Devaux/Keystone).

Archives nationales du monde du travail/Mathieu Thauvin
pp. 38, 41 (left), 42–43 (background), 51 (top left and bottom), 54, 66, 67, 94 (centre left and bottom right).

Bibliothèque nationale de France
pp. 62–63 (top), 91 (top left), 94 (top right), 95, 99 (bottom right), 108, 128.

Wikimedia Commons
pp. 46–47 (top: P4ntt), 53 (Eugenio Hansen), 64–65 (Dschwen), 80–81 (Paris 16), 77 (right: Joergens.mi), 90 (bottom: Joergens.mi; right: Paris 16), 100–101 (Claus), 131 (F1jmm), 156 (Jebulon).

Laboratoire aérodynamique Eiffel
pp. 126, 127 (top left).

Other sources
Autoridad del canal de Panamá: p. 6; Musée Bartholdi (Colmar)/C. Kempf: p. 63 (right); Archives départementales de la Côte d'Or/2E239-202 and 293 (© CG21/F. Petot/2013): pp. 14, 32–33 (background); Guy Lacquement/Sud-Ouest: p. 157; Studios d'architecture Jean-Jacques Ory: p. 170; DR: pp. 15, 26 (top left), 50 (bottom), 112–113 (background), 119, 144, 170.

Opposite:

The Eiffel Bridge over the River Vecchio, built in 1890–92. At 171 m long and 84 m high, it is the largest viaduct in Corsica, and its construction was a great event. It is crossed by the Trinichellu ("Little Train"), which links Bastia and Ajaccio.

Acknowledgements

Philippe Coupérie-Eiffel and Edition Olms AG, Zürich would jointly like to thank:

His Excellency Henry J. Faarup, Panamanian Ambassador to France,
Mariana Pereira,

Le musée d'Orsay et la Réunion des musées nationaux et du Grand Palais,
Caroline Mathieu and Fabrice Golec,
Laurence Kersuzan and Frédérique Kartouby,

Les Archives nationales du monde du travail (Roubaix),
Agnès-Gersende Piernas,

Le Laboratoire aérodynamique Eiffel,
Martin Peter,

La Société d'exploitation de la tour Eiffel,
Jean-Bernard Bros and Nicolas Lefebvre,
Isabelle Esnous,
Bob Franke,

Isabelle Calabre,

Florence Coupérie-Piccioni and Rosine Bastin-Lavauzelle,
Virginie Coupérie-Eiffel and Florence Bosson,
Amélie Granet-Garoscio,
Marie and Philippine Coupérie-Eiffel,

Stéphane Lieser and Caroline Lampre,
Fifax,

Les Archives départementales de la Côte d'Or,
Frédéric Petot,

Le musée Bartholdi de Colmar,
Régis Hueber,

La Société des bains de mer (SBM) de Monte-Carlo,
Christiane Cane and Charlotte Lubert-Notari.

Opposite:
The entrance hall of Le Centorial on the Boulevard des Italiens in Paris, formerly the head office of the Crédit Lyonnais bank, which has a glass roof designed by Eiffel et Cie in 1881. The building was badly damaged by fire in 1996 and the architect Jean-Jacques Ory supervised its restoration in 2001.

English bibliography

CUITO, Aurora & MONTES, Cristina, *Gustave Alexandre Eiffel*, teNeues Publishing Company, 2003.
JONNES, Jill, *Eiffel's Tower*, Penguin: Viking, New York, 2009.
LEMOINE, Bertrand, *The Eiffel Tower* (25th Anniversary Special Edtn), Taschen GmbH, Cologne, 2008.
LOYRETTE, Henri, *Gustave Eiffel*, Rizzoli, New York, 1985.
TISSANDIER, Gaston, *The Eiffel Tower: A Description Of The Monument, Its Construction, Its Machinery, Its Object, And Its Utility: With An Autographic Letter Of M. Gustave Eiffel...*,
Sampson Low, Marston, Searle & Rivington, Paris, 1889.

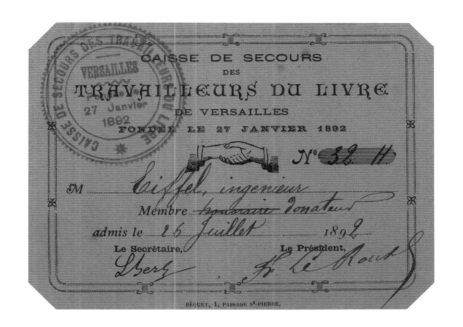